APOLLO

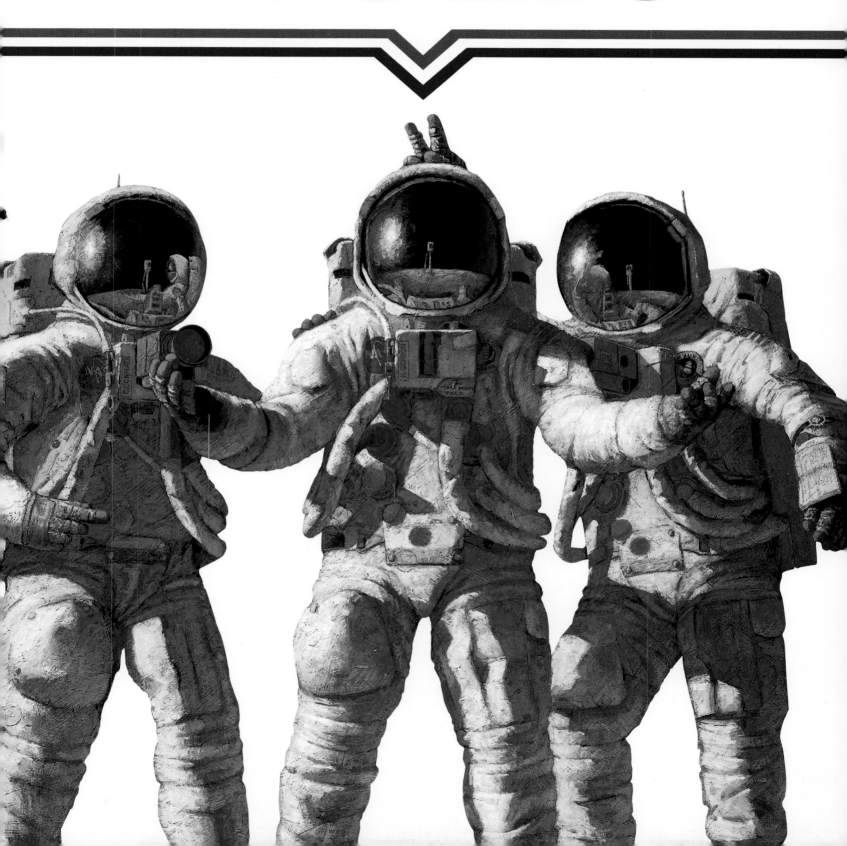

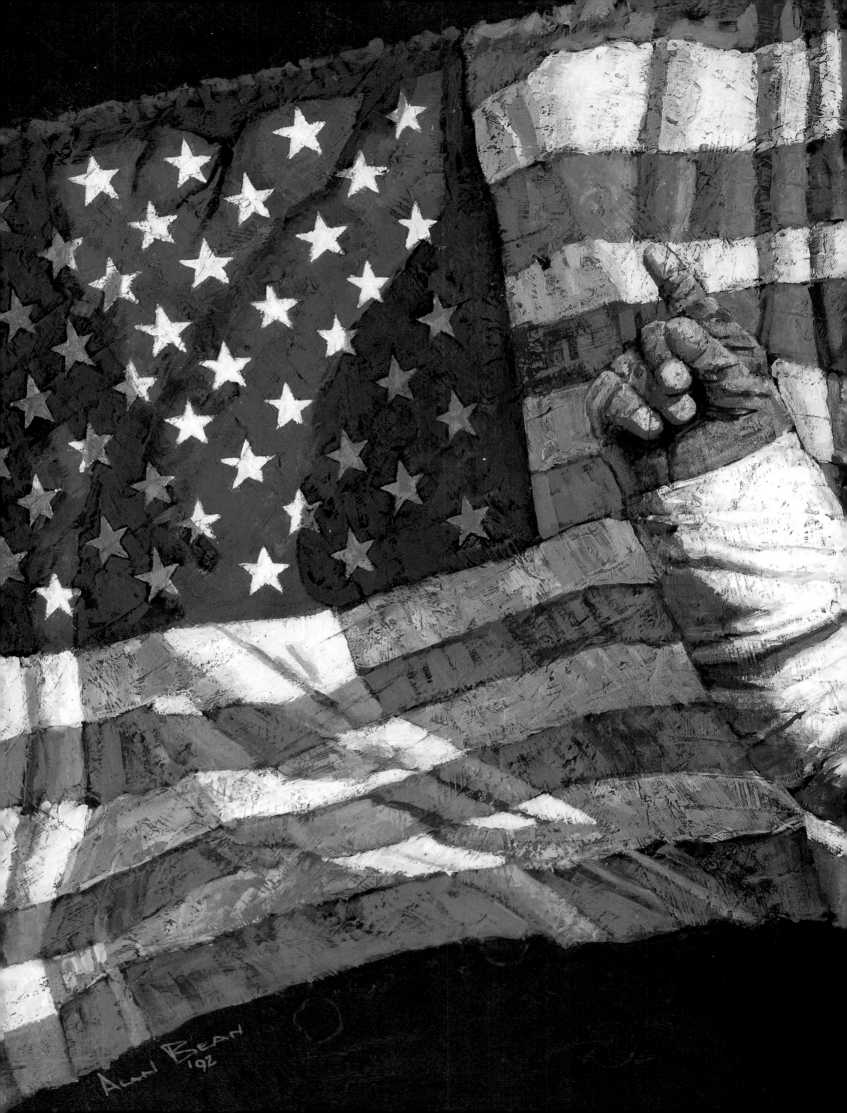

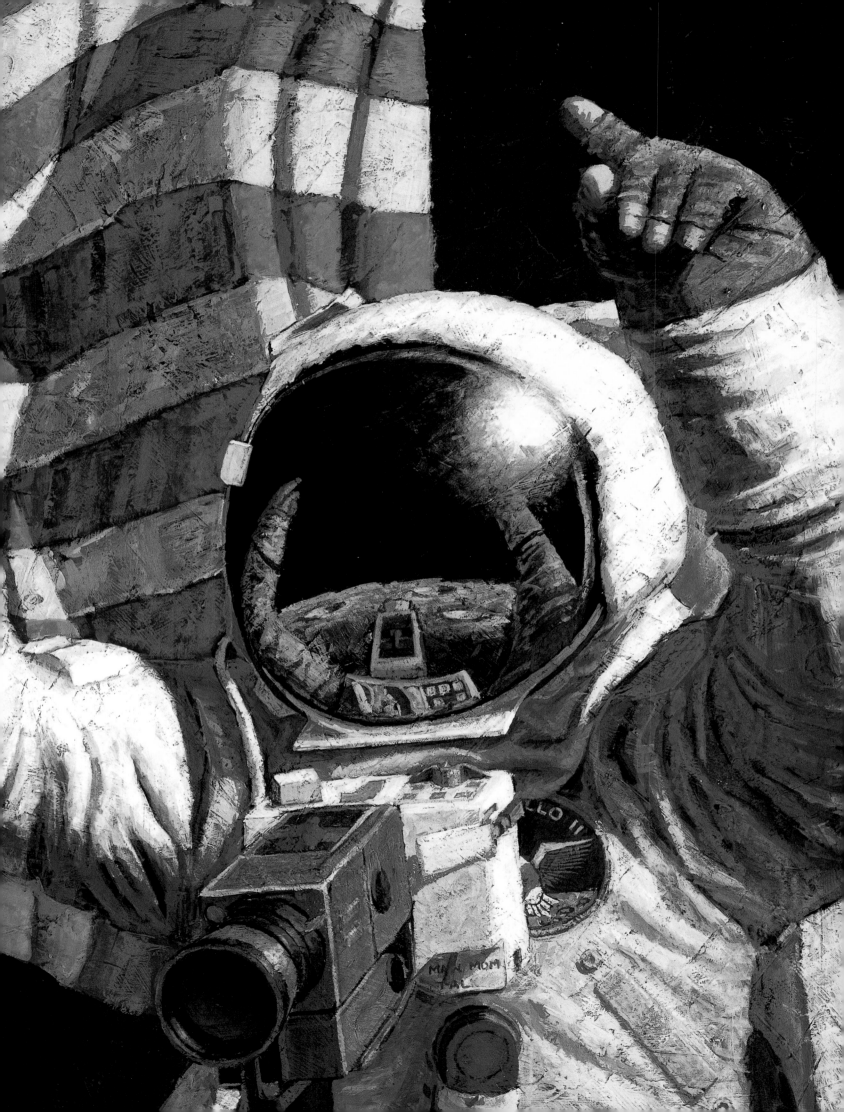

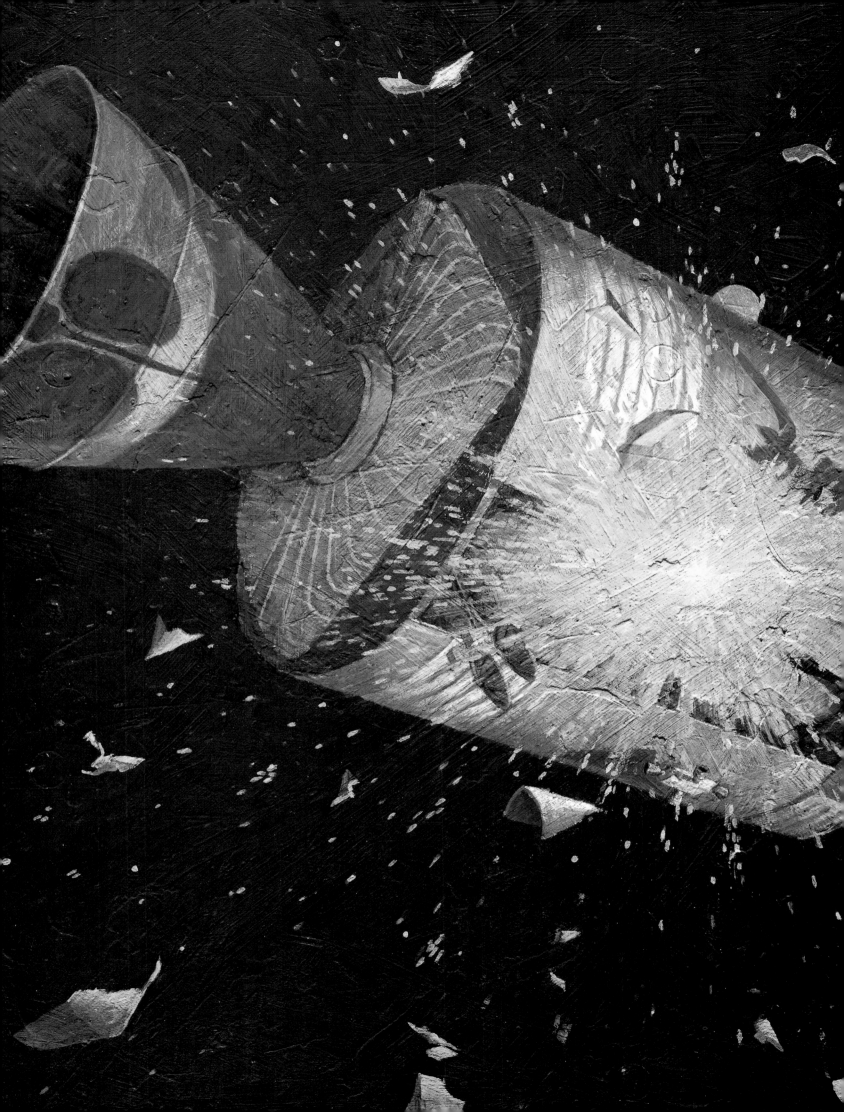

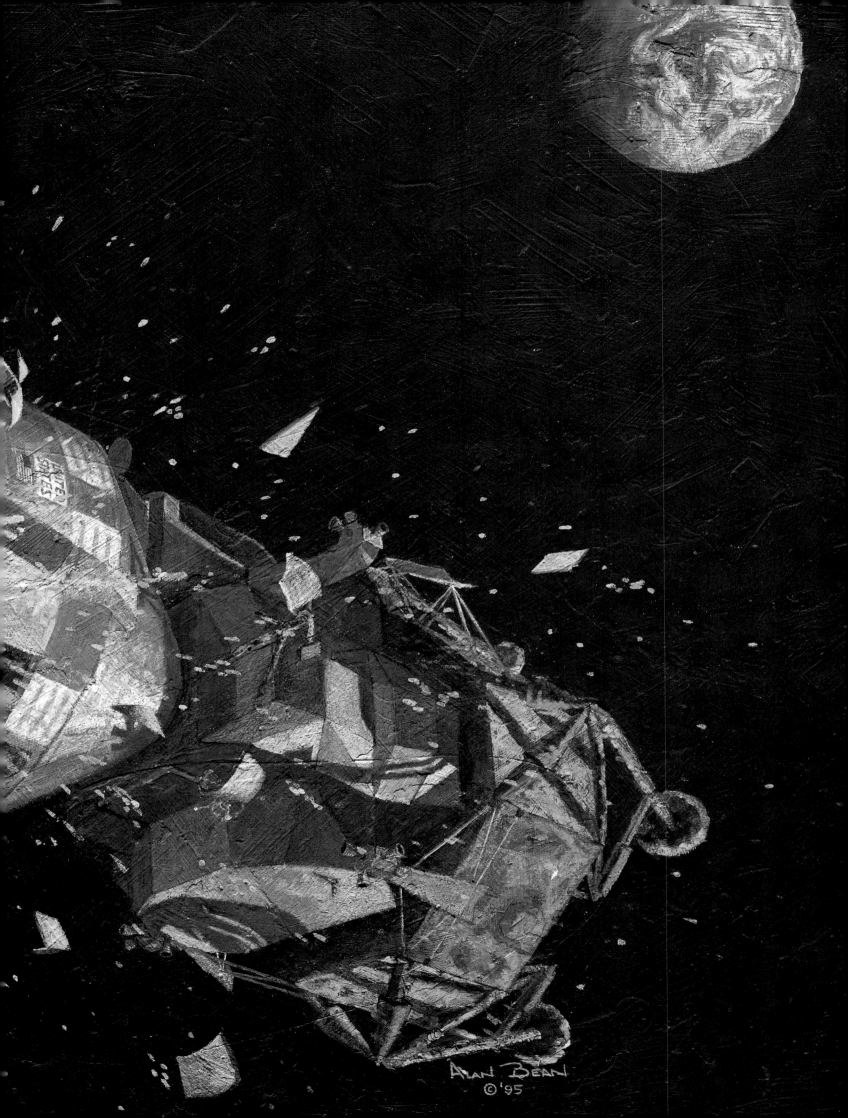

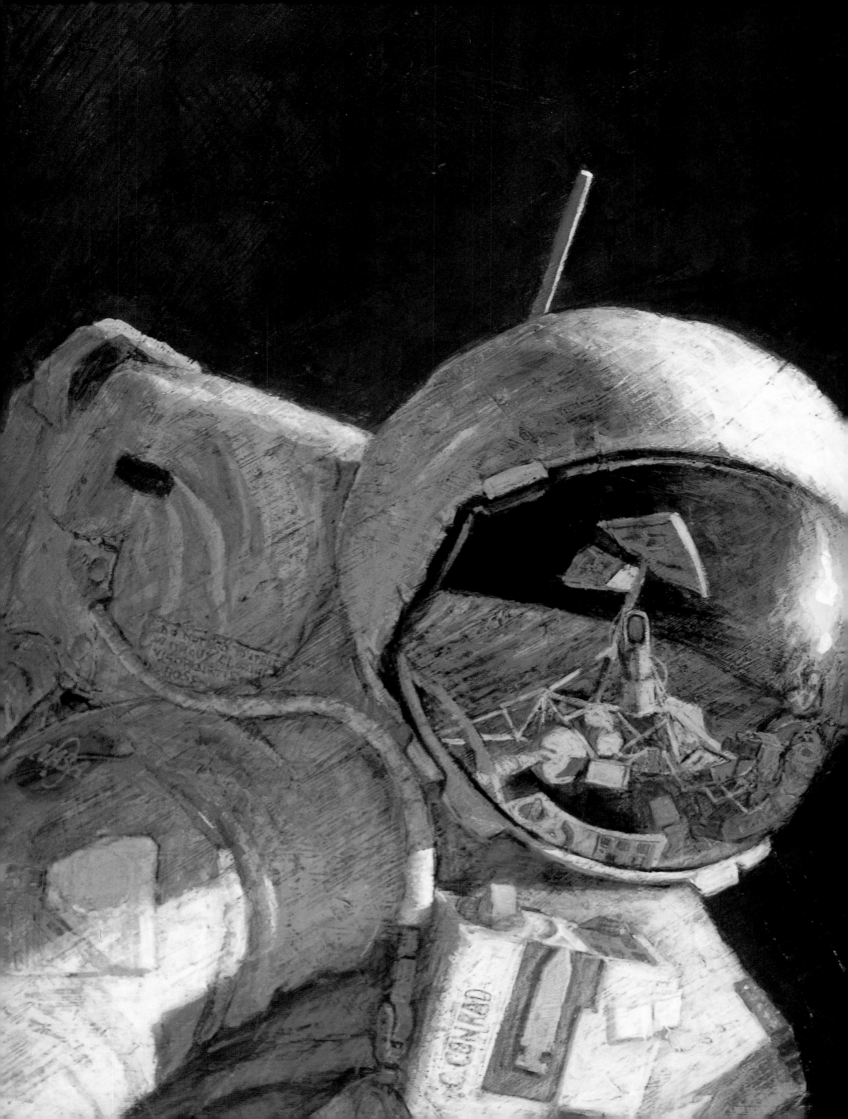

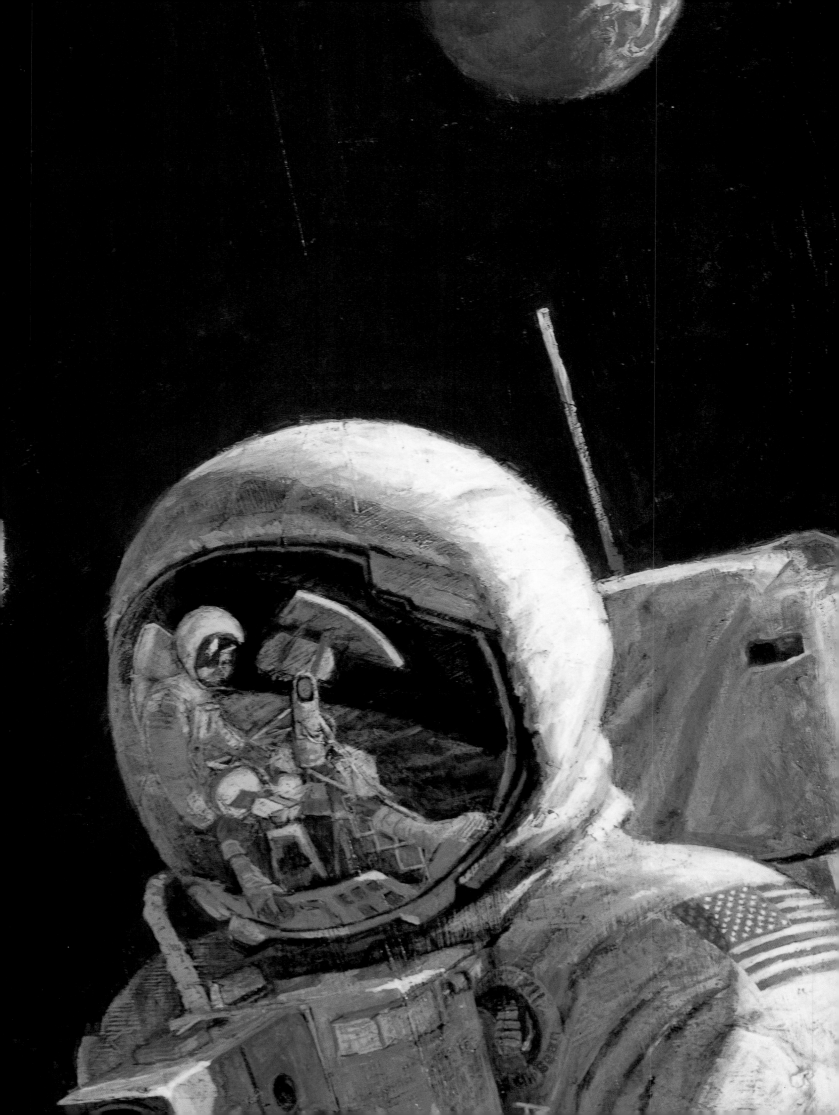

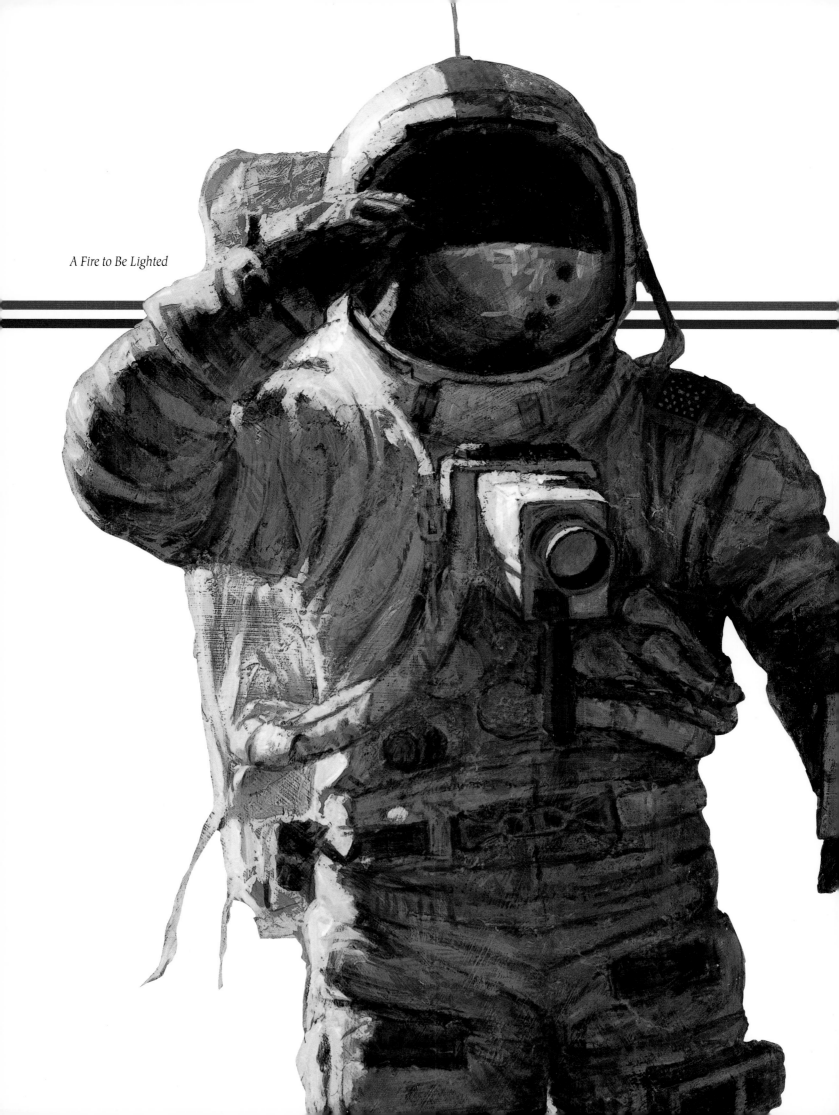

A Fire to Be Lighted

APOLLO

AN EYEWITNESS ACCOUNT BY
ASTRONAUT / EXPLORER ARTIST / MOONWALKER
ALAN BEAN

•

WITH ANDREW CHAIKIN

•

INTRODUCTION BY
SENATOR JOHN GLENN

•

THE GREENWICH WORKSHOP PRESS

DEDICATION

This book is dedicated first to my father and my mother. Since my father's profession
frequently took him away from home, it was my mother who saw the potential in me as a boy, when there was
no indication of it in my day-to-day behavior. Second, to Pete Conrad, my primary role model, who saw the possibilities
within me and who allowed me to achieve the dream I had of being a good astronaut. Third, to my wife Leslie,
who was willing to live in a very small apartment, on not a lot of money, for a whole lot of years so that I could do
whatever it took to change from an astronaut to an artist. I love her very much and her loving
and caring attitude is a constant inspiration to me.

A GREENWICH WORKSHOP PRESS BOOK

Library of Congress Cataloging-in-Publication Data
Bean, Alan, 1932-
 Apollo: an eyewitness account by astronaut/explorer artist/moonwalker Alan Bean/with Andrew Chaikin; introduction by John Glenn p. cm.
 ISBN 0-86713-050-4 (hardcover: alk.paper)
 1. Project Apollo (U.S.)—Anecdotes. 2. Space flight to the moon—Anecdotes. 3. Bean, Alan 1932- —Anecdotes.
4. Outer space—In art. 5. Moon—In art. I. Chaikin, Andrew, 1956- . II. Title. TL789.8.U6A5184 1998
 629.45'4'0973—dc21 98-19512 CIP

Inquiries should be addressed to :
The Greenwich Workshop, Inc., One Greenwich Place, P.O. Box 875,
Shelton, Connecticut 06484-0875
•
For information about the art of Alan Bean, please write to The Greenwich Workshop, Inc.,
at the address above, or call 1-800-577-0666 (in the U.S.) to be directly connected
with the authorized Greenwich Workshop dealer nearest you.
•
FRONTIS ART
2-3 Detail from *America's Team...Just the Beginning*
4-5 Detail from *Houston, We Have a Problem*
6-7 Detail from *Please Take Me Back Home Guys*
•
Book design by Peter Landa with Kristi Worden and Milly Iacono
Artist portraits and studio photography by David Nance
Manufactured in Japan by Toppan Printing Co., Ltd.
First Printing 1998
99 00 0 9 8 7 6 5 4 3 2

CONTENTS

ARTIST'S FOREWORD

When I left the space program in June of 1981, I did so with the idea that I would create paintings that depict one of the great adventures of humankind as only an insider sees it. With each of these paintings, I write a short narrative because I always like it when artists talk about a specific painting. I also realize now that many people either do not remember or do not know much about the manned Apollo missions to the moon.

When I dedicated myself full-time to art, I hoped that some day my paintings would appear in books and in school libraries, and that young people would be inspired to follow their own dreams as we Apollo astronauts had. And now that this book is a reality, I hope it can feed their dreams, and motivate them to believe that they, too, can take an active part in the explorations and adventures of their lifetimes, whether it means being among the first humans to reach Mars, or flying on the first starship to Alpha Centauri.

Through the years as I painted I've thought a lot about what I might include in a book. I knew many interesting stories about almost every astronaut who served when I was in NASA. I imagined I would be able to show my paintings, tell the stories about them, and also weave in anecdotes and behind-the-scenes stories about most of the other astronauts. In the early stages of creating this book, I realized I could not tell all the stories I wanted to tell. For example, I paint mostly astronauts at work on the moon, so I don't portray the command module pilots at all. Without them, however, none of us would have returned to earth. Since I have not yet painted Apollo 7 or Apollo 9 (both extremely important missions), I didn't have a way to include how I felt about those astronauts or some of the great stories I know about them. I'm thinking here particularly about some of my best friends, former astronauts Walt Cunningham and Rusty Schweickart.

And what to do about the mission directors and flight controllers, the Apollo program managers, our trainers, and key NASA headquarters personnel? Apollo was a program whose success depended on 400,000 men and women doing their jobs with care and precision. The fact that they did so superbly is obvious from the spectacular results. All of us who were lucky enough to fly into space owe them a debt we can never repay. Many of these people have stories just as important as mine and I encourage them to put the stories down on paper before they are lost forever.

I owe a debt also to Nan Liem and Pat Brill, two good friends who were instrumental in directing me some years ago toward my present career. More recently, grateful thanks to my publisher at The Greenwich Workshop Scott Usher, who never sacrificed content for schedule, and to my wise and wonderful editor Wendy Wentworth who never lost patience with Andy Chaikin and me as we struggled to make this book the very best it could be. George Hicks and Chris Hubbard helped us along the way. Credit for the layout of this beautiful book belongs to artist and creative director Pete Landa. Creating a book is truly a team sport.

It has been almost thirty years since I walked on the moon and thirty-six years since I came to NASA as a rookie astronaut. I think I remember the events accurately, and when I compare memories with my friends who were there at the time, we generally remember things pretty much the same way. However, from time to time we do remember things differently. We all process information in our own way and the unique trajectories our lives have taken may have colored our memories of the events we shared. These are the stories as I remember them.

—ALAN BEAN

INTRODUCTION

Early on the morning of February 20, 1962, I sat atop an Atlas rocket in a tiny spacecraft the world would come to know as *Friendship 7*. In the seconds before liftoff, I heard the voice of Scott Carpenter in my earpiece and the quiet words "Godspeed John Glenn." I shall never forget that moment or the challenge that lay before me.

As I look back across the miles and the years, I see more vividly that which I may not have seen before. It is partly from the vantage point of hindsight, but more, now, with the ability to appreciate just what it took this nation to get where we are now. We had a constant goal, and sometimes the struggle, to be better, to do it again and get it right, and to be as perfect as we knew how to be. This pursuit of excellence was the foundation upon which we built the American space program.

As these words are drafted, I note that thirty-seven years ago, President John F. Kennedy proclaimed before Congress:

"Now it is time to take longer strides—for a great new American enterprise—time for this nation to take a clearly leading role in space achievement . . .

. . . I believe that this nation should commit itself to achieving the goal, before this decade is out, of landing a man on the moon and returning him safely to the earth. No single space project in this period will be more impressive to mankind, or . . . be so difficult or expensive to accomplish."

That presidential edict galvanized the American industrial and scientific communities into action. Kennedy encouraged, dared—even challenged us not only to believe in a dream, but to make it happen. When I look back and compare the confines of *Friendship 7* to the sophistication of today's space shuttles, I know that we have succeeded as a result of hard work, often blind faith, the best technology available, good luck, and sometimes even accidently.

Today's space pioneers are much akin to the stoic men and women of the 1800s who traversed the great American frontier. In that early exploration, our pioneers included explorers, map makers, trappers, and adventurers. Also among them were a handful of explorer artists, men like Thomas Moran and Albert Bierstadt, whose crude maps charted unexplored rivers and canyons and suggested routes for settlers' wagons. Their paintings depicted these journeys through unspoiled lands with tall timber, green grasses, crystal blue skies, and clear cool water.

One hundred years later, President Kennedy's words spawned an entirely different kind of exploration. Lessons learned in space have positively affected medical science, energy conservation, telecommunications, and have fostered international cooperation in the management of the environment.

We can be thankful that our explorations in space happened to include an artist: Alan Bean. We knew him first as an accomplished naval aviator. The world discovered him as an astronaut and lunar explorer and now his art has garnered international attention. Alan Bean's story is as unique as that of our explorer artists of the 1800s. In his early days as a pilot Alan Bean possessed an interest and an ability in art. He worked to develop it. That special set of skills equipped him with a unique visual insight. He saw the same monochromatic world as the other astronauts, yet with an artist's eye he also saw intrinsic beauty in the rocks and boulders and their textures and shapes. To Alan, they suggested sculptures in a garden of stone, left by an artist from an era long, long ago. When Alan returned to earth he recreated for all of us his total experience, both visual and emotional, in many colors. He has given us an explorer's account of what he and our Apollo veterans witnessed and experienced.

This book is a visual treat, and documents what is clearly one of the outstanding achievements of the twentieth century. Each painting tells a story, and each portrays an innate sense of accomplishment and exultation that virtually every living American and every astronaut felt with each Apollo mission. You will find that the fine art and the patriotic fervor that follow are as compelling as they are inspirational. Even the titles remind us of that great American ideal, that *Beyond A Young Boy's Dream* all things are possible if we just keep *Reaching For the Stars*.

—Senator John Glenn
Washington, D.C., June, 1998

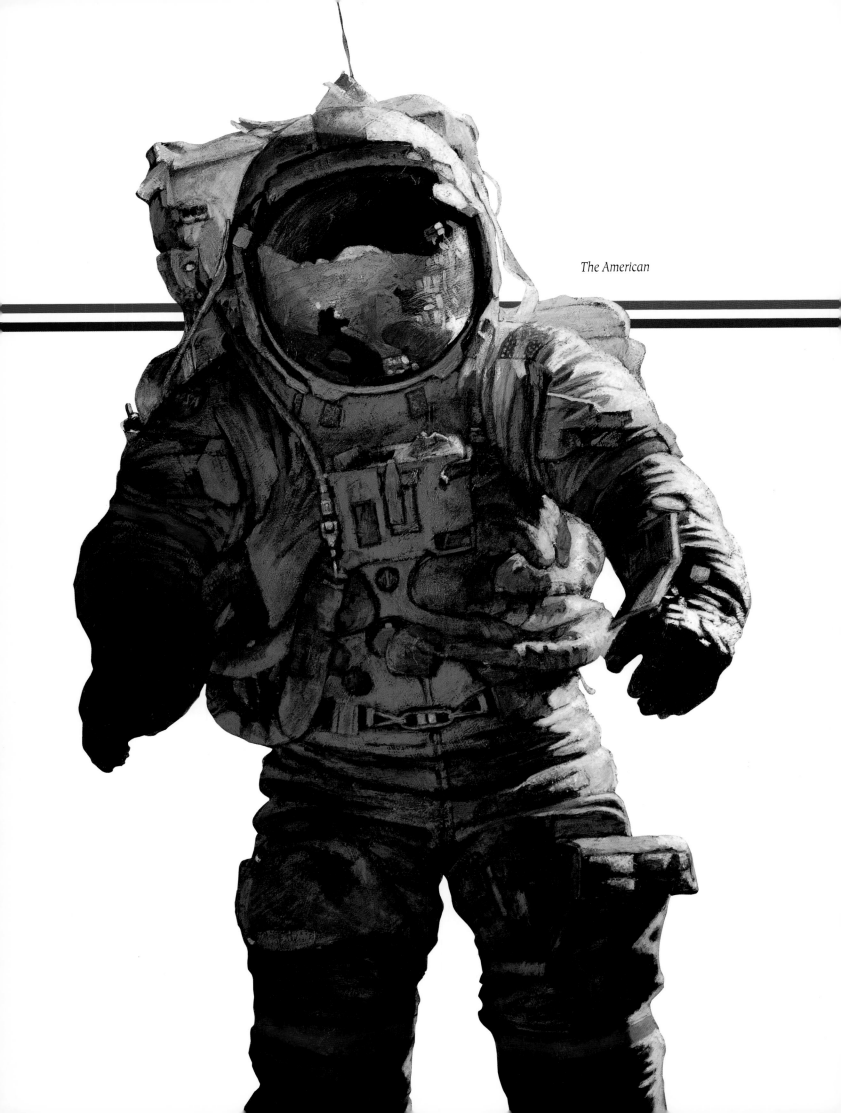

The American

·I·
AN ARTIST ON THE MOON

"Forty-two feet . . . Coming down at two . . .
Thirty-one. Thirty feet. You got plenty of gas. Hang in there."
Plenty of gas, if you considered less than a minute's worth of
descent fuel plenty. And now, from a quarter million miles away,
came a warning: "Thirty seconds." Half a minute of fuel remaining.
On earth, Bean knew, a pilot with only thirty seconds worth
of fuel in the tanks was likely to be justifiably panicked.
But it was normal for the final moments of
a lunar landing. He told Houston,
"He's got it made."

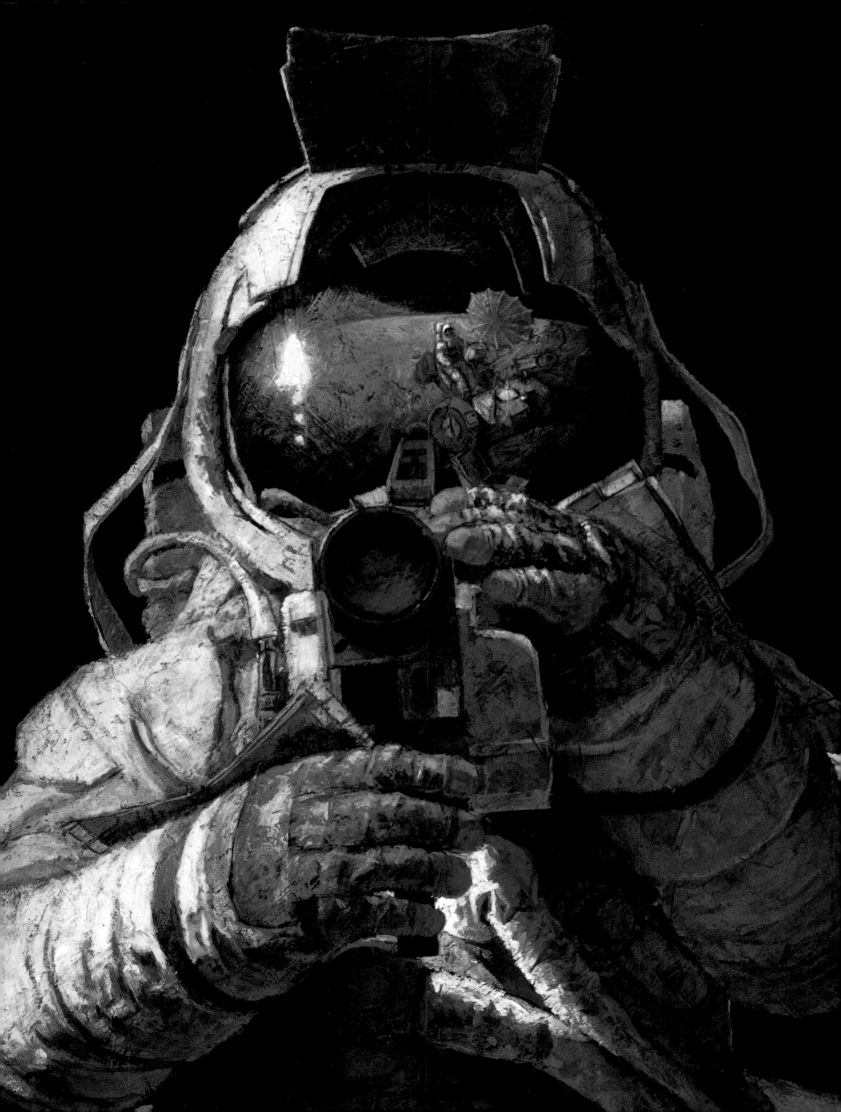

Moon Rovers,
(detail)

·I·
AN ARTIST
ON THE MOON

Somewhere over the far side of the moon, Pete Conrad was feeling tense—and he didn't feel tense very often. In 33 minutes and 27 seconds, the lunar module *Intrepid*, with Conrad at the controls, would undock from the command module *Yankee Clipper* and begin its descent to the surface of the moon. Everything was carefully timed for the moment of lunar touchdown and the clock was ticking. If the time for undocking arrived and he and Bean weren't ready, it could wipe out a 400-million-dollar mission. "Al," he told his lunar module pilot, "you're not going fast enough."

On the right-hand side of *Intrepid's* tiny cabin, Bean couldn't understand what his commander was talking about. He'd been working as fast as he thought was safe, setting switches and testing systems, going right down the checklist. He was doing everything the way he had countless times in the simulator on earth. A few minutes later, Conrad was still pushing.

"We've got to move through the checklist faster, Al."

Bean stepped it up a notch. "This is not the time to make a mistake," he thought. It was *read, think,* then throw the right switch or enter the correct data or check the status of some critical system.

Conrad and Bean both knew about the unforgiving reality of spaceflight. On the face of it, undocking was deceptively simple. Command module pilot Dick Gordon would release some docking latches, extend *Yankee Clipper's* mechanical probe and the two craft would separate. But this was the point at which things had begun to go wrong for Neil Armstrong and Buzz Aldrin on Apollo 11. Some excess oxygen had been trapped in the connecting tunnel between the two craft and at the moment of undocking it had pushed them apart slightly faster than planned. No one had noticed. That small error—and a few others that crept in—put Armstrong and Aldrin four miles beyond their target on the Sea of Tranquillity. Conrad and Bean knew they had to do better. Their mission was to make a pinpoint lunar landing. Everyone had worked hard to fix Apollo 11's bugs for Apollo 12; what worried Conrad most were the bugs that nobody had yet discovered. They could come up at any moment, even in

these seemingly calm moments of preparation. If that happened, they had better be ready. Crews take more time on checklist performance in actual spaceflight than in the simulator because the potential cost of error, almost any error, was more than anyone would be willing to pay. Make a major mistake and there won't be another chance. Bean stepped up the pace, afraid to and afraid not to.

"How you guys doing over there?" It was Gordon.

With one eye on the clock, Bean answered, "We're just completing the prep for undocking. I show 23 minutes and 48, 47, 46 seconds from undock."

Conrad grabbed a moment to look outside, as the far side of the moon drifted silently past. "Man, this is some rugged country down there, isn't it?"

"You better believe it."

Less than 2 minutes to go. Conrad entered a few numbers into the computer. He told Bean to make sure the tape recorder was on. "It's on," Bean said. They were going to do it.

"Five seconds," Gordon radioed. "Okay, here you go."

There was a slight bump. Bean looked nervously at Conrad, who was peering through the overhead window at *Yankee Clipper*. "Watch him," Bean said.

"Back off, Dick."

"Don't let him bump into any of our equipment," Bean said. When there was enough distance between the craft, Conrad put *Intrepid* into a slow pirouette to let Gordon inspect the lander, then pulsed the thrusters to move away. Bean could see *Yankee Clipper* out ahead, dwindling against a bright backdrop of craters. "Conrad was right," he thought. "We barely made it."

Later Bean would have time to realize what Conrad already knew. As they approached undocking and had to throw more critical switches and bring the system up to greater readiness, the cost of making a mental error grew enormously. It would take longer to get everything right in space. And Conrad had known that.

That was no surprise to Bean. Pete Conrad was the best

[17]

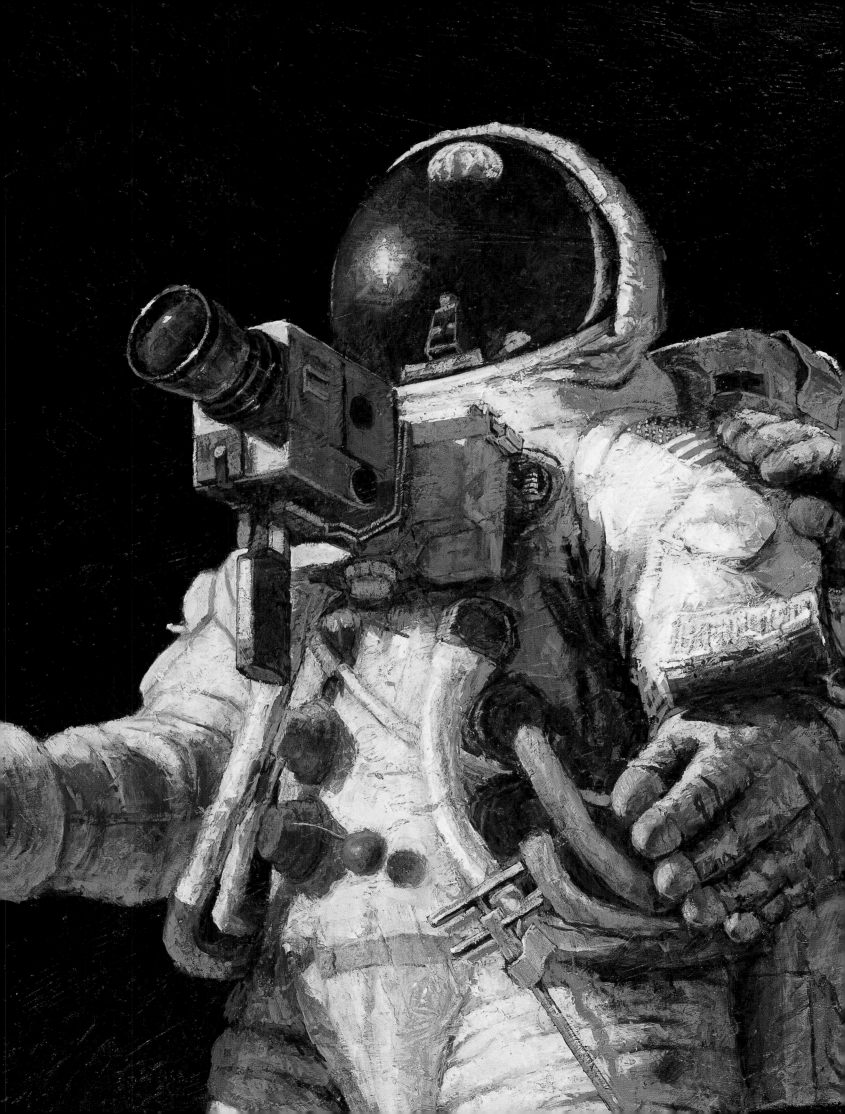

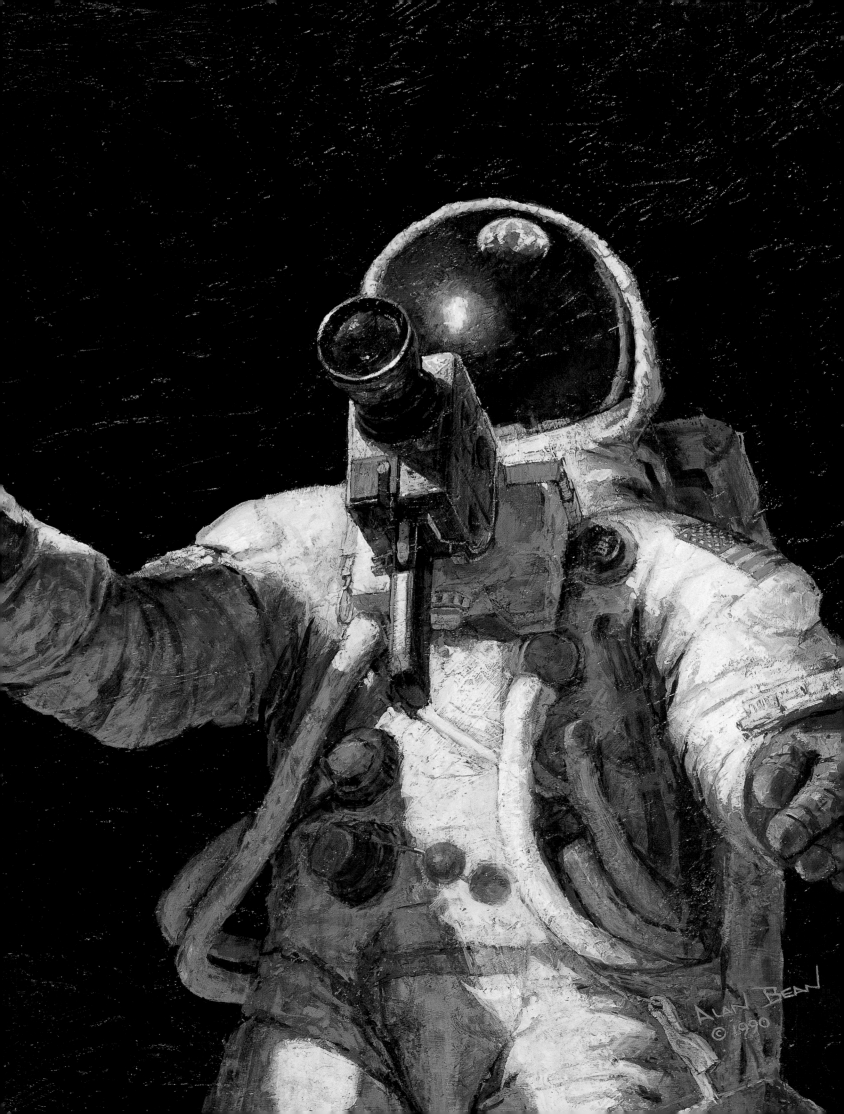

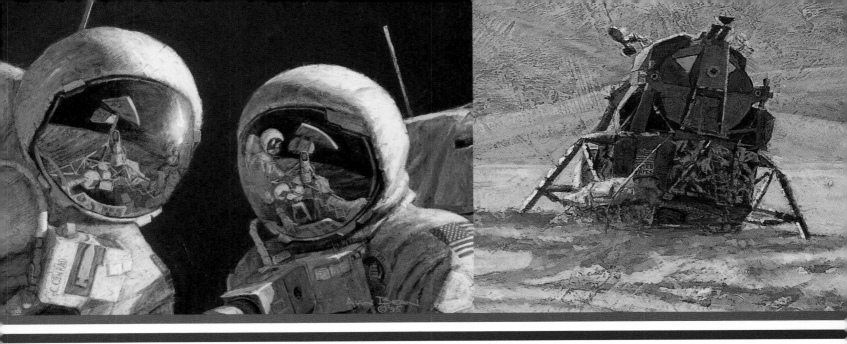

HEAVENLY REFLECTIONS

[P R E V I O U S P A G E]

Pete Conrad and I are 239,000 miles from earth, standing on the Ocean of Storms, looking homeward. We have come a long way together. We met some ten years before when I was a student in Navy test pilot school and Pete was one of my instructors. I admired him for his professional skills and for his relaxed, colorful attitude. He is the best astronaut I have ever known. It was incredible to stand on the moon with him and take a moment to reflect on all the dedicated people it took to get us there for America. We were the lucky ones.

The stars were not visible because the sunlight reflecting from the bright lunar surface caused the irises of our eyes to contract, just as they do on earth at night when standing on a brightly lit patio. As we looked up, the sky was a deep, shiny black. I guessed that deep, shiny black was the color one sees looking into infinity.

As I touched Pete's shoulder I thought: Can all the people we know, all the people we love, who we've seen on TV, or read about in the newspapers, all be up there on that tiny blue-and-white marble? Earth—small but so lovely—was easily the most beautiful object we could see from the moon. It was a wondrous moment. If there is a God in heaven, this must be what He sees as He looks toward His children on the good earth.

astronaut Bean had ever seen. It wasn't just that Conrad was a great pilot—"He could fly any airplane or the crate it came in"—but that he knew, instinctively, how to handle almost any situation, in space or on the ground. A few days before launch Conrad told Bean and Gordon, "Don't worry, because when things go wrong during the flight, and they will, it'll be something we've never seen before." Bean didn't have to wait very long to find out how right Conrad was. Just half a minute after liftoff, as Conrad, Gordon, and Bean rode the Saturn V rocket into a stormy November sky, alarms rang out in their helmets and the instrument panel was ablaze with warning lights. Something had gone desperately wrong with their spaceship. No astronaut crew had ever experienced this many caution and warning lights in their hundreds of thousands of hours in simulator training, and now here they were, in powered flight.

Most of the alarms were for the electrical system, which was Bean's responsibility, but as he stared at the gauges he was mystified. He wondered if something had severed the electrical connections between the command module and the service module, the part of *Yankee Clipper* that contained their main rocket engine. If that were true, they were thrusting into orbit on the front end of the giant Saturn V rocket with no way to come back to earth. But at that moment Bean was thinking, "What to do *now* . . ."

Over in the left seat, Pete had to make his decisions in the next few seconds. Was the Saturn V rocket okay? He peered upward through a single, small window for some visual cue but saw none. They were still in the clouds. On the instrument panel in front of him, the attitude ball was steady. The booster's own guidance system seemed to be keeping them on course.

What happened next, Bean would think later, was the kind of thing that separated Conrad from the rest of us. As the spacecraft continued its thundering acceleration away from earth, Pete saw another blinding flash and the attitude ball began to pitch rapidly. Were they beginning to tumble, or was it a sudden instrument failure? At this speed, if the booster strayed too far

into the onrushing air, it would break apart and explode into an enormous fireball. With a twist of the abort handle in his left hand, Conrad could fire *Yankee Clipper's* escape rocket to whisk the command module away from the danger. No one would have faulted him for aborting at that moment. But he would never have forgiven himself. In that instant, Conrad made his decision. His experience and gut had told him they were still on course. He was right again. The Saturn V rocket was speeding them out of the atmosphere and toward orbit. Conrad would later be awarded the space Congressional Medal of Honor for restoring the Skylab Space Station to satisfactory operation. Bean thought that it should have been his second one, as he earned his first right here on Apollo 12.

Once in orbit Pete said, "I'm not sure we didn't get hit by lightning." And he was right about that, too. As it sped through the rain clouds, the Saturn V's exhaust plume had acted like a giant lightning rod. All of the crew had seen their airplanes get hit by lightning and they knew it usually struck the aircraft's nose. They thought about the nose of *Yankee Clipper*, where the pyrotechnics for the command module's parachute system were stored. Had they been disabled by the lightning strike?

"Let the ground worry about it," Conrad said. "We've got work to do." And the ground did worry about it. In mission control, there was talk of trying to bring the men home right away. What if the explosive devices didn't blow the apex cover, or deploy the drogue or main chutes, or don't separate the chutes cleanly? Then the *Yankee Clipper* would slam into the Pacific, killing all three crewmen. But cooler heads prevailed. Conrad, Gordon, and Bean would go to the moon, gather their rocks and do their experiments. Let them have a little fun on the moon first. They, and the rest of the world, could find out later whether the parachute system was damaged or not.

Days later, *Intrepid* sank toward the moon. The view through the two triangular windows left no doubt about the diminishing altitude; out ahead a mountain range seemed to rise almost high enough to block their path. Conrad laughed and radioed Jerry Carr in mission control, "I sure hope you have us lined up

right, Houston, because there sure are big mountains right in front of us."

Intrepid was heading toward a pre-chosen spot on the lava plains of the moon's Ocean of Storms. Minutes from now, as they reached 50,000 feet, Conrad and Bean would light their main engine and begin their final descent. Getting *Intrepid* onto the proper flight path to reach the landing site was a consummate test of mission control's skill, and then it would be up to Pete Conrad to land. If everything went as planned, Conrad and Bean would touch down within walking distance of the unmanned spacecraft Surveyor 3. Reaching the Surveyor would provide visible proof of the pinpoint landing.

W e've done this so many times, we'd better do it right," Conrad said. "Don't let it get out of sight, don't get too low and don't try to fly too hard." Bean wondered if his commander was psyching himself up, like a quarterback before the big game. Bean had no worries. If Pete couldn't make this landing, nobody could.

In mission control, Capcom Jerry Carr tried to think of something to break the tension. There was only one kind of flying that compared with landing on the moon and that was night carrier landings, with little more than a lighted mirror and your own aircraft's instruments to guide you, and the ship a tiny spot in a vast, black ocean. Carr had worked with Conrad and Bean throughout the months of training and he understood the difficulty they were about to face. He knew just what to say. "When do you want us to turn on the mirror?"

"Turn it on," Conrad chuckled. "We've got the hook down."

Miles above and behind *Intrepid*, Dick Gordon joined in. "Clear the deck."

If anybody deserved to land on the moon with Pete, Bean knew, it was Dick. They were a team even before coming to NASA. In 1962, they were shipboard roommates, flying F-4s off the USS *Ranger*. Four years later, they flew in space together on Gemini 11. The people who trained them called them one of the most competent teams ever sent into space. They were more

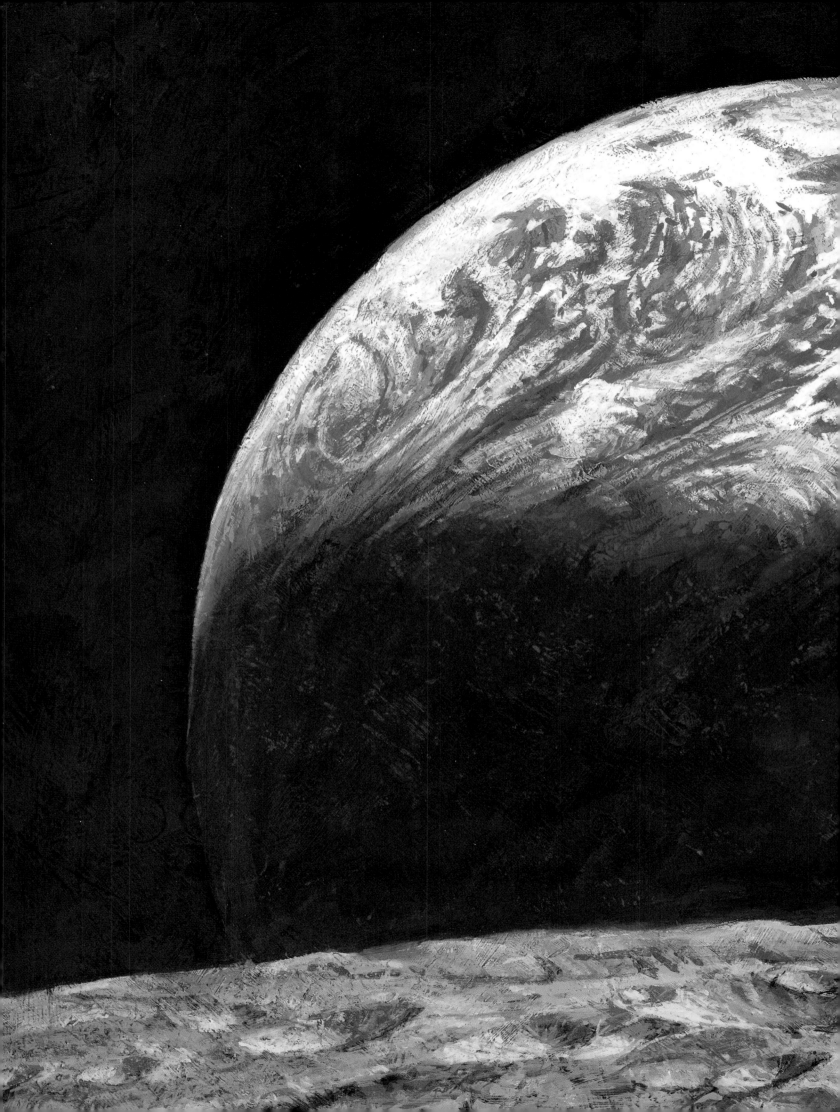

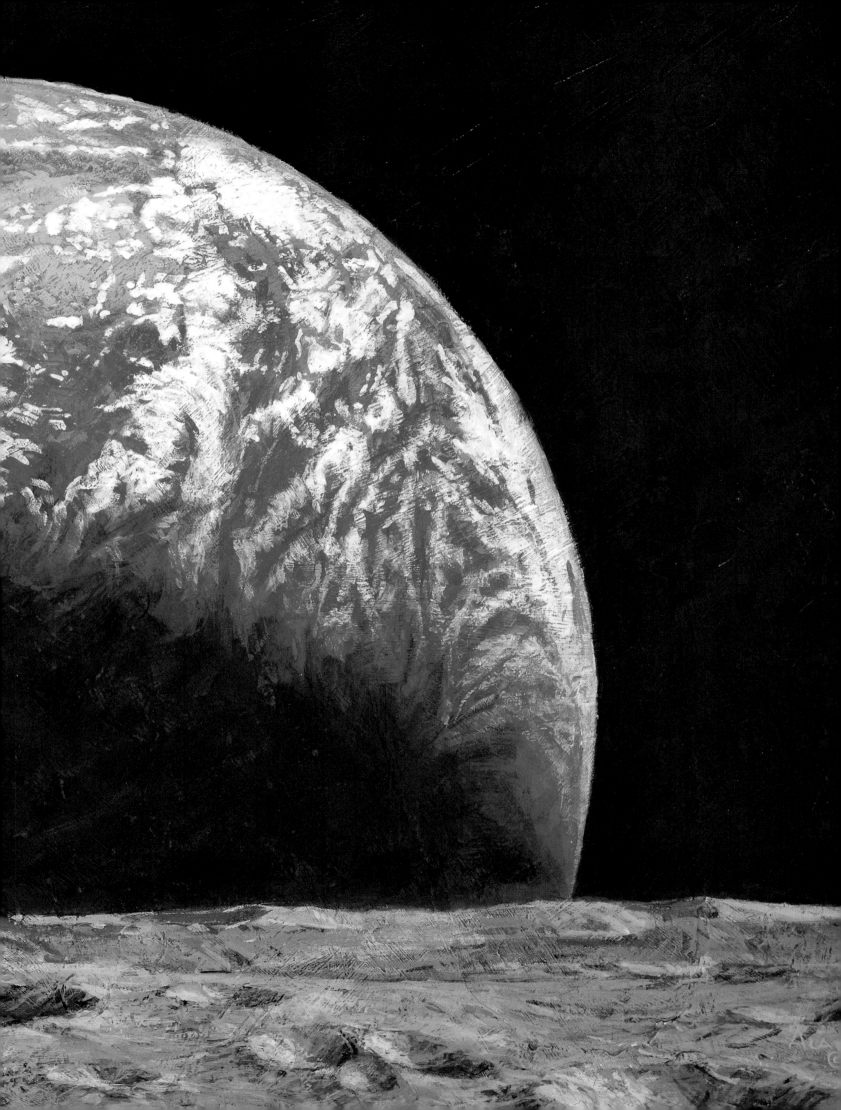

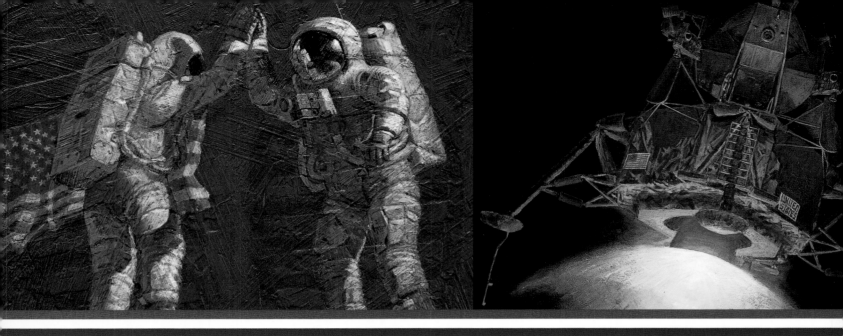

KISSING THE EARTH

I was rapidly but carefully going over my descent and landing checklist. As I glanced to my left I could see, barely an arm's length away, Pete Conrad, my friend since our Navy test pilot days and now my commander on Apollo 12. He looked calm and cool, all buttoned up in his white space suit.

As I looked out the small triangular-shaped forward window of the lunar module, I could see the sharply curved horizon. We indeed were orbiting a body much smaller than the earth. As I looked, the earth, some 239,000 miles away, appeared to rapidly rise. Australia was just coming into view. It was breathtaking.

After returning to earth, I needed to paint my experience. But what would be a suitable title? I thought of my favorite painting by Winslow Homer, an American artist of the late 1800s, depicting three fishermen in a small boat. In the distance was a faint full moon just being touched by the earth's horizon. Homer's title was Kissing the Moon. *Seeing our shiny blue and white planet rise above the moon is a wonderful memory I often think of now. But in November of 1969, I wondered if I would ever return to beautiful planet earth again.*

than colleagues; they were best friends. Conrad and Gordon had something between them that could make the difference between life and death in a crisis: the instinct to make the right moves first. And they were tested when Dick Gordon made a spacewalk, 180 miles above the earth. He became so exhausted performing his tasks that Pete feared he would not have the strength to wedge his space-suited body back inside the Gemini's tiny cockpit. If that happened, there would be no way to help his friend. He would have to cut him loose and leave him in orbit forever. Pete remembered that incident, perhaps a little too often, as the only time in his entire spaceflight career when he was truly afraid.

With that experience under their belts, and enough space stories to last a lifetime, Conrad and Gordon were ready to move on to Apollo. But Deke Slayton, the "Original 7" member who oversaw the astronaut corps, had rules about crew selection, and one of them was that a man with Gordon's experience was ideally suited to be command module pilot, the crewman who would have to be ready to make an emergency rendezvous with his crewmates if they got into trouble before landing on the moon, or after the lunar liftoff. The lunar module pilot, on the other hand, wasn't really a pilot at all; he was mostly a systems engineer. During the landing, he would read off important information to the commander, but he would do no flying. Any rookie could fill the LMP slot, and on Apollo 12, that rookie was Alan Bean. Dick Gordon would have to accept going ninety-nine percent of the way to the lunar surface, and no further. Bean could only imagine how Gordon must feel every time he heard Bean introduced as the guy who was going to land on the moon with Pete Conrad. It wasn't fair. And yet Gordon never said a word about it the whole time they trained together. Bean was sure that if the situation had been reversed, he could never have handled it as well.

And now he and Conrad were leaving Gordon behind in lunar orbit, and all three of them felt the risk they were taking. A few hours ago, while preparing *Intrepid* for undocking, they

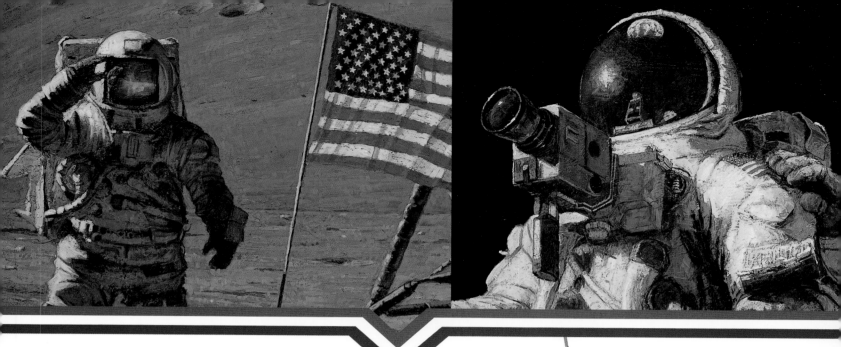

gazed through the connecting tunnel to *Yankee Clipper* and saw Gordon, floating at the other end, about to install the command module's hatch. A brief moment passed in silence as Gordon looked at his two crewmates, and in that moment, with the three of them so far out on a limb, Bean knew the bond they shared. Bean had no idea what Conrad and Gordon were thinking, and he kept his own thoughts to himself. And nothing needed to be said: each of them was here because they had chosen to be, because they craved the mixture of elation and fear, exhilaration and dread that came with the job. They had spent their adult lives facing deadly risk; this time, the location was different, and maybe their necks were out a little farther—239,000 miles farther. Dick Gordon took a last look at Pete Conrad and Alan Bean and said "I guess I've got to close the hatch now." Bean wondered whether he would ever see Gordon again. He wouldn't know the answer for another two days.

Telephoto Opportunity

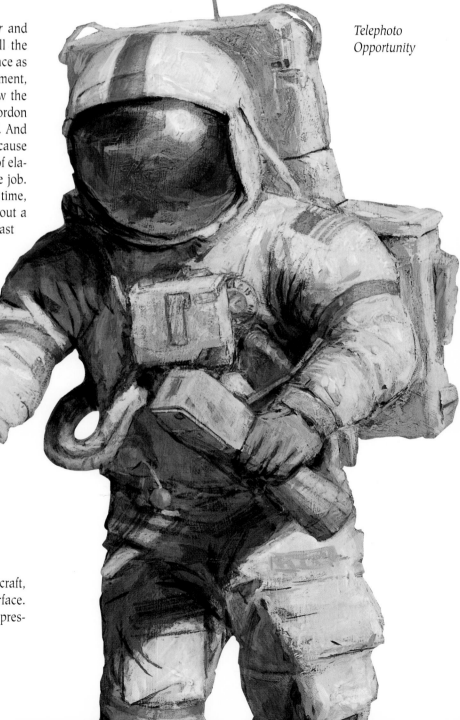

T en, nine, eight . . ." There was adrenaline in Pete Conrad's voice as he counted down the last seconds. He and Bean were still weightless, but their bodies were secured to the cabin floor by harnesses. "Seven, six, five . . ." He pushed the PROCEED button on the computer, and a moment later *Intrepid's* descent engine came to life. There was no sound, but Bean could feel the vibrations through his feet—a high-frequency buzz— and the onset of acceleration. Less than half a minute later, the computer throttled the engine up to full power, and the men felt its force. It slowed the 15-ton spacecraft, dropping it out of lunar orbit and onto a path for the surface. Finally, they were on their final approach. Bean felt the pressure: everything mattered. Everything was for keeps.

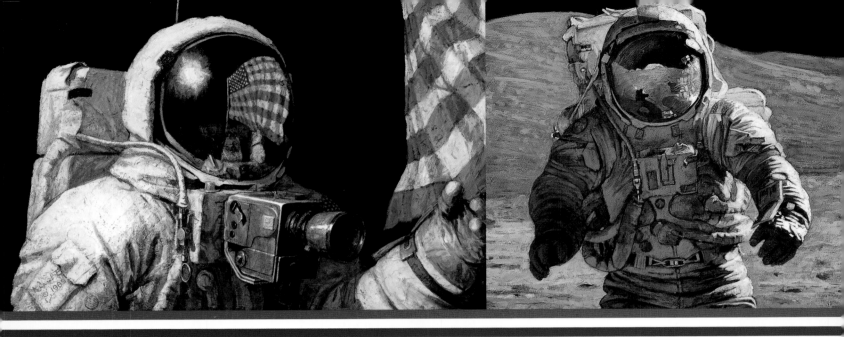

Six minutes and twenty-three seconds into the burn the men felt the lander's engine throttle back under the computer's control, and called out, "Throttle down!" Loud bangs from the lunar module's Reaction Control System thrusters filled the cabin. Bean had jumped the first time he'd heard them; they were only an arm's length away, on the other side of the thin windows. They were firing much more often than they had in the simulator. Conrad said, "This baby is really giving it the gazoozie with the RCS, isn't it?"

"Sure is," Bean said.

Intrepid was tipped back, its engine pointing toward the landing site. Conrad and Bean were speeding toward the moon feet first, staring up into the blackness of space. Somewhere out ahead lay the target, a clump of craters that bore a rough resemblance to a snowman. On the slopes of the Snowman's lower body sat Surveyor 3—or so the experts had determined. In the simulator, Conrad had studied the Snowman until he could pick it out among the hundreds of craters that surrounded it. Seconds from now, *Intrepid* would pitch forward to begin the last phase of the descent. He would be able to sight through a special grid on his window and see the Snowman dead ahead—if *Intrepid* was on target. Even a minor error in the flight path could ruin Conrad's chances. During training one of the trajectory experts had asked Conrad where he wanted to land, and Pete couldn't believe what he was hearing. He told the man, "We'll have to walk to Surveyor, so target me for the center of that crater." The response was, "You got it, babe." But Conrad would believe it when he saw it.

"Okay, Pete," Bean advised, "7 minutes."

"We're out of 19,000 feet." Conrad leaned forward and peered through the bottom corner of his window, straining to spot that pattern of craters. "I got some kind of a horizon out there. I got some craters, too, but I don't know where I am yet."

Eight minutes. Bean radioed, "Passing 12,000 feet, according to our tapemeter, Houston. Spring-loaded to go grab that Surveyor."

[26]

"Standing by for pitchover," Conrad said, punching the computer's PROCEED button.

At 8 minutes and 38 seconds, right on schedule, *Intrepid* pitched forward, and a wide-screen panorama of the Ocean of Storms swung upwards into Conrad's view. He had no idea what he was looking at. There were so many craters—thousands of them, maybe tens of thousands, each brilliantly illuminated, a sea of holes and shadows. Where was the Snowman? The computer had given him a number to use in sighting through his window, to see where they were headed. Now he used it. Suddenly, he could see the Snowman in the distance, right where they were heading. Conrad was stunned to realize that if he didn't touch the controls, they would land in the center of the Surveyor crater. Mission control's aim had been perfect, and Conrad could not contain himself.

"Hey, there it is! There it is! *Son of a gun, right down the middle of the road!*"

Bean could barely take his mind off the job to answer Conrad's elation with his own: "Amazing!" He allowed himself only a quick glance out the window, then forced his attention back to the gauges. Conrad was depending on him to read off crucial information from *Intrepid's* computer. "We're passing 3,500," Bean said. "Coming down at about 99 feet a second. You're looking good. Got 15 percent fuel remaining."

"*Intrepid*, Houston. Go for landing."

Conrad heard the words, but his mind was totally on the moonscape before him. He didn't want to land in the center of the crater; he'd planned all along to touch down close to the crater's near-right rim. Nudging the hand controller, he told the computer to aim there.

Nine hundred feet above the moon, Bean stole another glance outside and saw the Ocean of Storms rushing toward him. It was almost more than he could stand to look at—mind-boggling, even a little scary. "Get your head back in the cockpit

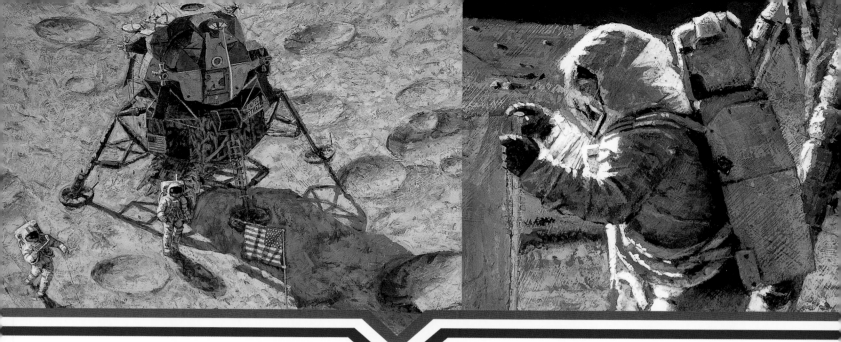

and help Pete," he told himself. "It'll be just like the simulator." He wrenched his gaze back to the instrument panel and told his commander, "Looks good out there, babe."

But it didn't look good to Conrad. He could see now that the place he had planned to land was much too rough. *Intrepid's* computer could not dodge craters or boulders; that required human eyes and hands. He would have to hunt for a new spot. Six hundred feet up. Now 500. Now, with a flick of the hand controller, Conrad took control, and hoped something better lay up ahead.

"Four hundred feet. You're in P66, Pete."

"Yeah. I gotta get over to my right."

The moon drew nearer, and Conrad was still searching. Without meaning to, he'd flown past the Surveyor crater. Just beyond it, and off to the right, he saw a place that looked better. Conrad headed for it.

Piloting a lunar module above the moon was a bit like flying a helicopter; you had to tilt in order to change direction. With the helicopter, you were redirecting the thrust of the rotors; with the lunar module, it was the rocket engine. Bean knew that, but still, as Conrad began hunting, *Intrepid* seemed to tilt unnaturally, even alarmingly. He didn't show his concern as he told Conrad, "Hey, you're really maneuvering around."

"Yeah." Conrad knew the lander was flying just the way it was supposed to. Because lunar gravity pulled only one-sixth as hard as earth's, *Intrepid* had to tilt six times as far to make the same change. He'd practiced this many times on earth, using a special training craft, something Bean had never flown. It wasn't a task that came naturally, but by the time Conrad and his crew left earth it had become ingrained.

Conrad slowed his descent to buy time. With each second the fuel supply dwindled. Both men knew they were in danger of running out if they descended too slowly. "Ten percent fuel," Bean called. "Two hundred feet; coming down at 3. Need to come on down."

"Okay."

Still almost 200 feet up, Conrad brought *Intrepid* into a slow, vertical descent. "Come on down," Bean coached. This was a balancing act; descend too slowly and they risked running out of fuel; too fast and the lunar module would not be able to slow to a safe landing.

"Ninety-six feet, coming down at 6," Bean said urgently. "Slow down the descent rate! Eighty feet, coming down at 4 . . . 50 feet, coming down; watch for the dust."

Conrad and Bean knew about the dust. Neil Armstrong had come back from Apollo 11 and said that in the final seconds before landing, his rocket engine had kicked up a veritable dust storm—but one unlike any on earth. On the airless moon, instead of billowing up around the lander, the dust particles went shooting away in all directions, creating something that resembled a fast-moving ground fog. Now Conrad could see the same thing brewing below, on the Ocean of Storms, but this one was much worse than the Apollo 11 film had shown. It was crucial to touch down while descending vertically, or else risk tipping over. But this veil of speeding dust created the illusion that the lander was drifting backward. He had to fight every instinct telling him to nudge the stick forward in response. His eyes flicked back and forth between the instruments—would they guide him through this last crisis?—and the moon. There were boulders poking up through the dust; Conrad used them as signposts to gauge his motion. Conrad had twenty years worth of flying experience; right now he needed every bit of it.

"Forty-two feet. . . Coming down at 2 . . . Thirty-one. Thirty feet. You got plenty of gas. Hang in there." Plenty of gas, if you considered less than a minute's worth of descent fuel plenty. And now, from a quarter million miles away, came a warning: "Thirty seconds." Half a minute of fuel remaining. On earth, Bean knew, a pilot with only 30 seconds worth of fuel in the tanks would be justifiably panicked. But it was normal for the final moments of a lunar landing. He told Houston, "He's got it made."

Bean knew they were close now. In his scans of the instrument panel, he began to include a blue light labeled LUNAR

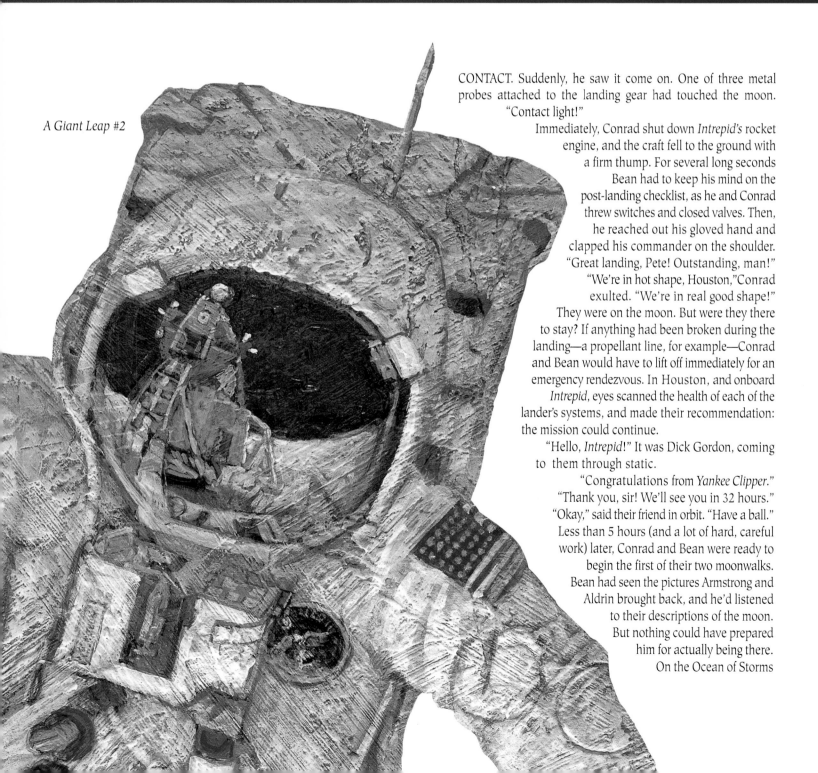

A Giant Leap #2

CONTACT. Suddenly, he saw it come on. One of three metal probes attached to the landing gear had touched the moon. "Contact light!"

Immediately, Conrad shut down *Intrepid's* rocket engine, and the craft fell to the ground with a firm thump. For several long seconds Bean had to keep his mind on the post-landing checklist, as he and Conrad threw switches and closed valves. Then, he reached out his gloved hand and clapped his commander on the shoulder. "Great landing, Pete! Outstanding, man!"

"We're in hot shape, Houston,"Conrad exulted. "We're in real good shape!" They were on the moon. But were they there to stay? If anything had been broken during the landing—a propellant line, for example—Conrad and Bean would have to lift off immediately for an emergency rendezvous. In Houston, and onboard *Intrepid*, eyes scanned the health of each of the lander's systems, and made their recommendation: the mission could continue.

"Hello, *Intrepid!*" It was Dick Gordon, coming to them through static.

"Congratulations from *Yankee Clipper.*" "Thank you, sir! We'll see you in 32 hours." "Okay," said their friend in orbit. "Have a ball." Less than 5 hours (and a lot of hard, careful work) later, Conrad and Bean were ready to begin the first of their two moonwalks. Bean had seen the pictures Armstrong and Aldrin brought back, and he'd listened to their descriptions of the moon. But nothing could have prepared him for actually being there.
On the Ocean of Storms

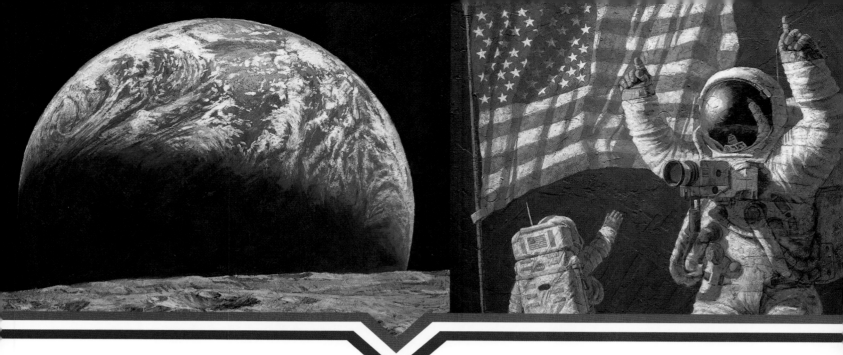

he saw a bright, rolling expanse of craters and rocks; above he saw a sky that was not only black but somehow shiny, like patent leather. This was a world where time was measured not in decades or even millennia, but in eons. In this utterly still and lifeless panorama there was, somehow, a kind of beauty. He and Conrad would walk on that alien ground, and probe its secrets. For all of his adult life Bean had been a pilot. Now he was going to be a lunar explorer.

The men were sealed in their space suits, wearing life-support backpacks and special lunar helmets and boots. Inside his helmet, Bean felt the cool flow of oxygen go past his face. He heard the reassuring whir of the fan that blew air through the suit, and the pump that circulated water from the back-pack through tubes in a special pair of long underwear; the water would keep him cool during the moonwalk no matter how hard he worked. Like everything else in Apollo, Bean's space suit existed because of the best efforts of 400,000 engineers, technicians, and scientists. He had gone to the factory in Dover, Delaware, where the suits were made, and he'd met the women who glued and stitched these space-age garments. Now he thought, "I hope those ladies cared as much then as I care right now."

Fighting the stiffness of his pressurized suit, Bean reached down and opened a valve to release the cabin pressure. Even through their helmets, the men could hear the rush of escaping gas. After long minutes Bean peeled back a corner of the thin, square hatch, letting out the last bit of oxygen that had kept it closed. Pulling the hatch open, Bean backed into his corner of the cabin and cleared the way for his commander to go outside. Bean watched carefully as Conrad squeezed his suited bulk through the narrow opening, making sure his commander's suit didn't damage the hatch seal. "You're headed right square out the hatch. Wait, wait, wait—come forward a little. There you are."

Bean watched as Conrad descended the ladder and took his first, halting steps on the powdery ground, bouncing the way a fighter dances in the ring to keep his balance. "I feel like I could fall over at any moment," Conrad said. But that didn't stop him from finding an answer to his most burning question. He turned to his right and took a few steps, until he could look back behind *Intrepid*, across a vast, old crater. A high-pitched cackle filled Bean's earphones. "You'll never believe it," Conrad said. "Guess what I see sitting on the other side of this crater?"

Bean had a pretty good idea. "The old Surveyor?"

"The old Surveyor, yessir. It can't be any more than 600 feet from here."

There was applause in mission control. The pinpoint landing was a reality. Tomorrow, Conrad and Bean would visit the un-manned probe and cut off pieces to bring home—but only if they could reach it safely. Conrad wasn't at all sure.

"That's one steep slope it's on," he told Bean.

But they would have to worry about that later. And as Conrad went about his work, it was clear that the moon had re-ceived its most exuberant visitor. Conrad hummed and laughed as he bounced around, as if he were having the time of his life.

Alan Bean, meanwhile, finished helping Pete with getting some gear down to the surface, and then there was nothing to do but wait. For a minute, it seemed that there was a problem with the cooling system in his backpack—imagine coming all this way, only to be kept inside by a last-minute malfunction! But the problem turned out to be tempo-rary. At last it was his turn to join this generation's ultimate adventure. Bean backed carefully out of the tiny cabin and descended the ladder, unaccustomed to the strange lightness of his space-suited body. At the bottom rung he leapt back-ward, sliding his hands along the rail like a fireman as he fell in slow motion, and landed gently but ungracefully in the foil-covered footpad. He lifted his foot and placed it onto the ancient, alien dust of the Ocean of Storms. Conrad was there, taking his picture. "You look great," said his commander. "Welcome aboard."

[29]

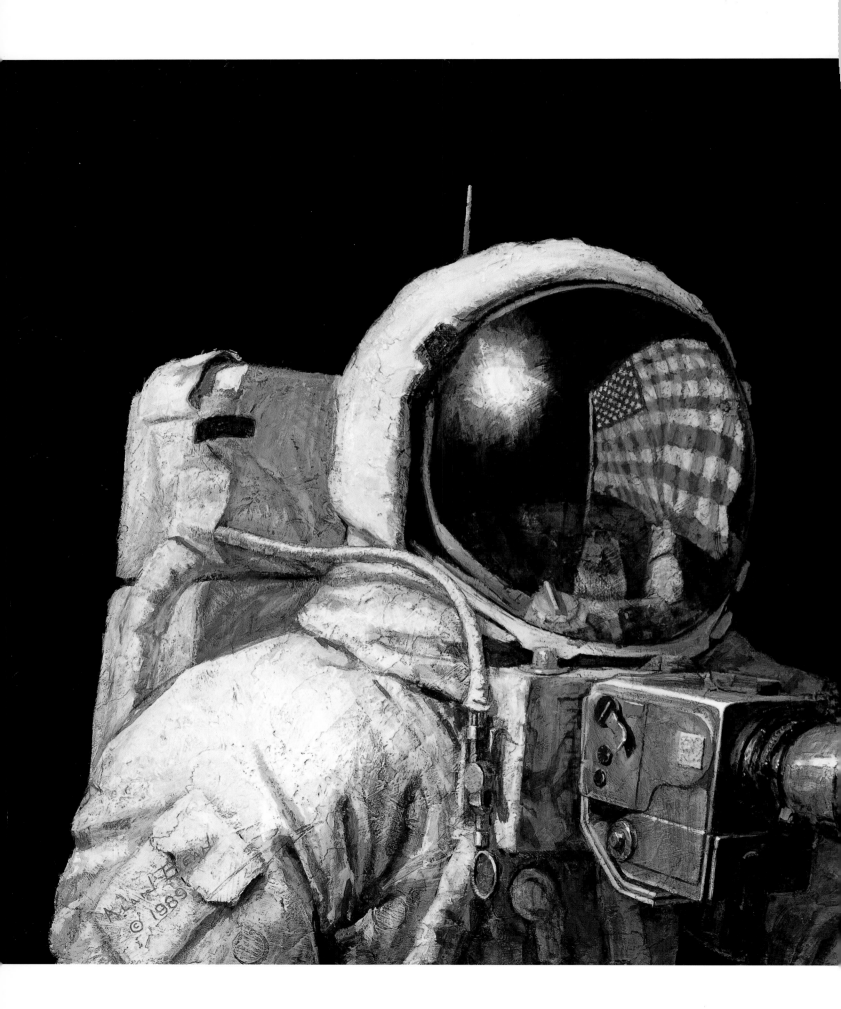

BEYOND A YOUNG BOY'S DREAM

When I was a boy, I dreamed of flying airplanes. I built model airplanes of balsa wood and paper and glue. Some were powered with thin rubber bands and others with small noisy gasoline engines. By the time I was in high school, model airplanes of all shapes and sizes were hanging by thin wires from the ceiling of my room. Airplanes were the last things I would see before falling asleep at night. I dreamed of flying higher than the highest cloud and faster than the fastest wind.

As I grew older, the dream grew stronger: when I completed flight training and my mother pinned on my Navy Wings of gold . . . when I was a jet pilot flying off tiny gray aircraft carriers on vast blue oceans . . . when as a test pilot flying all the Navy's latest aircraft to their limits . . . and when, as an astronaut, I was training to rocket to the distant white moon in a silver spaceship.

Well, here I am standing on the moon. To reach this distant world, I flew higher than any cloud and many times faster than the wind. I am living much more than my boyhood dream. And now, as I look out over the "magnificent desolation" of the lunar surface, little boys and girls on earth are building model rockets, dreaming of flying higher than the moon and faster than a shooting star.

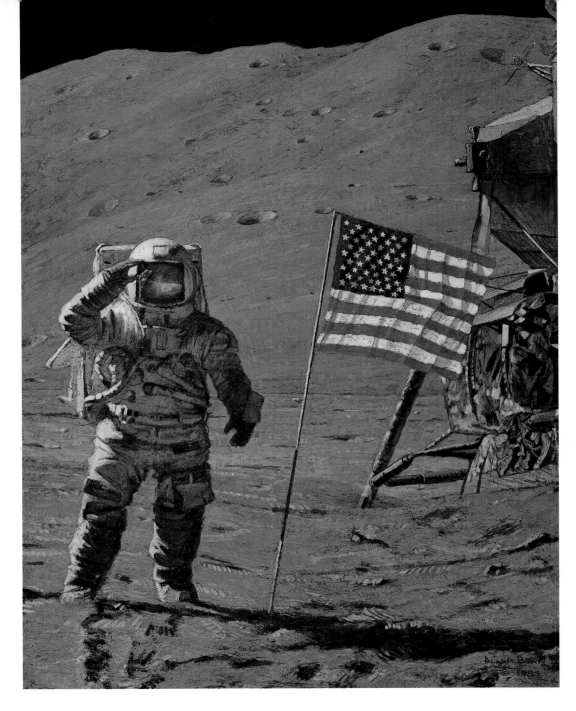

HI, MOM

Is Apollo 15 Astronaut Jim Irwin rendering a smart, military salute as he stands beside the American flag on the Plain at Hadley? Jim and I think so, but will his partner, Dave Scott, agree?

The Apollo 15 lunar module, Falcon, carrying Jim and Dave, had touched down on the stark, lonely, and beautiful surface the day before. Since then they had collected many rocks, deployed a number of experiments, and made significant scientific observations. Much of their success was made possible by the fact they could drive around in the first moon car. Dave and Jim could travel faster, gather more samples, and make more scientific observations with their lunar wheels. It was a great mission.

When this painting was about half completed, Jim Irwin dropped by my studio to visit. We looked at some of the paintings I was working on at the time, and I asked him to make suggestions for motifs I might paint in the future to more completely capture the essence of Apollo 15.

Jim made some excellent suggestions and it was an enjoyable afternoon. As he was leaving, he said, "You know, when Dave Scott sees this he probably won't think you've painted me saluting the flag at all because my feet aren't together, and from the looks of my casual body position, he'll say I'm just waving, 'Hi, Mom!'"

IN THE BEGINNING...

I knew that creating a painting to celebrate the twenty-fifth anniversary of the first lunar landing and the achievement of the Apollo program would be difficult. I wanted it to depict some of our most important accomplishments on the moon and, most of all, the spirit of the adventure as we experienced it.

But how does one show in a single painting the dedication, the intensity, the sacrifice, the sense of duty, history and patriotism that engulfed us all in our quest for the moon? I wasn't sure it could be done.

I made a number of preliminary sketches but none seemed adequate. I talked with other artists, fellow astronauts, and interested friends. More ideas and sketches, but still the feeling just wasn't there. Then an artist friend sent me a rough but imaginative sketch. He didn't know much about space suits, but he knew a lot about emotion and design. His idea served as the basis for this painting. Thanks, Peter Landa.

Two months later, when the painting was almost complete, I made a list of about fifty title possibilities, but none seemed quite right. I was talking with Pete Conrad, my fellow Apollo 12 moonwalker, and his wife. She said, "I like In the Beginning..." So did we. Thanks, Nancy Conrad.

I enjoyed creating In the Beginning... *because it was created just like Apollo: it was not the handiwork of one person, but of many dedicated people working together to make an ages-old dream come true. That was nearly thirty years, and a lot of wonderful memories, ago. Thanks, America.*

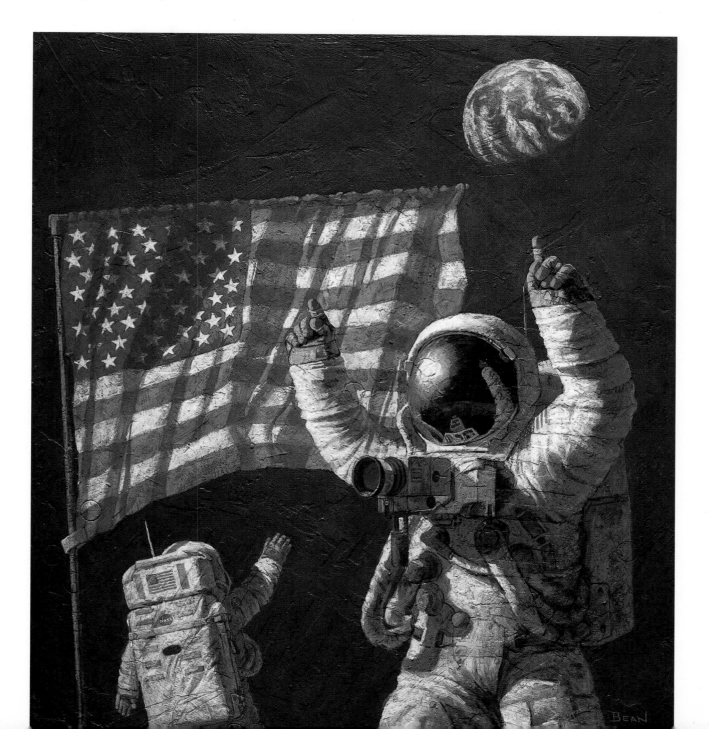

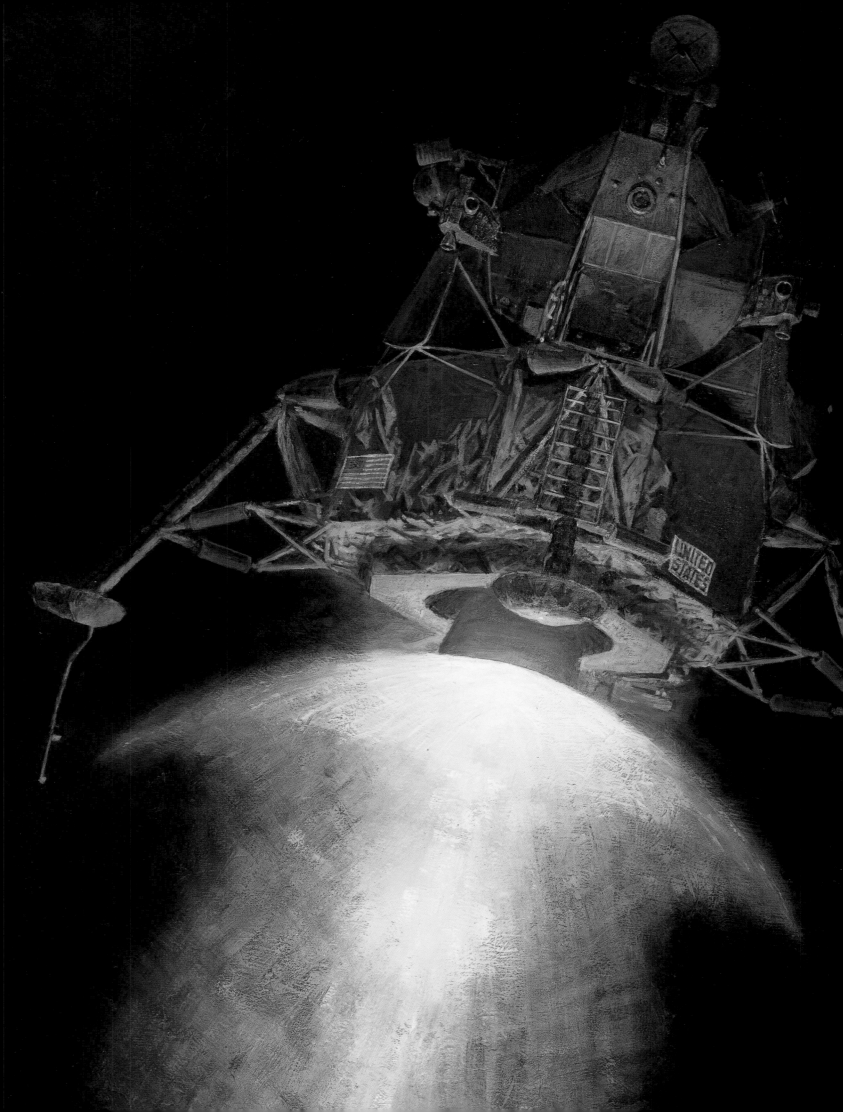

ARMSTRONG, ALDRIN, AND AN AMERICAN EAGLE

The Eagle, with Neil Armstrong and Buzz Aldrin aboard, is just about to touch down on the Sea of Tranquillity, July 20, 1969. The descent engine is firing in order to slow the descent rate to ensure a gentle landing as Neil flies the lunar module beyond some rough terrain in his search for a level area.

The Eagle was designed to fly like a helicopter even though it has a rocket on the bottom rather than rotor blades on the top. NASA's reasoning was that controls and techniques for operating a machine that could move up, down, and sideways and even stand still, were needed on the lunar module. The helicopter was such a machine, and its controls and techniques had been proven over many years.

Neil is looking out the left-hand window, Buzz out the other. Between them is the square hatch Neil will use to exit the lunar module. After crawling backwards along the platform, he will descend the ladder to the surface; a small step for a man, but a giant step for mankind.

Many space enthusiasts say the Eagle was the first true spaceship an incredible vehicle on an unbelievable mission. But we all knew that first. It had to work right or Neil and Buzz wouldn't be bringing home

When we Americans put our minds and energy to it, nobody, but what it was supposed to do and more. I believe the Eagle (and her crew)

because it could land and then take off again. It was every worthwhile endeavor seems impossible at any moonrocks.

nobody, can do the things we can do. The Eagle did could only have been made in America.

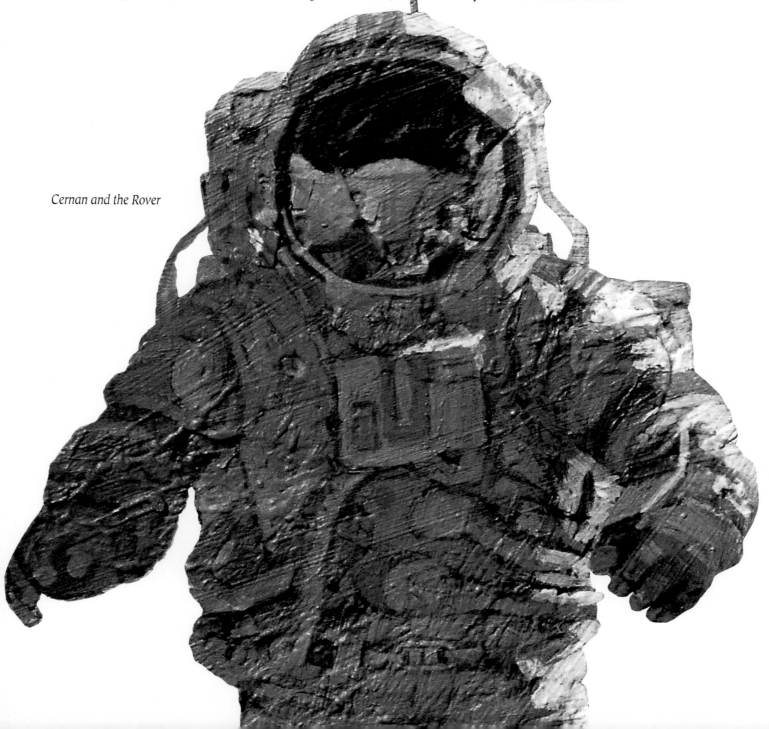

Cernan and the Rover

MANKIND ROCK #1

This is Gene Cernan as he was near the end of the third moonwalk of Apollo 17. He and Astronaut-Geologist Jack Schmitt had completed most of their work and were just gathering final equipment and samples, putting them aboard the lunar module. At this point, Gene turned toward the television camera and said, "Jack has picked up a very significant rock, composed of many fragments of many sizes and many shapes, probably from all parts of the moon, probably billions of years old. But a rock of all sizes and shapes and even colors that had grown together to become a cohesive rock, outlasting the nature of space, sort of living together in a very coherent, very peaceful manner. We'd like to share a piece of this rock with many of the countries throughout the world. We hope that this will be a symbol of what our feelings are." Then they continued their preparations for leaving the moon. Gene knew he would be the last man on the moon for quite a long time. As he closed his checklist and prepared for his ascent up the ladder, he said, "As we leave the moon at Taurus-Littrow, we leave it as we came and, God willing, we shall return with peace and hope for all mankind." Gene Cernan, last man on the moon, 12:40 PM December 13, 1972.

THE AMERICAN

The way Gene Cernan looks in his suit reminds me of the classic hero of western movies. Even his hands look poised for a quick draw. In this strange world, all bundled up in a bulky space suit, he still looks American. He even wears a white hat.

I painted Gene with the sun almost at his back and his suit almost shadowed. The colors I used were not as literal as they are expressionistic, or impressionistic. It was a beautiful mission to an incredible place—the Taurus-Littrow Valley.

Apollo 17 was our last mission to the moon. Gene, Ron Evans, and Jack Schmitt called it "The End of the Beginning." It was a perfect mission, with records set in time spent on the surface, rocks returned, and in many other ways. Those records have stood for a long time and may stand for decades to come.

I have a special admiration for Gene. We were in the same group of fourteen astronauts selected by NASA in 1963. We were all about equal in experience and potential, but Gene worked harder and developed more, and by the time we left NASA, he was easily one of the very best.

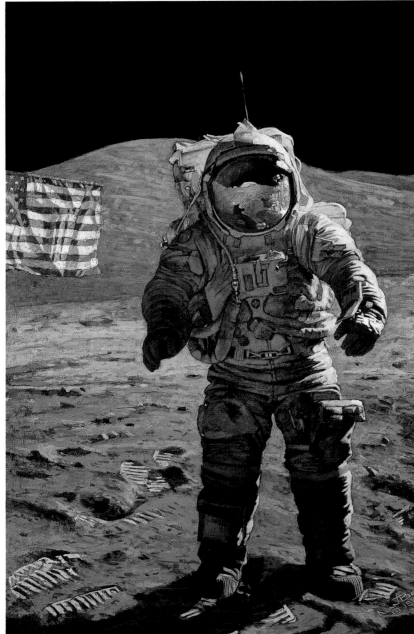

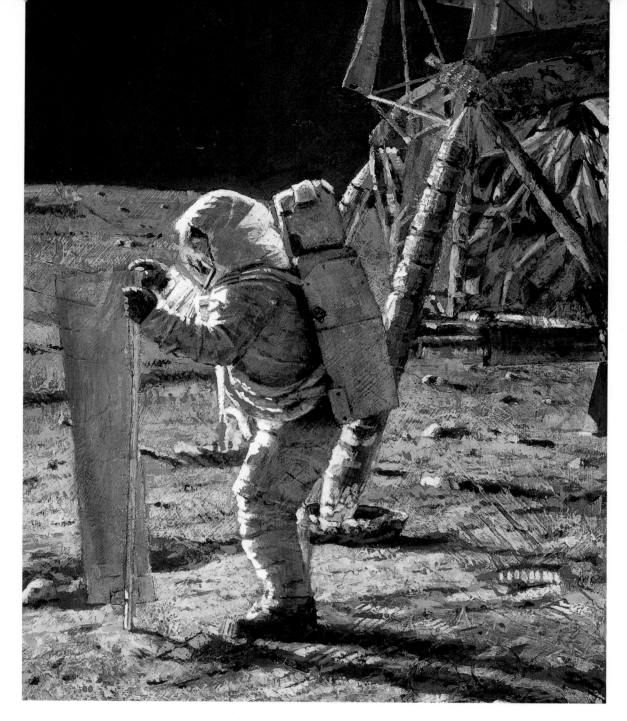

COLLECTING THE WIND

Without the sun, none of us would be here to look at this painting. The continuous nuclear activity of the sun produces abundant energy and sends enormous amounts of ionized particles, called the solar wind, streaming out into space. The strong magnetic field of the earth deflects most of this solar wind away from our planet. The moon does not have this natural shield.

I painted Apollo 11 Astronaut Buzz Aldrin deploying the solar wind composition experiment. It's a five-section telescopic pole and an aluminum foil screen rolled up on a reel. The foil would be left exposed to direct sunlight for seventy-seven minutes, then rolled up, placed in a sample box and returned to earth for examination. With this experiment we hoped to gather a bit of the sun.

Buzz would later say, "The shaft extended and the foil unrolled easily. In putting it in the ground, it went down about four or five inches. The cast shadow afforded a good check that I had mounted it perpendicular to the sun."

Sensitive post-flight testing showed that perhaps 100 trillion solar particles—atoms of helium, neon, and argon—streaming from the sun had indeed imbedded themselves in the foil, penetrating as much as a millionth of an inch. As predicted, it was a small sample, less than a billionth of an ounce, but sufficient to learn new and important information about our most important star.

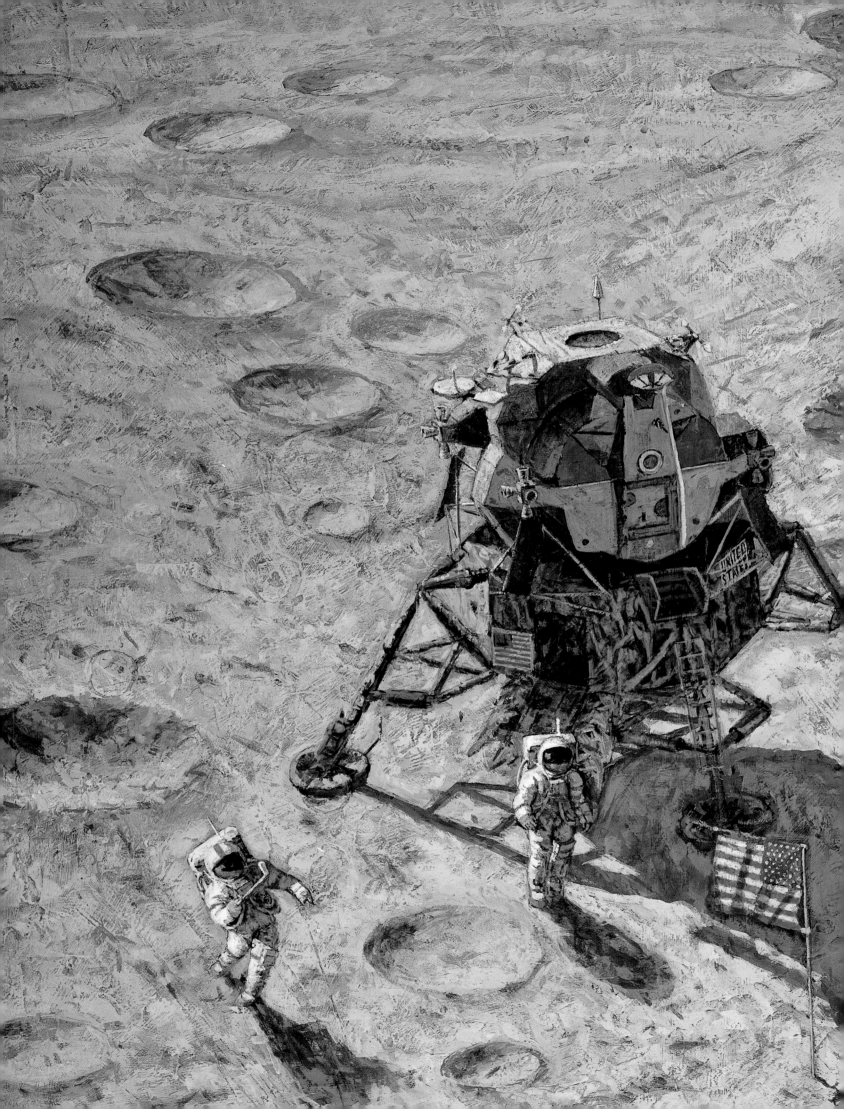

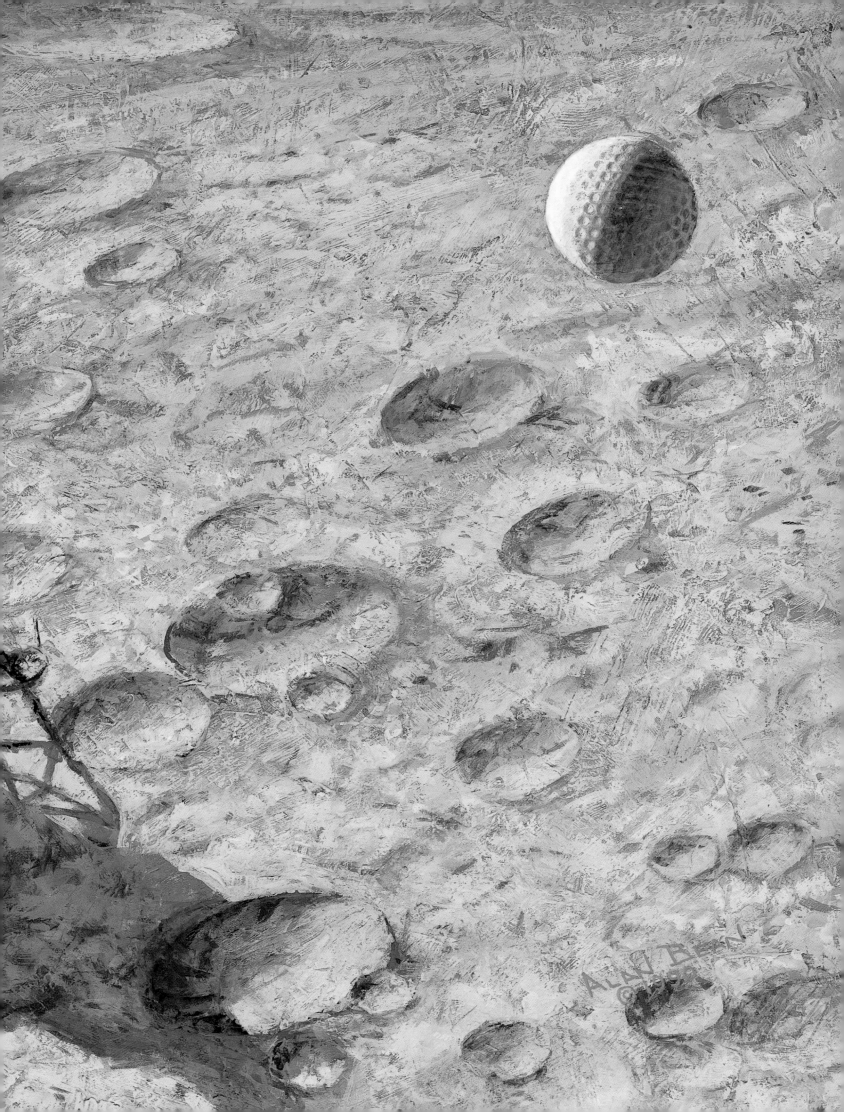

Alan Bean
© 1998

IN FLIGHT

[P R E V I O U S P A G E]

As Apollo 14 Astronauts Alan Shepard and Edgar Mitchell were winding up their second moonwalk, Al turned toward the television camera. "Houston, you might recognize what I have in my right hand as the handle for the contingency return sample. It just so happens to have a genuine six iron attached to the end. In my left hand, I have two little white pellets that are familiar to millions of Americans. I drop one down in front of me." Al faced the ball and began a modified backswing. "Unfortunately, the suit is so stiff, I can't do this with two hands, but I'm going to try a little sand trap shot here."

With the Apollo space suit, a smooth arm and hand motion is impossible and Al just topped the ball. It rolled into a small crater a few yards away. Ed Mitchell observed, "Hey, you got more dirt than ball that time." As the whole world watched on television, Al dropped the second ball. "Well, here we go again," and took his best swing. Dirt and dust flew, the ball disappeared, and Al exclaimed, "Miles and miles and miles."

As Al would say later, "The fun with the golf shot certainly had to be the greatest thrill. It was a one-handed shot and I wasn't able to make a very big turn on the backswing so the clubhead didn't come through the ball with a lot of zip. But due to the conditions there, the ball ended up traveling 200 yards and probably had a flight time of 15 seconds."

MOON ROVERS

[R I G H T]

Astronaut Jim Irwin is doing just what tourists do around the world: take snapshots of the wonderful and exotic places they visit. In this photograph he is immortalizing his partner, Apollo 15 Commander Dave Scott, proudly riding in their new car, the Lunar Rover.

This is not just any car. This special car is a genuine first edition, the first car on the moon. Because there is no atmosphere up here, it cannot use a gasoline engine. Two large batteries power four small one-quarter horsepower electric motors, each about the size of a handyman's electric drill, one driving each wheel. Looking like a stripped-down dune buggy, it weighs 455 pounds on earth but only 76 moon pounds. In fact, Jim and Dave will occasionally just lift it up and turn it around rather than drive in reverse. There is no way they could turn around in their stiff space suits to see where they would be going in reverse. The Rover can reach speeds of almost 10 miles per hour on level ground. The tires are of woven piano wire. The TV camera and umbrella-like antenna beam the Rover's activities back to earth.

Later today, Jim and Dave will take a two-hour drive to the brink of a canyon and to the dusty base of a moon mountain. Jim will say, "The ride is bouncy and rolling, a combination of a bucking bronco and a rowboat in a rough sea." Dave remembered, "It's a sporty job to drive and not run into the craters." They will cover 5 miles in all—more than the 4.1 miles covered by all of us who came before. We were moon rovers, too, but only pedestrians.

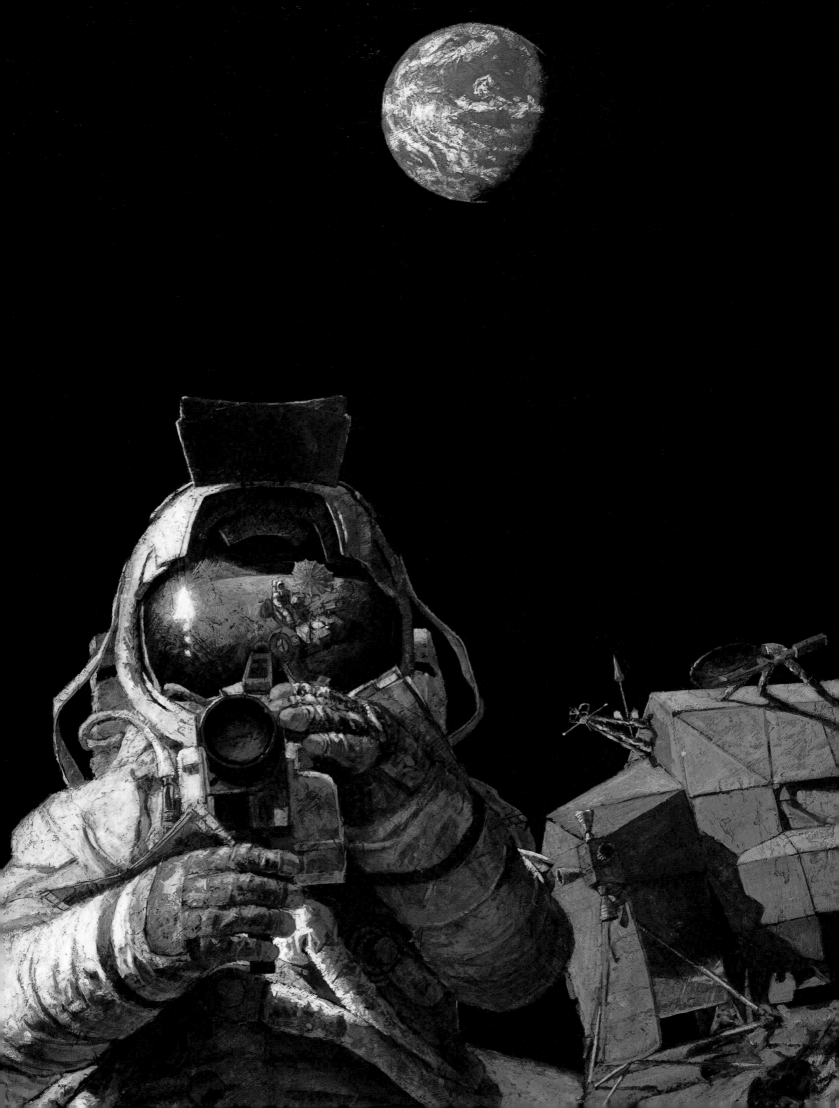

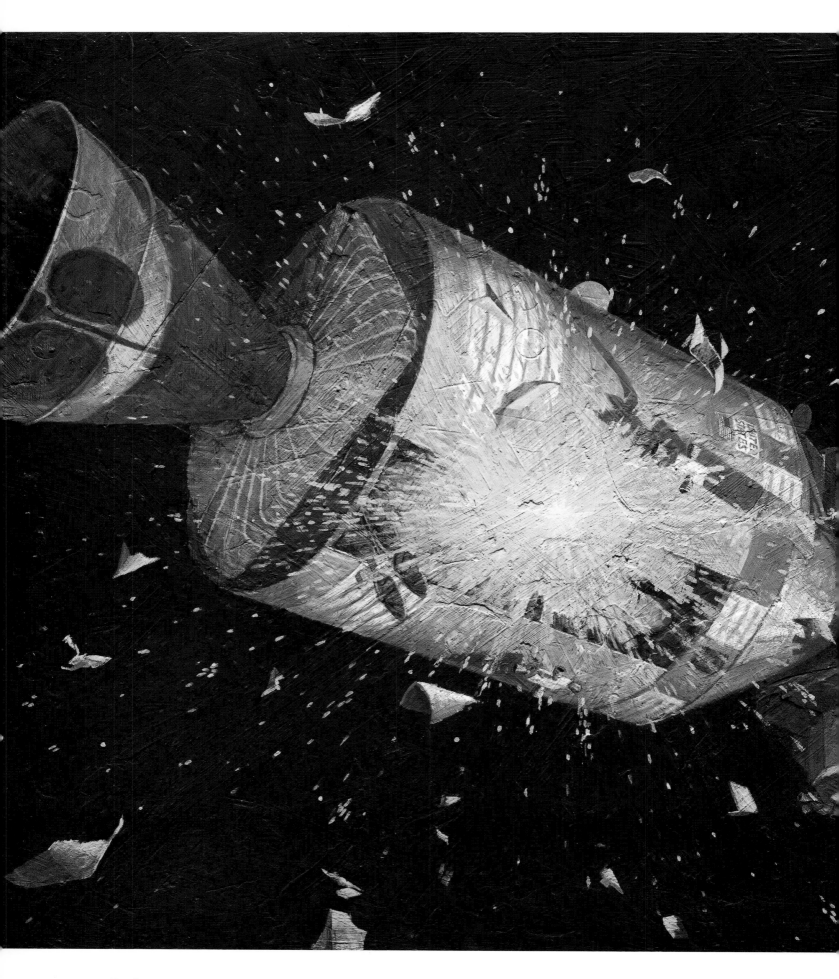

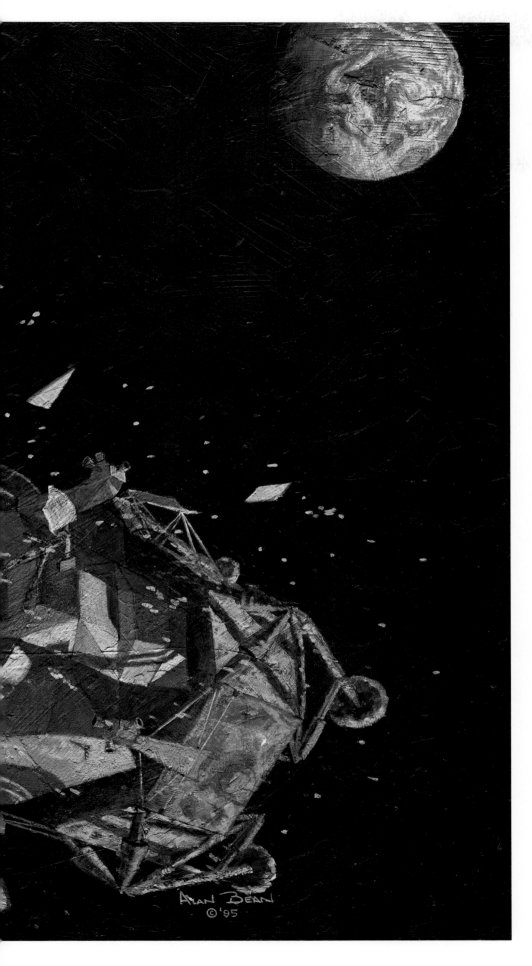

HOUSTON, WE HAVE A PROBLEM

The explosion of Oxygen Tank Number Two
was the defining moment of Apollo 13, and it
marked the start of America's finest hours in
spaceflight. Astronauts Jim Lovell, Jack Swigert,
and Fred Haise thought that having one extra
liquid oxygen tank was enough. If one failed the
other could get them safely home. An explosion
that would tear away piping from both tanks
was not considered possible. Unfortunately,
it happened exactly that way.

I have painted the explosion in space with
particles of liquid oxygen, plus vaporized tank,
wiring, and insulation materials streaming
away from tank number two. I do not believe
an explosive cloud forms in the vacuum of space
as it does on earth because everything
I saw move in space moved in a straight line.
There was no dirt cloud as we landed on the
moon, just small pieces speeding away radially
from the rocket exhaust.

This painting was created to celebrate
the motion picture, Apollo 13, directed by
Ron Howard and starring Tom Hanks, Kevin
Bacon, Bill Paxton, and Gary Sinise. The movie
tells the remarkable and inspiring story of how
astronauts deep in space, and engineers and
scientists on planet earth, worked together to
change a potentially fatal tragedy into a tri-
umph of human skill and spirit.

LUNAR HIGH FIVE

A walk on the moon was everything I thought it was going to be . . . and more. But it was a fragile chain of good fortune that put Pete Conrad and me on the Ocean of Storms. The giant Saturn V rocket performed almost flawlessly to get us into earth's orbit. And, the command service module, our "home" to and from the moon, checked out impeccably. On the way, both spacecraft remained spaceworthy (not at all like what happened on the next flight after ours, Apollo 13). Our service module engine provided thrust as advertised for course correction burns and to place us into lunar orbit.

After a good night's rest and donning our space suits, Pete Conrad and I checked all systems in the lunar module. Precise burns with our descent engine followed. The final maneuver was a powered descent from our orbital speed of 6,000 miles an hour to zero at touchdown on the Ocean of Storms. All critical systems had worked as predicted. We were on the moon.

Being on the Ocean of Storms was not luck but a result of careful and dedicated work by thousands of engineers and scientists back on planet earth. We were so happy and excited about getting ready to do the productive work we had trained long and hard to do, that a high five would have felt just right.

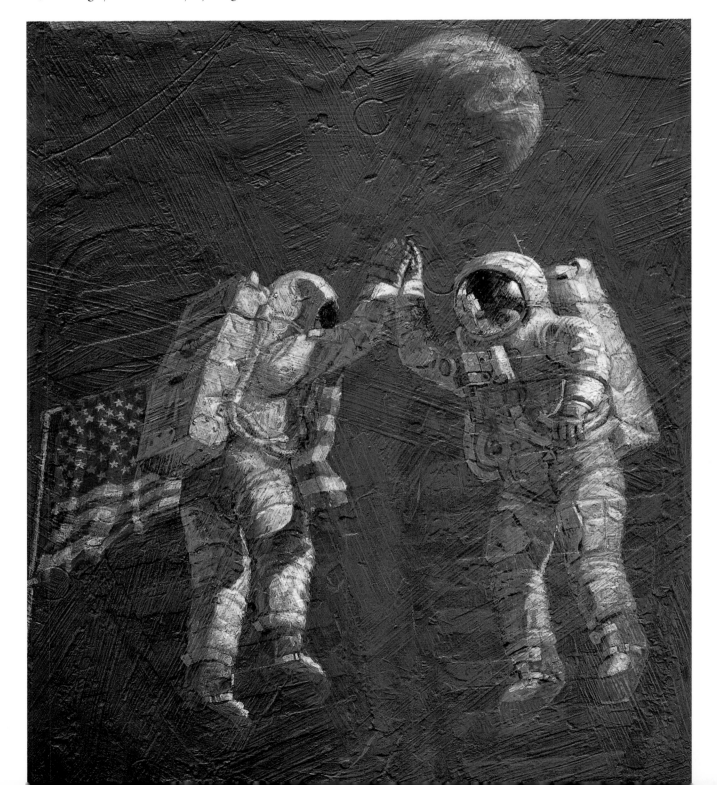

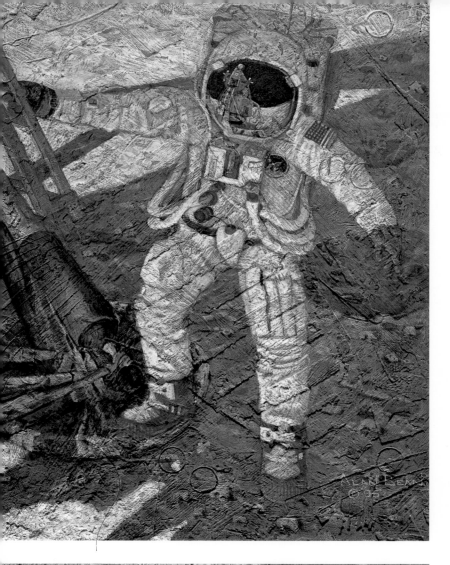

A GIANT LEAP

Neil Armstrong's first step on the moon was Apollo's most celebrated moment. No matter what our age, those of us on planet earth remember exactly where we were and what we were doing at that time. Unfortunately, there are no good photographs of this moment, and although the black-and-white television image was not very good for that first moonwalk, the soundtrack is still very clear.

I talked with Neil for quite a while before I started this painting. I wanted to know which rung he was holding with his right hand as he stepped off the ladder with his left foot, and how far around on the landing pad was his right foot? He remembered most things, but we agreed there were some details we just couldn't remember from our missions.

In one painting, I show Neil shifting his weight from his right foot to his left so his weight is supported by the moon instead of the lunar module landing pad. This would be considered the first step on the moon. ". . . one small step for man . . ." In the second painting, he is pulling himself back up on the landing pad and lifting his foot so he can make technical observations about it.

I had difficulty accurately painting the reflection in the visor, so I went out to the Johnson Space Center where they have a lunar module. A friend of mine, wearing a gold helmet, posed in the same position that Neil was in on the moon. Then I painted what was in the visor.

As the centuries unfold, there will be first steps on Mars and other celestial bodies that we can walk on. They will be much farther away than our moon but none will ever be a more giant leap for humankind than the one made by Neil Armstrong and all the people who helped him make that leap on July 20, 1969.

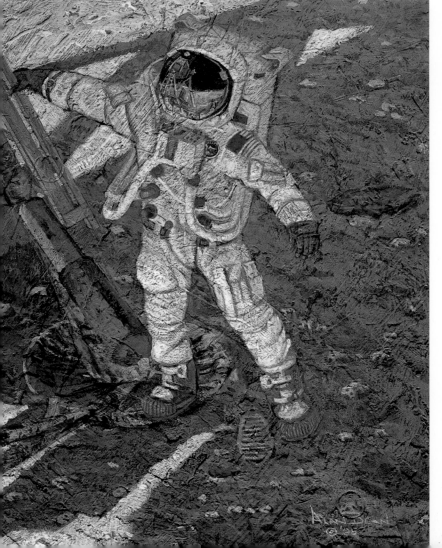

PLEASE TAKE ME BACK HOME GUYS

Boy, here they come at last. Thirty-one long months I've been resting just inside this unremarkable 656-foot-diameter crater on the Ocean of Storms. All this time I've had to endure the searing 225-degree heat of the lunar day and the chilling minus 243-degree lunar nights. It hasn't been fun. After all, I was sent here to see if the ground was firm enough to support human beings who would come several years later. Project Apollo it was called.

I see by my reflection in your visors that I've become rather dusty since the engineers packed me on top of an Atlas Centaur and blasted me to the moon. They said that I had only one day, one lunar day (14 twenty-four-hour earth days), to complete my mission: look around with my television, dig trenches with my scoop, perform a few soil bearing and impact tests, and radio my findings back to earth. Well, I did it superbly if I do say so myself. I took 6,315 pictures with my television, dug four trenches and performed twenty bearing and impact tests.

Now I'm ready for my trip back to our blue-and-white planet. I know I'm too big and heavy for your spacecraft, but my scoop and television camera should fit on board nicely. I'll always remember that on November 19, 1969, C. Conrad and A. Bean rescued me from this lonely, dry and dusty place and took at least part of me back home.

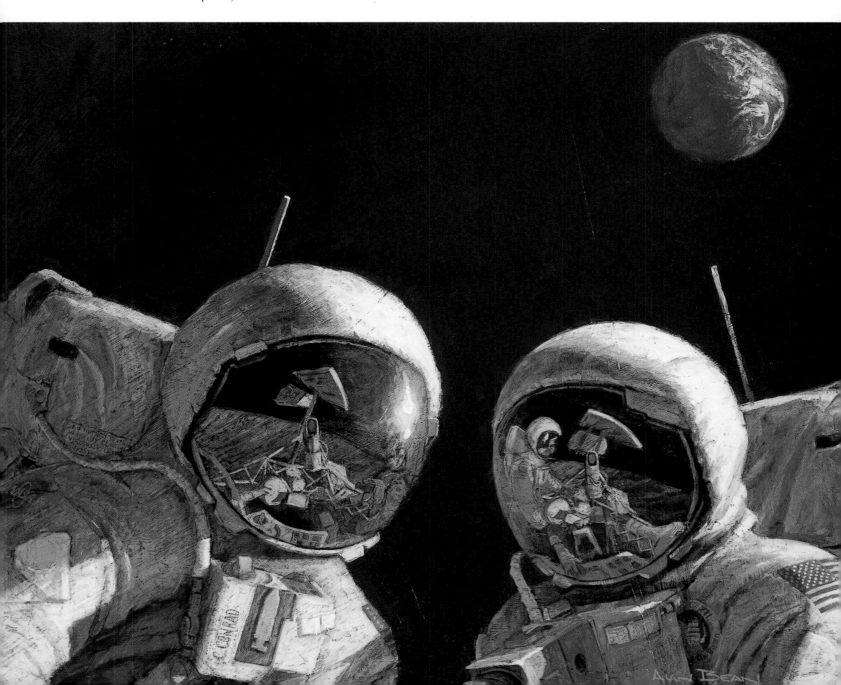

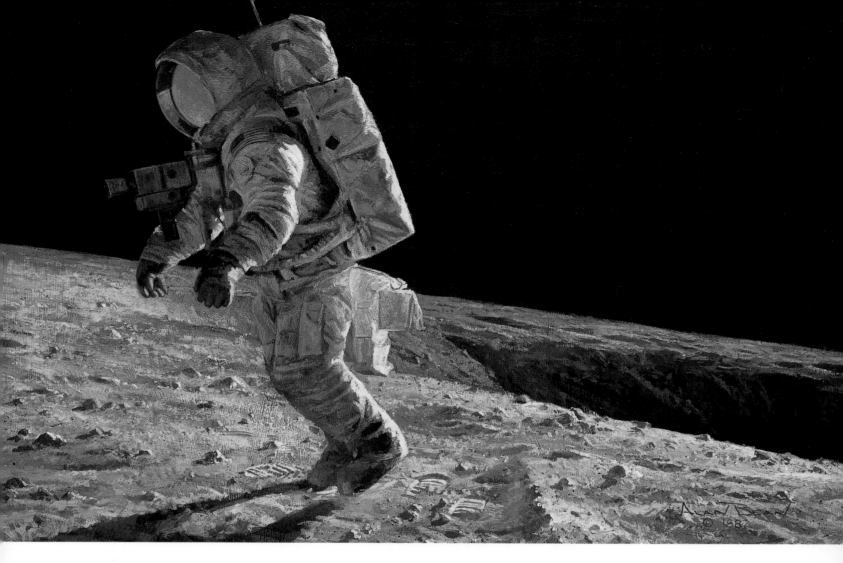

TIPTOEING ON THE OCEAN OF STORMS

I can remember running along next to this crater. It seemed I could run forever on the moon and my legs would not get tired. There was a reason, however. On earth I weighed about 150 pounds and my suit and backpack another 150 pounds. On the moon with its one-sixth gravity, my equipment and I only weighed a total of 50 pounds. This light weight made me feel as if I were super strong—that I could run forever.

An astronaut learns very quickly to run in a space suit. The suit is stiff and hard to move at the knee and hip joints but moves easily at the ankle joints. Moving about is most readily accomplished by keeping the legs relatively stiff and using mostly ankle motion. It feels and looks as if you are dancing on tiptoe. If I could bring that one-sixth gravity field back to earth, I could win the Boston Marathon and never even get tired. And why not, my legs would only have to carry 25 pounds.

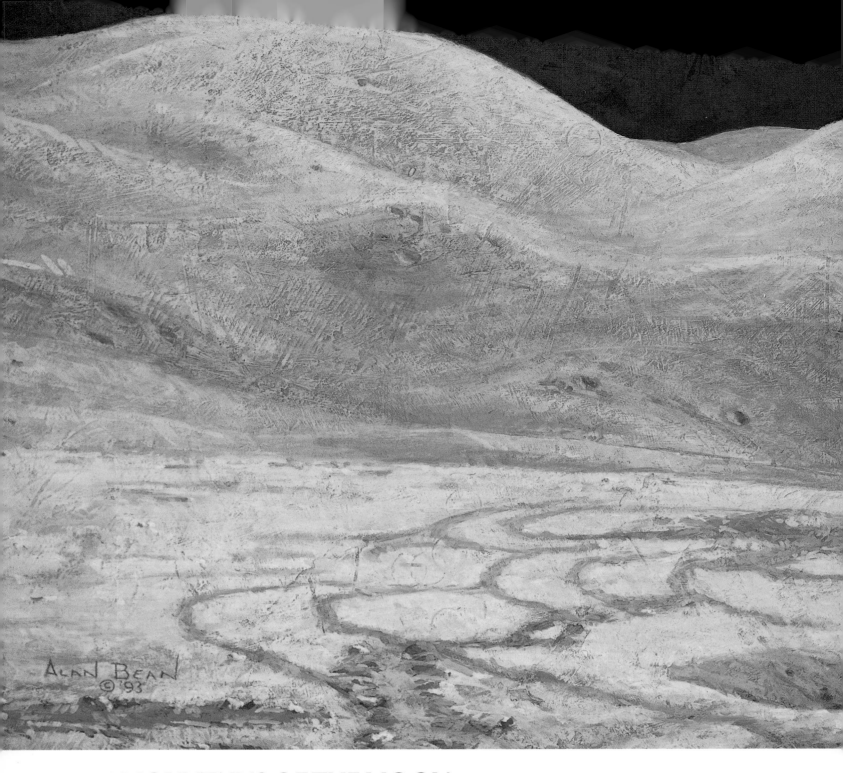

MOUNTAINS OF THE MOON
WITH THE LUNAR MODULE FALCON

Falcon, *the Apollo 15 lunar module, sits on uneven ground, all alone on the plain at Hadley. The Apennine Mountains are on the horizon, about 3 miles behind. We are near the eastern edge of Mare Imbrium, the dark circular plain that forms the right eye of the "man in the moon" when we view it from earth.*

No one is around. Dave Scott and Jim Irwin have gone for a ride in their new Rover, a small electric dune buggy. The Rover will prove itself an important tool for exploring the moon. We can see where Dave and Jim walked and where the Rover's woven-piano-wire tires made their distinct marks in the soft gray lunar soil. Dave would later say, "These mountains

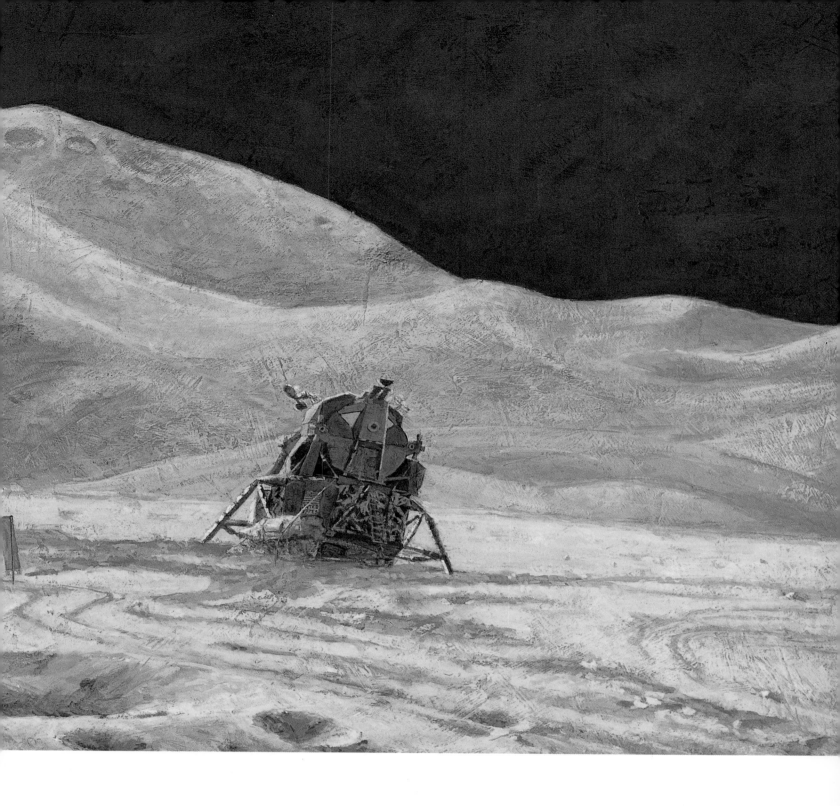

were never quickened by life, never assailed by wind or rain, they loom still and serene,
a tableau of forever. Their majesty overwhelms me." This landscape indeed presents a
beautiful yet unearthly scene. I wonder how Claude Monet, my favorite artist, might
have painted it. With him in mind, I have not painted the moon the neutral gray I saw
with my astronaut-geologist's eye, but rather a more beautiful combination of hues
that I saw in my explorer astronaut artist's eye. I think Monet would approve.

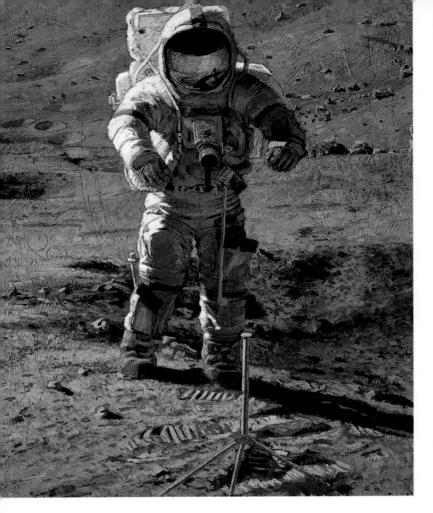
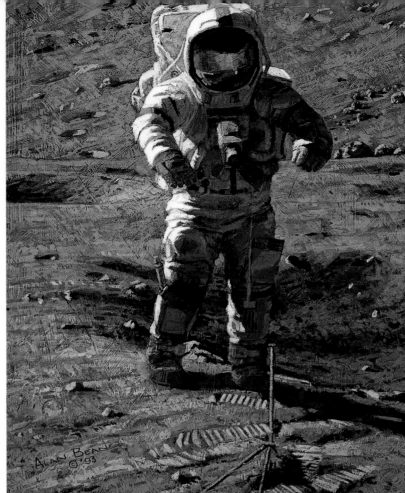

THE COLOR MOON

Without a doubt, the greatest challenge I face as an artist is to create paintings that are not only accurate, but beautiful. The moon was a stark and beautiful place. Perhaps the best description was given by Apollo 11's Buzz Aldrin as he stood on the Sea of Tranquillity: "Magnificent desolation." But as an artist, the challenge for me is to translate the beauty I feel for this other-worldly scene into something worthy of the Apollo tradition. We all cared deeply about what we were doing and I want my paintings to reflect that, and what it meant to be one of mankind's emissaries on another world.

In my mind's eye, I can still see the bright, pristine landscape of the Ocean of Storms. The sun was low in a shiny black sky. Because the moon has no atmosphere, sunlight seemed brighter than it does on earth. I knew that the lunar rocks and dust were dark gray. But as I stood in that intense sunlight, the landscape appeared a light grayish tan. The shadows were black, and it was difficult to see any details within them. But if I stood in the only available shadow, that of the lunar module *Intrepid*, the dust, rocks, and craters within the shadow looked dark gray, almost black. And if I looked out from the shadow to the sunlit ground, it appeared so intensely bright that I had difficulty seeing the surface features I knew were there.

When I first began painting the moon, I painted it exactly as I remembered it as an astronaut, and much the way it looks in photographs. I sometimes added touches of red and blue for the American flags we wore on our space suits. I needed gold for our

helmet visors, light blue for the fingertips of our gloves and the soles of our lunar boots, reddish orange for the foil covering the lunar module, and so on. To the astronaut-engineer-scientist in me, the paintings looked correct. But they didn't completely satisfy the explorer artist in me, the part of me that loves color and impressionist paintings.

Over the years, as I've looked at paintings in museums or books, I have noticed that the paintings I find most interesting depict nature in more beautiful hues, and with more color variety, than I can see in the world around me. So I studied some of the paintings of one of my favorite artists, Claude Monet, and paid particular attention to his subjects—the Rouen Cathedral series, the grainstack series, and the water lily paintings. Were his eyes different from mine? Did he actually see colors as intense as he used in these paintings?

I believe the answer is no; he saw the same color intensities anyone with normal vision sees. I went to Monet's home in Giverny, France, and I saw the lily pond he painted. The water looked gray-green to me, not the many vivid hues I see in Monet's paintings. I traveled to Rouen, France, to see the cathedral Monet painted thirty times, and many times from almost the same point of view. Most of these paintings are colorful with blues and yellows in several pieces and purples in some others. He titled them carefully: *Morning Effect, Sunlight, Dawn,* and one, perhaps more accurately, *Harmony in Blue.*

[50]

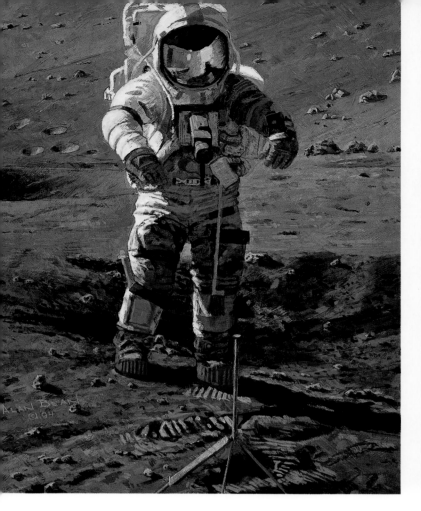

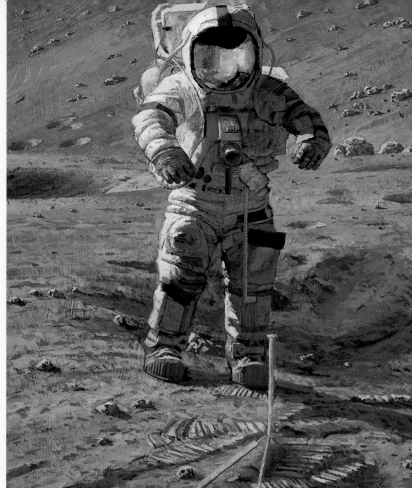

I arrived at the cathedral before first light. I watched the first rays of the sun strike the stone walls. The lighting was like that in one of Monet's paintings, but the colors I saw in the cathedral were basic hues of dark gray and light gray. Several hours later the lighting had changed, but I saw no new colors. I left and returned several more times until sunset, and at no time did I see any of the colors Monet had painted so beautifully. It seems strange to me now that I had to go all the way to France to understand that in an artist's vision, the way he or she chooses to see things is not the same as what he or she actually sees.

So now I paint the moon as beautifully as I can with my vision. I have found that grayed yellow-greens, yellows, oranges, and reds are best for representing the sunlit lunar surface. For the shadows I use some of the same hues at a lower value, with touches of green, blue, and violet. Both beauty and realism are possible with these color combinations.

I often wish, when I'm faced with a painting difficulty, that Claude Monet would drop by my studio and help. I believe he would approve of my modest efforts and could, with a few quick brush strokes, solve the problem and create a masterpiece. Claude hasn't shown up yet to help me with my creative work. Still, he has helped me understand that an artist's value to the world is to help all of us experience more fully, feel more connected to beauty, and become more completely human than we could without art.

CERNAN, GNOMON AND CRATER

These four paintings, which are the same view of Apollo 17 Astronaut Gene Cernan, were done over the last seven or eight years in an attempt to find the limits of colors that could be used to realistically portray the moon. A number of these paintings, particularly the greenish-gray one which was the first, have about four or five other paintings under them which I did as I tried to develop the color scheme. I think my role as artist is not to duplicate nature but to interpret it in ways that are beautiful and important to the artist and, hopefully, to other people.

When I first started, any painting that wasn't mostly gray didn't seem right, and I would go back and overpaint it. Then I began to see that these paintings didn't show the heat of the moon, the feeling of the sun, so I painted the one that looks a little more reddish to suggest the heat, and it's also more beautiful. I began to use violets in the craters and to make the dirt quite beautiful instead of just gray. The other two paintings are a little more advanced and typical of my work today, where I search for any colors that I can use while still making the moon look like itself. ∎

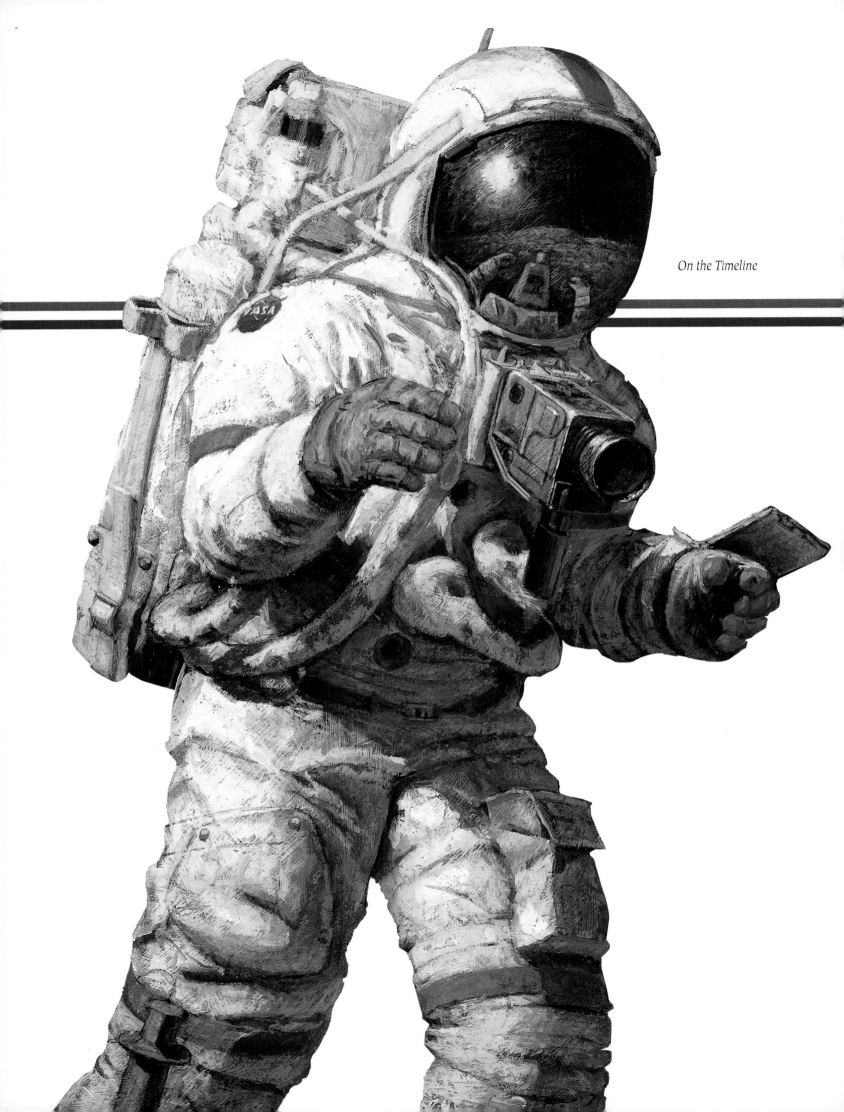

·II·
THE MAKING
OF AN ASTRONAUT

For a few hours or days after one of these
"mentoring sessions" with Pete or Dick, Bean would
walk around wishing he knew about some other space program
he could join. But as time went on, he realized that his
crewmates really cared, and were going well out of their way
to help him see more clearly. NASA was teaching
him how to go to the moon; Conrad and Gordon were
teaching him how to be a better human being
and a good astronaut.

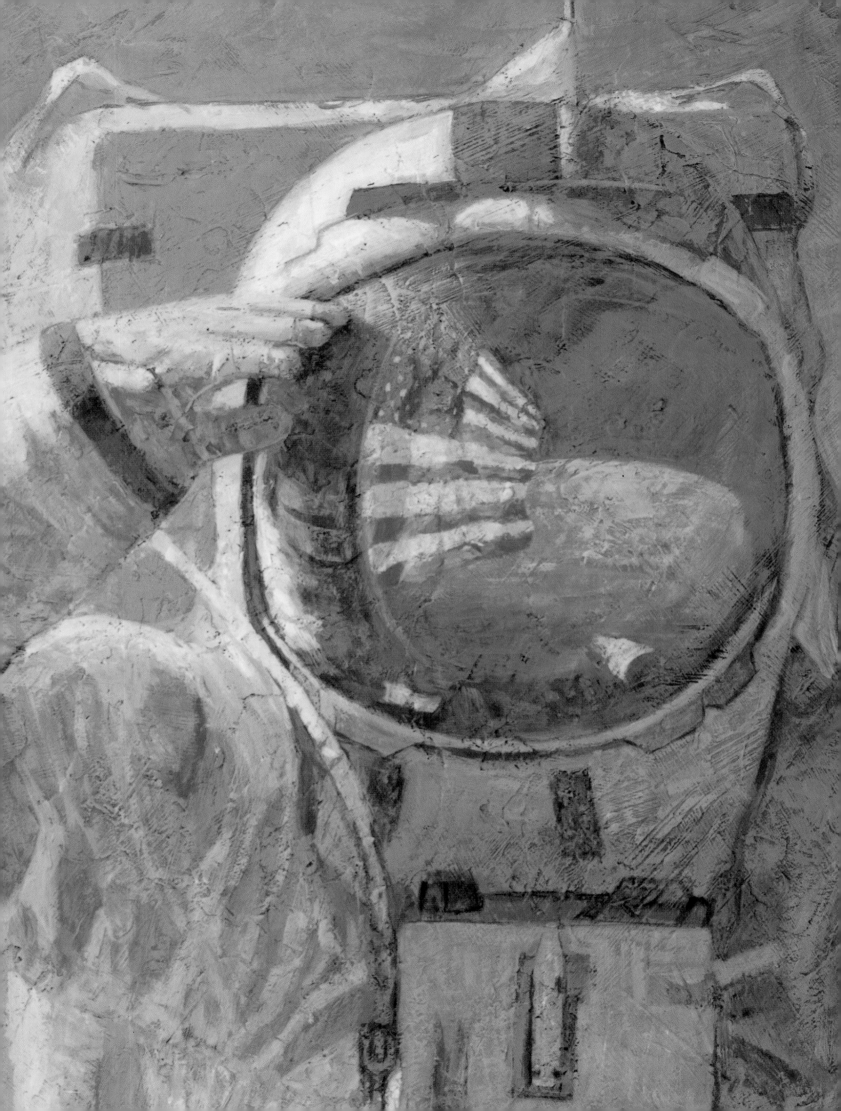

·II·
THE MAKING
OF AN ASTRONAUT

Alan Bean's A-4 responded crisply as he brought the light attack jet in for a landing at Patuxent River Naval Air Station in Maryland. The A-4 was a swift and agile airplane, and Bean had learned to fly it as well as anyone could. That was what he loved the most about being a pilot: the feeling of controlling the machine, flying it with such skill and precision that he could often place a practice bomb squarely on target. It was the satisfaction of doing a job that few others could handle, doing it for his country, and doing it well.

On this day, February 20, 1962, Bean had been putting the A-4 through its paces on a test hop. He felt good about where he was in life. Recently graduated from the Navy's test pilot school at Pax River, he joined the ranks of top military pilots. The road to Pax was paved with persistence and hard work, but it was also straight; in the Navy Bean always knew what the next goal was, and how to achieve it. Now, as a pilot in Service Test, his job was to evaluate and recommend improvements in new airplanes before they saw service. That meant putting the plane through its paces under all the conditions it would meet in everyday squadron operations. At the tender age of twenty-nine he was on a fast track to the heights of his profession. And he was about to learn that there were summits he had never dreamed of.

When Bean arrived back at the ready room, he was feeling pretty cocky. The television was on, and everyone was gathered around it. Someone named John Glenn was circling the earth in his Mercury spacecraft. After a fiery launch atop an Atlas missile, Glenn became the first American in orbit. With a jolt, Bean understood what was happening. In his own 90-minute test hop, flying at 25,000 feet, Bean had traveled maybe 600 miles at a maximum speed of 450 miles per hour. In the same amount of time, Glenn went all the way around the world—flying at about 600,000 feet, at a speed of 17,500 miles per hour. As the realization began to sink in, Bean wondered, "Why didn't they ask me? I could do that!" Up to now he had never given any thought to being an astronaut. Now he felt certain that given the chance, he could be a good one.

What would it take to become one of those pilots who ride rockets into space? Bean had no idea, but it wasn't long before

he had a chance to find out. In the spring of 1962 NASA announced it was looking for more astronauts. Bean had never seen anything as thorough as the astronaut selection process. First, there was the paperwork, then the recommendations, and the background check. His spirits soared when he learned that he was one of thirty-five finalists asked to report to Brooks Air Force Base in San Antonio, Texas, for the physicals, a grueling array of tests. After that came psychological screening, from IQ to inkblots. And finally, the interview with Deke Slayton, Al Shepard, and the other members of the selection committee. Bean came away feeling he'd had a chance to show his best.

But he had no illusions about the competition. There was Neil Armstrong, who'd flown the X-15 rocket plane to the edge of space. And Frank Borman and Ed White, Air Force men who were not only seasoned test pilots but had advanced degrees in aeronautical engineering. And there was Pete Conrad, an old friend of Bean's who had a reputation as a superb aviator. Bean knew firsthand how special he was, because he had been one of Bean's instructors in test pilot school. With candidates like these to choose from, Bean felt his own chances were probably slim.

The news arrived in September. Conrad made it, and so did Armstrong, Borman, McDivitt, and five other men, but not Bean. Conrad and the others would be going into space while he stayed behind. The mark of a winner, Bean knew, lay not in whether a person fails (because everyone does at one time or another), but in what he or she does after the failure. At Pax River, he went back to being the best aviator he knew how to be. When his tour was up, he was selected for the Navy's Aviation Safety School at the University of Southern California, where he did very well. Then he went to fly with an attack squadron in Jacksonville, Florida. Bean reveled in each new opportunity that came his way. He was doing a job he loved, but he hoped NASA would give him a second chance.

Bean got it in the spring of 1963. Once more he faced the indomitable treadmill, the inscrutable inkblots, and the all-important interview; once more he went home to wait. He was working in the backyard several weeks later when he got the

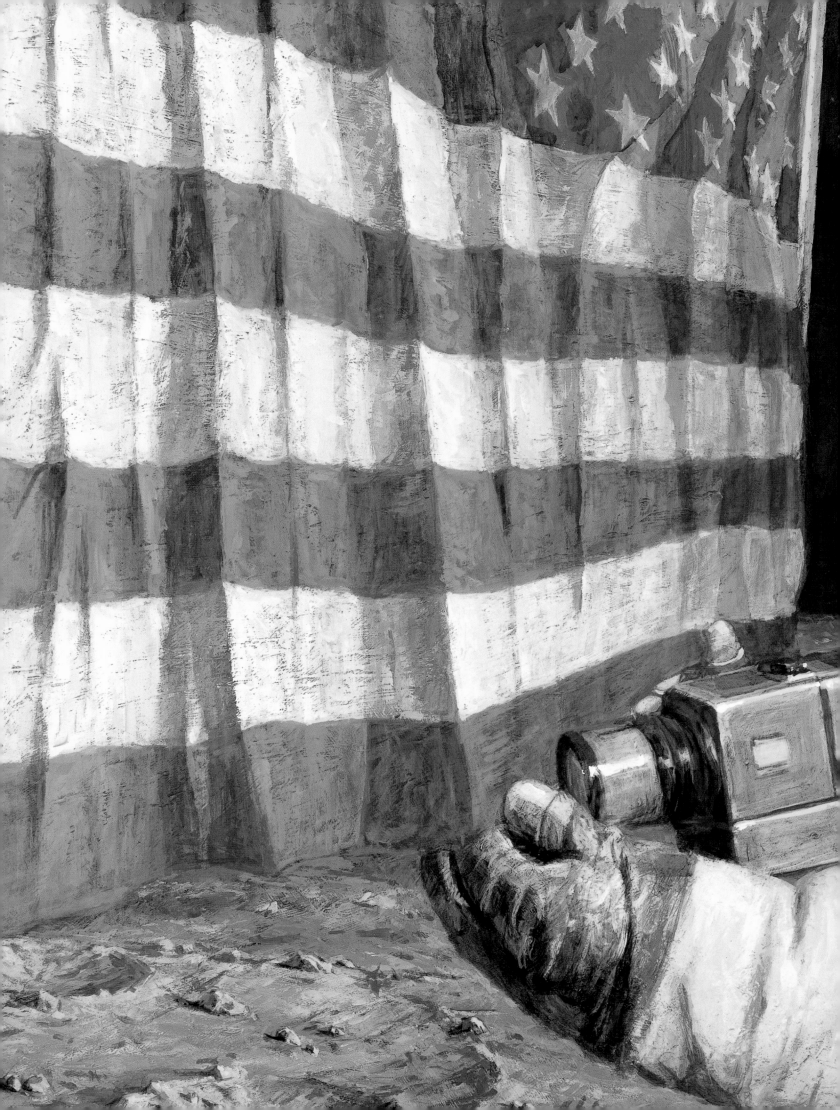

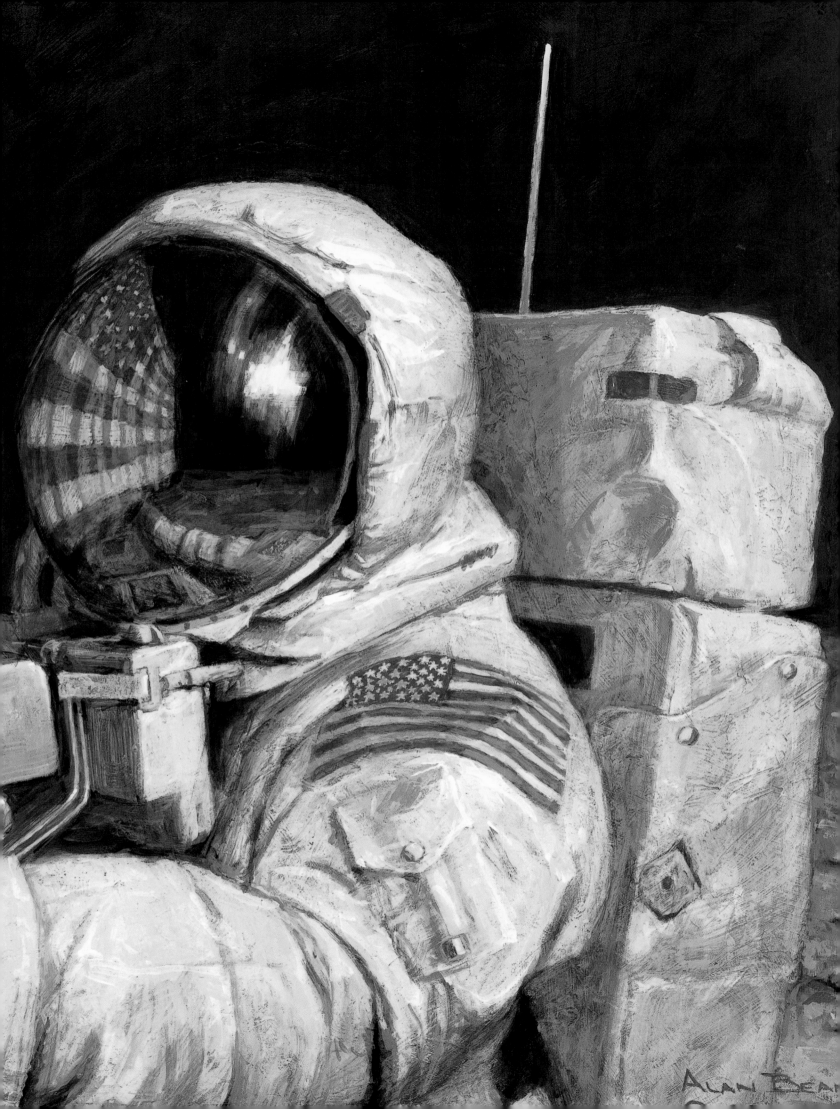

STRAIGHTENING OUR STRIPES

[PREVIOUS PAGE]

I recall that when Apollo 11 got back to earth in July of 1969, Life magazine was eagerly sifting through the flight photos to find just the right one for their cover. With each passing minute their concern grew stronger. "Is this Neil?" "No, that's Buzz." "How about this?" "That's Buzz too." I have a copy of that Life magazine and on the cover Neil Armstrong is a hazy golden reflection in Buzz Aldrin's helmet visor, a blowup of a photo taken by Neil himself.

At the time it was concluded that there was no photograph of "the first man on the moon" actually on the moon, because Neil mounted the camera on his space suit, but he never passed the camera back to Buzz and posed himself. Almost twenty years later, after more careful study of the photos, some experts now believe that a photo of an astronaut stowing equipment is, in fact, the first human on the moon: Neil Armstrong.

To make this painting authentic I studied and sketched the television pictures of Neil deploying the flag. I then asked NASA to pose a man in a space suit under similar lighting conditions. They agreed and this painting is the result. I painted Neil stretching the bottom of the flag to eliminate creases. The flag had been folded during the flight from earth to the Sea of Tranquillity. Neil said of the flag installation, "It went as planned except that the telescoping top rod could not be extended. It didn't show much." He added, "I was able to stick the flagpole 6 to 8 inches in the lunar dust. The first 4 or 5 inches were fairly easy. After that it gets hard quickly." Most Americans watching on earth didn't even notice, we were so happy it was our flag and not one from some other nation.

phone call that would change his life forever. From the other end of the line, Deke Slayton offered an invitation as calmly as if he were talking about a weekend fishing trip: "Just wanted to know if you'd still like to come fly for us."

"I'll be right there, Deke," Bean said. "I'll clean things up as fast as I can and I'll come down in a couple of weeks."

Bean thought he heard Slayton suppress a laugh. "Not necessary, Al. We're bringing everybody on board in a couple of months." Bean thanked Slayton, hung up the phone, and announced to his wife, Sue, "We made it!"

For the rookie astronauts, Houston was the only place in the world to be. It was NASA's pathway to the moon. Not that Bean had any particular interest in the moon. As a boy in Fort Worth, Texas, he had not looked at the moon through a telescope, or told his parents he wanted to go there someday. Astronauts existed only in the pages of science fiction. What was very real to Bean was the lure of flight. He was only a small child when his father and mother took him to watch planes land and take off at Mecham Field, and he was captivated by the sight of them. Even in high school, he knew where he wanted to go in life—into the air. He joined the Naval Air Reserve in high school so that he could be around honest-to-goodness military airplanes at the Naval Air Station in Dallas. On weekends he would gas and clean the planes, and help the pilots strap in. As a boy he built models of World War II aircraft like the F4U and the F8F; now he was working around real ones. Reservists were supposed to show up one weekend a month; Bean was at the Air Station almost every weekend.

Near the end of his senior year, Bean heard about the competitive exams the following Saturday for NROTC (Naval Reserve Officer's Training Corps) college scholarships. Bean had talked about it with his family, and told them this was the chance he'd been waiting for. With an NROTC scholarship he could attend the University of Texas to study aeronautical engineering, which would help him along the road to becoming a Navy pilot. When Saturday came he lay in bed for a long time

convincing himself there was no reason to get up and ride the bus downtown, because he had no chance of passing the exams with high enough scores. Then he heard his mother's voice.

"Why aren't you up yet? Today's the big day."

"It isn't going to happen. I can't win one of those scholarships. My grades aren't good enough." But Frances Bean believed in her son more than he did. He would always remember what she said next: "If you'll hurry and get up and get ready, I'll drive you downtown." That kind of offer was very rare from Bean's mother, who instilled self-reliance in her children. "This is your chance to make your dream come true. And I know if you give your best effort, you can do it." His mother's loving intervention spurred Bean to win that NROTC scholarship to the University of Texas. He later pointed to that moment as the real turning point in his life. Frances Bean would never imagine that her extra care and encouragement could result in her son venturing 239,000 miles from Fort Worth someday.

Without a space program, Bean would certainly have been happy flying jets for the Navy, working his way up to commanding a squadron, and beyond. But the chance to fly in space, and maybe to the moon, and to do it in the name of a national goal, was as much as any test pilot could ask for. But Bean wasn't going anywhere yet, at least not into space.

First came an intensive course of classroom instruction fundamental to flying in space that included subjects Bean had never studied in detail before, like computers, rocket propulsion, and celestial navigation. And then there was survival training. In these early days of spaceflight, NASA felt that certain emergencies, like a cabin fire, could force astronauts to return to earth immediately, perhaps coming down far from planned recovery areas. Along with Pete Conrad, "den mother" for the new astronauts, Bean and the other thirteen were deposited in the jungles of Panama, where they savored such delights as boiled iguana. (Bean's friend Bill Anders turned down this unorthodox meal. "It just depends on your appetite," Anders explained.

"I've already eaten once this week.") For Bean it was hard to imagine a worse place to come down—until he learned what would await him in the desert and the open ocean. In the end, Bean realized that by comparison the jungle was a prime vacation spot—after all, it had water, and "gourmet" food.

Back home, the future lunar explorers were expected to learn geology. That meant hours of difficult lectures and laboratory exercises on subjects such as rock and mineral classification. Strange as it may seem, Bean had never heard of terms like "aphanitic vesicular basalt" or "plagioclase feldspar phenocryst." Now he was expected to make them part of his working vocabulary. But there was good news, too: field trips to spectacular places like the Grand Canyon, where a billion years of history were written in layers of rock. And to Iceland and Hawaii, whose lava flows were the geologists' best approximation of the lunar surface. When the end of astronaut "basic training" arrived, Bean felt as if he'd earned a couple of advanced degrees, at the very least.

Officially now an astronaut, Bean now wore the silver astronaut lapel pin—a star ascending through an orbit, trailing three rays. But he didn't feel like an astronaut. In the Astronaut Office, he would walk the halls and run into members of the Original 7, like Al Shepard, John Glenn, and Gordo Cooper. Bean couldn't help feeling inadequate around them. The Original 7 seemed to move on a higher plane of existence. They drove expensive sports cars; they socialized with the Houston elite; they played touch football with John Kennedy. To Bean they all seemed larger than life.

Bean noticed that they were always trying to one-up each other. Alan Shepard told a story about the time he scored a "gotcha" on Schirra, who had recently bought a Ferrari sports car and wouldn't stop talking about it. Shepard knew that there were sports cars, and then there were race cars. When he heard Schirra was going to drive his Ferrari to work for the first time, to show off to the other astronauts, Shepard was ready. As Schirra proudly pulled into the parking lot, he saw a beautiful Ferrari

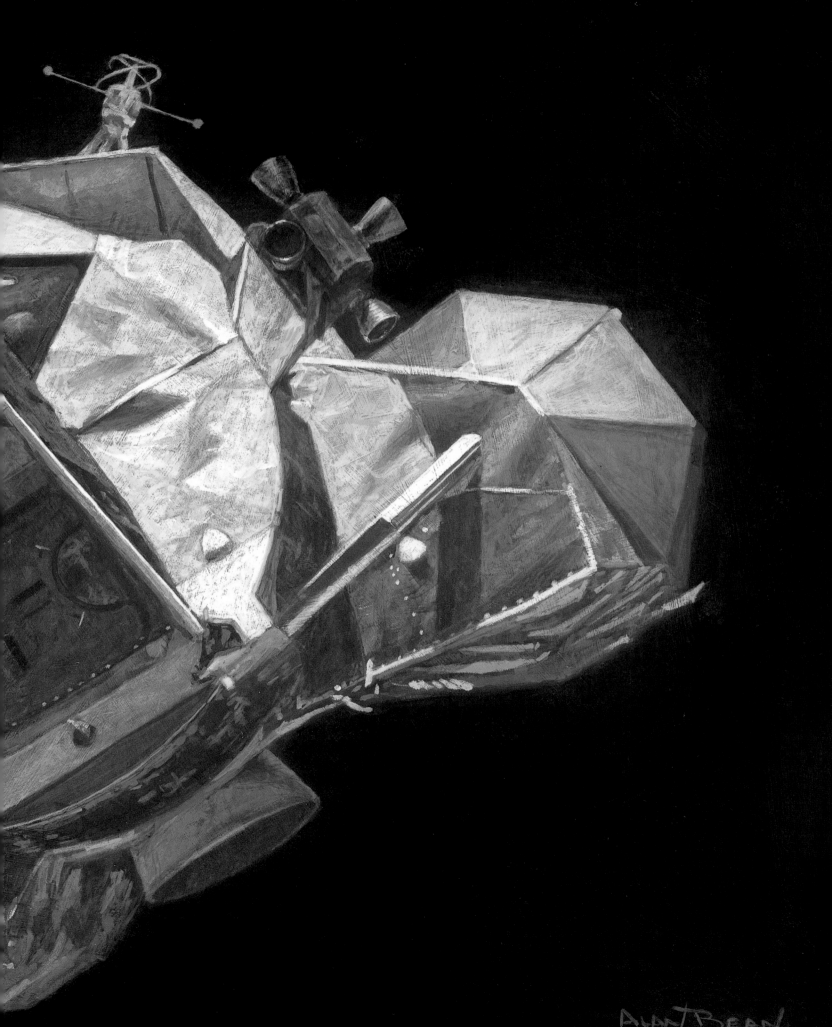

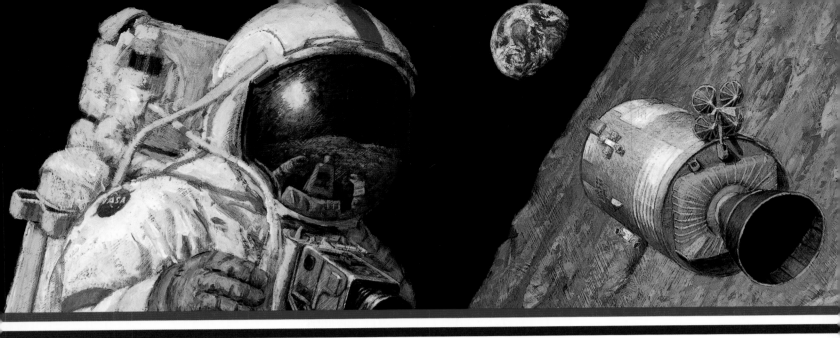

WHAT A GREAT WAY
TO START HOME

[P R E V I O U S P A G E]

*We can just barely see Jack Schmitt and Gene Cernan
through the right- and left-hand windows of the lunar module
Challenger. They have just completed three days exploring
the surface of the moon and are about to rendezvous
with Ron Evans in the "Mother Ship America." Their radar
antenna is locked onto America, to measure range
and rate of closure.
We can see the squarish front hatch that Gene and Jack
used to enter and exit on the lunar surface. The round hatch,
which they will use after docking to move rock samples and
equipment back to the command module, is not visible, but it
is on the top just behind the radar antenna.
The shapes of the lunar module are interesting to look at and
they were fun to paint. Challenger has the look of a machine
built to do a specific thing well and efficiently. This was all-
important to Gene and Jack because if, for example, the rocket
engine we see at the bottom did not do its job, they would
never come home. I remember on Apollo 12 when we had
rocketed back into lunar orbit, and we were going fast again,
I felt we were really going to make it. It was a
great way to start home.*

racer parked in Shepard's spot. Suddenly Schirra felt as if he were driving an old VW. To Bean's amazement, Shepard had borrowed the racer from one of his millionaire friends. Bean could only imagine what it would be like to know someone who could lend you a race car. The Original 7 were the ultimate fraternity.

The only fraternity that Bean wanted to join was the "real" astronauts, and that meant flying in space. What he didn't know was how to get selected for a mission. He was willing to pay any price, just as he had been in the Navy. But this wasn't like the Navy. There were no written rules about how to get ahead in the astronaut corps. When he looked around at his own group of fourteen, he was humbled. Dick Gordon had a cross-country speed record under his belt, and hundreds of night carrier landings. Dave Scott was not only an excellent test pilot who had graduated fifth in his class at West Point, but he had the physique and boyish good looks that fit "central casting's" idea of an astronaut. And many of the fourteen seemed to pick up difficult subjects like astronomy and geology faster than Bean. He would have to make up for his deficiencies with after-hours and weekend effort.

Meanwhile, the goal of putting a man on the moon became part of the astronauts' day-to-day job. Each of the rookies was assigned to one of several key areas of Project Gemini (the program NASA had created to pave the way for the lunar missions) and Project Apollo. Bean drew recovery operations, an area that he knew almost nothing about. He went to meetings and found himself wanting to contribute. Often, when he did think of something original, he convinced himself it had little value. After all, he just got there. And even when he felt confident with an idea, he knew his spaceflight knowledge was not strong enough for him to speak effectively. After all, these engineers and scientists had started working on the problem years before Bean came to NASA; what could he possibly know that they didn't? In the sky, he would have been happy to stack his skills against almost anybody in the astronaut corps. In the conference room, he felt as if he had lost his wings.

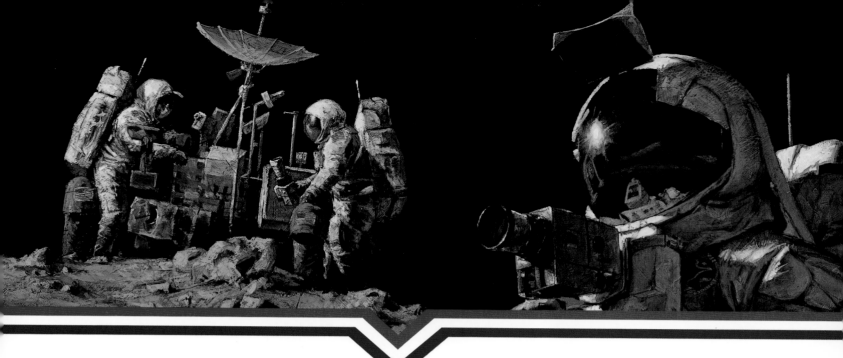

At Pax River, Bean had been surprised and proud when he found out he would be promoted early to lieutenant. But at NASA, military rank had no official bearing on an astronaut's standing. In the minds of people at the space center, Bean later realized, becoming an astronaut was like getting an instant promotion to captain. The trouble was, Bean still felt like a lieutenant, while his colleagues seemed comfortable with their newfound status. Bean noticed that some other astronauts seemed to have no hesitation voicing their opinions on subjects they knew little more about than he did, which wasn't all that much. Like Bean, they were at ease with working-level engineers, but they were far more comfortable with senior NASA managers than Bean was. Their competence and confidence must have impressed Deke Slayton and Al Shepard, who picked the crews for every space flight. When Gemini crew assignments were announced, it was other members of the fourteen, not Bean, who made the list. Before long Dave Scott, Dick Gordon, and others were training for their first space flights, while Bean watched from the sidelines with guilty envy. His mixed feelings were those of a second-string quarterback rooting for his team, but longing to get into the game.

Finally, at the end of 1965, Bean took a giant step toward the moon. He was named as the backup commander for the following year's Gemini 10 mission. Surely the next step would be a space flight. By the crew-rotation pattern, he would have been in line to fly on Gemini 13—except there wasn't going to be a Gemini 13. Bean was on a dead-end assignment, but he and co-pilot C.C. Williams dug in anyway. For Bean, training for Gemini 10 meant mastering the arcane art of space rendezvous, a task which tested his piloting abilities to the limit. But there were other things about being a backup crew commander that Bean didn't know—things like how to effectively assist the prime crew, the subtleties of team-building, and coordinating with Shepard and Slayton and other NASA officials. Even worse, he was unaware that his understanding of what it took to be an astronaut was woefully incomplete. And he would never figure it out—at least not on his own.

NASA was ready to begin reaching for the moon by early 1967. Gemini had ended on a note of triumph, and the first manned Apollo flight in earth orbit was just weeks away. But on January 27, as Mercury veteran Gus Grissom and his Apollo 1 crew went through a simulated launch countdown, there was a spark inside their sealed command module. In seconds

America's Team: We're #1

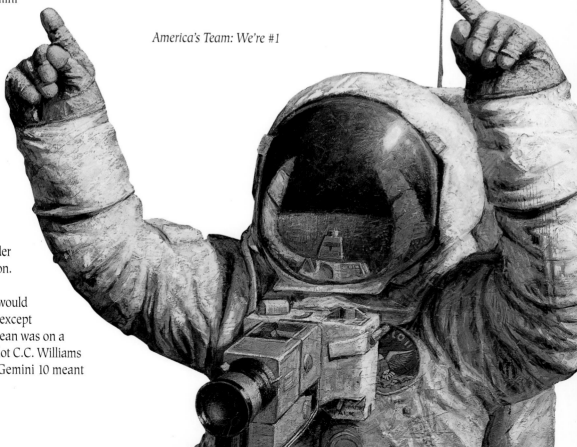

it became a flash fire and just minutes later the astronauts were dead. Bean shared his colleagues' sadness at the loss, and their determination to recover and move on.

Unlike them, however, Bean was not working on Apollo. He was the astronaut representative on the earth-orbit space station project that would eventually be known as Skylab. Did this mean Shepard and Slayton had written him off? He had no idea. All he knew was that every time he thought about Apollo, it hurt. Every other member of his astronaut group was on an Apollo crew now; C.C. Williams was training with Pete Conrad and Dick Gordon. They would be going to the moon; Bean would be lucky to make it into earth orbit. For Bean it was a time of soul-searching. He was looking for answers, but he didn't even have the right questions. By now he had learned how to be more effective in meetings, and with the NASA hierarchy, but he suspected he had learned too late.

Then, one day in October 1967, C.C. Williams was flying a T-38 jet over Florida when the aircraft suddenly went into a violent, uncontrollable roll. Williams tried to eject, but it was too late for his parachute to save him. Once again the astronaut corps mourned a colleague. Not long afterward, Bean ran into Pete Conrad on the tarmac at Ellington Air Force Base. The words that passed between them are no longer in Bean's memory, but their meaning was unforgettable. Conrad had spoken to Slayton, and Bean was now on his crew. He would be going into space after all—and he would be doing it with Pete Conrad and Dick Gordon.

Conrad and Gordon were already best friends, and they welcomed Bean into the crew. To Conrad and Gordon's cocky exuberance, Bean added a quiet thoroughness. He immersed himself in the details of checklists and schematics, things that Conrad and Gordon disliked spending as much time on. The crew spent most of 1968 at Cape Kennedy, backing up Jim McDivitt's Apollo 9 crew on the first manned, earth-orbit test of the lunar module. As time went on, Bean and his commander learned to fly the lunar module as skillfully as any other crew.

But most importantly, with Conrad and Gordon, Bean began a kind of training that wasn't in any NASA manual.

Bean and Conrad were in the simulator one day, waiting to begin a practice rendezvous, when Bean told him about a conversation he'd had earlier with Deke Slayton. Bean had gone to Slayton with an idea, but Slayton seemed to pay little attention. Finally he'd told Bean his idea wasn't going to work. "I don't even think he likes me," Bean told Conrad. "When I get to be Chief Astronaut, I'm going to treat my people better." Bean was waiting for Conrad to agree with him when he noticed a funny look on his commander's face.

"You know something, Al? About two months ago we were having the same conversation, only this time you'd gone to Al Shepard with an idea, and he'd agreed with you. You were talking about how great you were, how you said just the right things. Well, it seems to me that any time somebody likes your idea, you think you're the genius. And any time they don't, you think they've got a bad attitude. Don't you think that if you're going to take credit for the successes, you ought to take credit for the failures?"

"Of course," Bean explained. "But this is different. After all, what can I do if Slayton didn't like me?"

Conrad zeroed in: "If it's important to your life for Deke to like you, then you'd better get this into your head: It's up to you to find a way to get him to like you." Bean was mad. Didn't anybody understand how misunderstood he was? And all this from Pete, who was supposed to be his friend! It took time, but slowly Bean began to realize his commander knew things about life that he just never understood clearly.

So did Dick Gordon. One afternoon Bean was talking with Gordon about a briefing they'd had that morning from a specialist. Bean didn't like the expert's ideas, and even more, the way he presented them. "He doesn't fit in with our way of thinking," Bean said. "He's on our team, but he's not a very good team member." Gordon responded, "Well, Al, it seems to me that you're the guy that's not being a good team member." Gordon continued, "There's one characteristic a good team

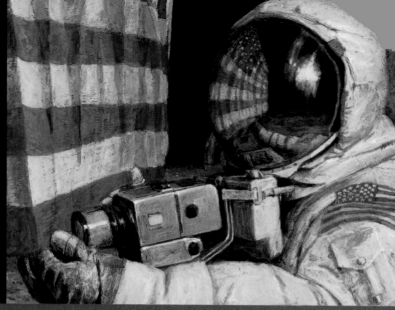

member must have above all others. And that's the ability to find a way to admire and care about and appreciate the other team members. Be glad they're different from you. Because 400,000 Al Beans could never get us to the moon, and neither could that many Dick Gordons. But 400,000 different, dedicated people have a chance of doing it."

For a few hours or days after one of these "mentoring sessions" with Pete or Dick, Bean would walk around wishing he knew about some other space program he could join. But as time went on, he realized that his crewmates really cared, and were going well out of their way to help him see more clearly. NASA was teaching him how to go to the moon; Conrad and Gordon were teaching him how to be a better human being and a good astronaut.

By the fall of 1968, Apollo was moving ahead with a speed that astonished Bean. Every day, another piece of the huge program fell into place. In October the first manned Apollo flight, Apollo 7, was a great success. In December, in one of NASA's boldest decisions, Apollo 8's Frank Borman, Jim Lovell, and Bill Anders rode the Saturn V out of Earth orbit and onto a course for the moon. They arrived on Christmas Eve and circled the moon for twenty hours. Bean was in mission control when Borman's crew sent back TV pictures of the most desolate landscape anyone could have imagined, and then capped the transmission with a surprise reading from the book of Genesis. Bean left mission control still in a state of awe, and looked up to see a crescent moon overhead. He knew the three astronauts who were orbiting that bright world. And when they returned to earth three days later, NASA was a giant step closer to putting the first men on the moon.

Pete Conrad, Dick Gordon, and Alan Bean were nearing the end of their tour as backup crew for Jim McDivitt's Apollo 9 mission. After McDivitt's crew successfully tested the lunar module in earth orbit, Conrad, Gordon, and Bean got the assignment they'd been hoping for: they were the prime crew of Apollo 12. This was the home stretch in the race to meet John Kennedy's challenge for a lunar landing by the end of the decade. Apollo 10 would take the command module and lunar module into lunar orbit for a dress rehearsal in May. Then, in July, Neil Armstrong and Buzz Aldrin on Apollo 11 would attempt the landing. Conrad and Bean were among the estimated 600 million people watching and listening as Armstrong and Aldrin left their footprints on the Sea of Tranquillity. Conrad and Bean could claim a special interest in the event: they were next.

Bean felt no great disappointment in not being first to land on the moon. He was happy to be on any mission. To be on a lunar crew was as much as Bean could have asked for; to be going to the moon with Pete Conrad and Dick Gordon was almost too good to be true. They were the first all-Navy Apollo crew, and they had a spirit unmatched by any other space trio. At the Cape they even drove matching Corvettes, thanks to General Motors, and they had the cars customized by Jim Rathmann, a friend of Pete's who owned a local Chevrolet dealership, with nameplates reading "CDR" (commander), "CMP" (command module pilot), and "LMP" (lunar module pilot). They trained together and had fun together, and they knew they were the best team of astronauts NASA would ever send to the moon.

Still, in the fall of 1969 it was hard for Bean to convince himself he really was going to the moon. It seemed unreal, even as he and Conrad were flying simulated lunar landings, and going over the flight plan, and checking on the health of their spacecraft. Not until the morning of November 14, as he was lying on his back inside the command module *Yankee Clipper*, with fifteen minutes to go before launch, did the truth sink in. Everything he had worked toward for six long years at NASA was about to come true. With just sixty seconds to go, Pete Conrad put out his gloved hand, and Gordon and Bean clasped it for a moment. And then, Bean was aware of a rumbling far below as the Saturn's engines ignited, and his career as a space traveler began. He would never forget what Pete and Dick had done to help him get to the moon, even as he took his first steps on the Ocean of Storms.

ON THE RIM

Apollo 16 Astronauts John Young and Charlie Duke have just arrived on the rim of North Ray crater. John reported, "As we climbed the rim to North Ray it was really a steep slope going right up to the edge of the rim. Of course, the old Rover didn't notice it—just went right up." Charlie continued, "The slope must be on the order of 20 degrees—you don't realize it 'til you get off and turn around." As they looked around they could see that the rim was populated with rocks of all sizes and shapes. These rocks had been thrown up and out when a large meteorite impacted the moon's surface over three billion years ago. The resulting hole is North Ray crater.

I painted John on the left selecting tools for the traverse while Charlie is removing the Hasselblad camera with the 500mm telephoto lens from beneath the seat. Charlie would later report, "We did take 500mm photos of the interior of the crater. I couldn't see the bottom and I wasn't going to get close enough to see in because there was no way I could have gotten out if I had fallen in."

North Ray was the largest crater, 300 feet in diameter, and possibly the deepest crater, directly explored in the Apollo Program.

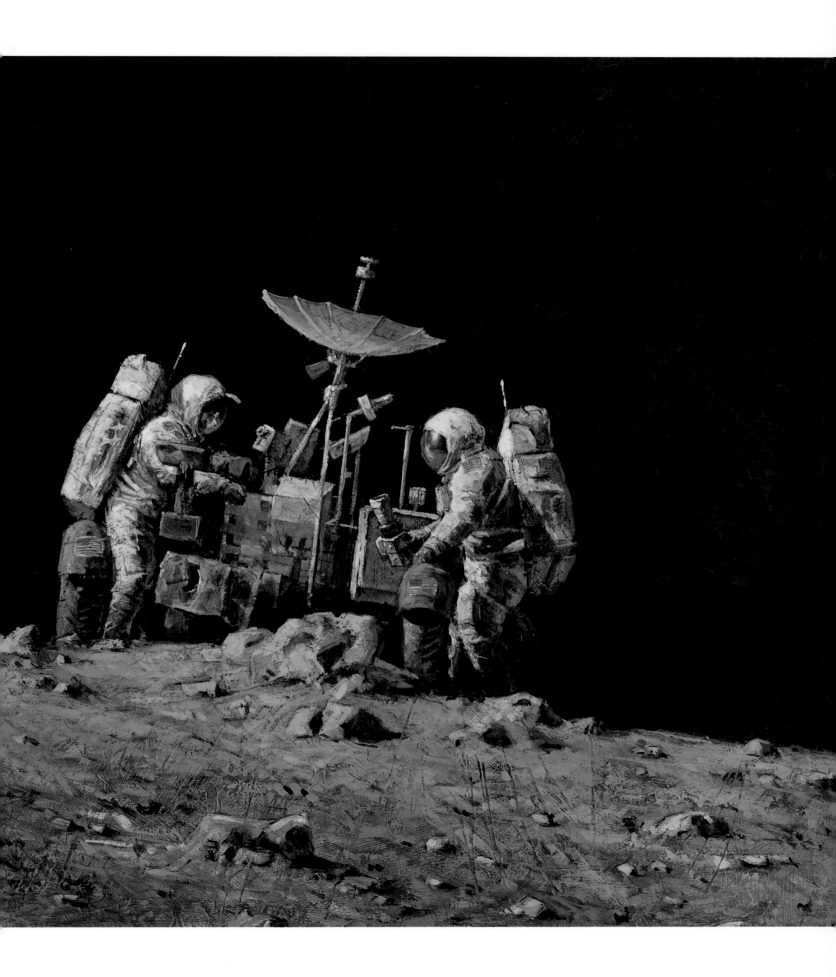

LOCKING UP THE ROCKS

We knew even before Apollo 11 blasted off that the single most important thing Neil Armstrong and Buzz Aldrin could do would be to bring back pieces of the moon. These samples would be loaded into two return containers, each formed from a single piece of aluminum. A ring of soft metal called indium lined the lip of each box, while around the edge of the lid was a knife-like strip. I painted Neil just as he activated one of the four locking levers which causes the knife edge to bite deeply into the indium, thus sealing the rocks in the moon's vacuum for their quarter million-mile trip to earth. I thought about painting this for a long time, but put it off again and again. I concentrated instead on painting astronauts working in the intense lunar sunshine because I enjoy the bright white sun-struck space suit. This painting would be different because Neil would be in the shadow of the lunar module. All Apollo landings were made with the sun to the rear of the lunar module so that the craters and boulders would be most visible during the landing descent. After landing, the area in front of the lunar module is then in total shadow, and this is where Neil stood to fill, close, and lock the rock sample box.

To my delight, this total shadow effect worked beautifully, with Neil somewhat dark and colorful in shadow, and the Sea of Tranquillity a bright counterpoint.

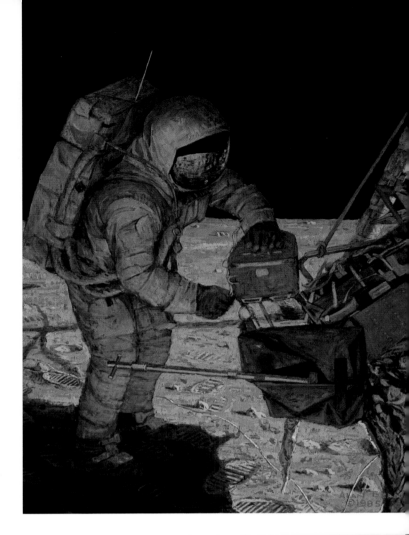

HARD DRIVING

Apollo 11 Astronaut Buzz Aldrin is driving a core tube into the moon's surface. He is finding it more difficult than he anticipated, much harder than driving into the dirt or sand he used in training here on earth.

The whole idea of a core tube is to quickly obtain a continuous sample of surface and subsurface soil. The core tube itself is a hollow metal pipe a foot long with a sharp edged bit on the leading edge. It is then attached to a tool extension handle so that it can be driven into the surface from a standing position.

Well, the core tube is not going into the moon as expected. Buzz would comment, "I pushed in 3 or 4 inches and then started tapping it with the hammer. I found that it wasn't doing much at all in the way of penetrating further. I started beating it harder and harder and I managed to get it into the ground maybe 2 inches. I was hammering it in about as hard as I felt I could safely do it. Well, it just wouldn't go in any farther." Buzz continued, "I didn't find any resistance at all in retracting the core tube. It came up quite easily. I didn't find any tendency at all for the material to come out."

Later, on earth, scientists would say that the soil was fine grained, granular, slightly cohesive, and incompressible. The samples show no fossil life, no living organisms, and no organic materials. More importantly, they would conclude that moon dust holds no threat to life on earth.

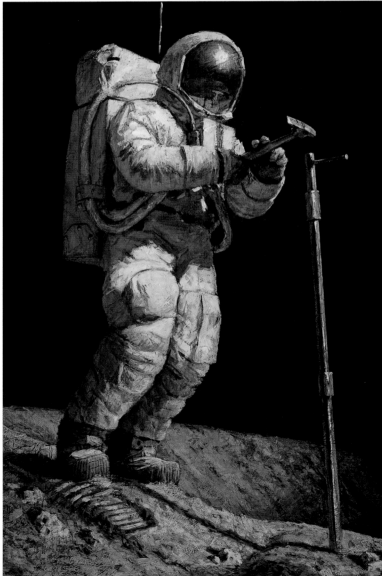

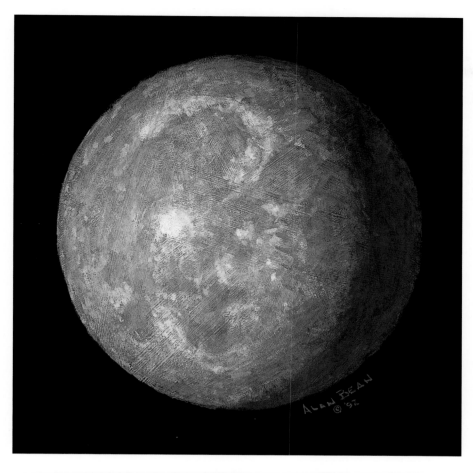

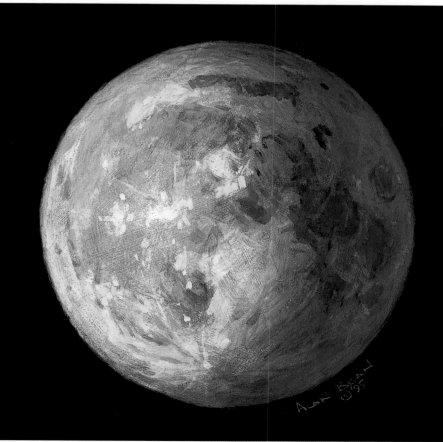

MONET'S MOON AND BLUE MOON

I began these studies a number of years ago to record some of my memories of seeing the moon close up. My first study showed how Pete Conrad, Dick Gordon, and I saw the moon an hour or so after we thrusted out of lunar orbit heading for home. The moon appeared exactly as if we were looking at a large black-and-white photograph because of the strong direct back scatter of sunlight by the lunar dirt. I could not recognize the moon as a sphere, only as a flat disc. The study was technically accurate but to me an unartistic black-and-white painting. I set it aside.

My first try at this second study was an unsuccessful attempt to show the pronounced blue of the reflected earth light as it strikes the shadow area of the moon. It was an unartistic, blue-gray, black-and-white painting. I set it aside. I did several others with similiar results.

Years later I decided to rework two of these studies as color exercises. The first was painted with my favorite artist in mind. I studied a print of one of Monet's Rouen Cathedral series created in reds, violets, and blues. I then re-painted the moon with Monet's colors, this time without regard to mountains or craters. For this second study, now titled Blue Moon, I tried to retain some of the reflected-earth light-shadow effect while adding other earth colors.

I satisfied my curiosity with these studies. I'll leave the job of creating a body of full-disc moon paintings to future artists. I'm spending most of my time recording an event that will never happen again in our history, humankind's first visit to another world.

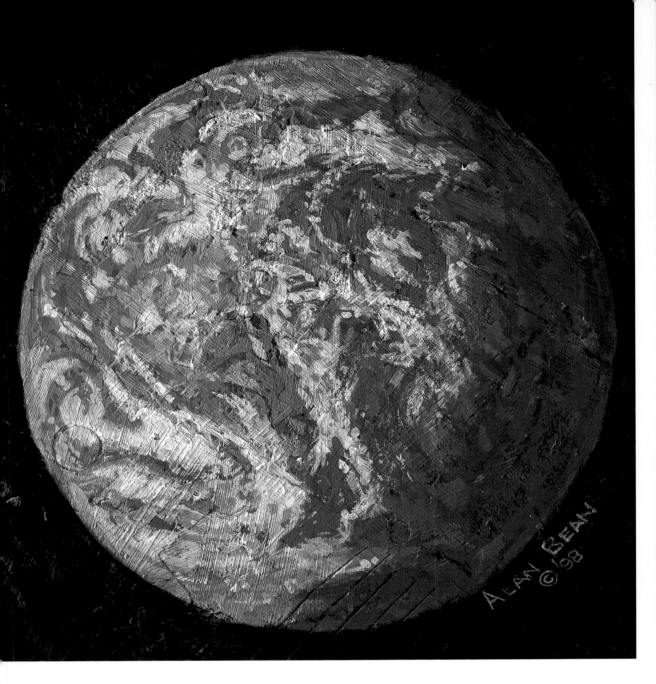

IMPRESSIONISTIC EARTH

Most astronauts would agree that the most beautiful view from space is the earth itself. From any distance, it's a wonderfully bright blue-and-white ball. From the moon, earth reminded me of the larger marbles I played with as a kid, or a very small Christmas tree ornament.

Where the sunlight strikes the planet, there are mostly blue oceans and white clouds. Familiar land forms are difficult to see even from a quarter of the way to the moon. The same blue scattering effect we see looking up from the earth into the sky, astronauts see as they look back through our atmosphere to earth, so the earth has a blue cast. The color of the deserts cuts through the blue, but a place like Florida, which is green, looks blue-green and nearly fades into the ocean. In this painting, you can easily make out Australia since there are large areas of brown deserts, and, (less easily) the Philippines, which are green and more cloud-covered.

When I left the space program I thought that I would paint Apollo, Gemini, and Mercury astronauts, spaceships, and so forth, and that I could just jump from one subject to the other. I quickly discovered why artists don't do that. It is difficult and time consuming to learn what must be well understood in order to paint a specific subject. This is why we can identify many artists by their color schemes and favorite motifs. I admire Claude Monet because he learned to paint a great number of things well. He was able to create a beautiful new way to paint a new motif, and that is what I am trying to do in this painting. I have used more colors in the earth and clouds, and worked with more impressionist brush strokes. I call this a "quality control" painting because although it's not quite finished, it represents the best I can do in this motif at the moment. I hope before long I can take what I painted here, and improve on it.

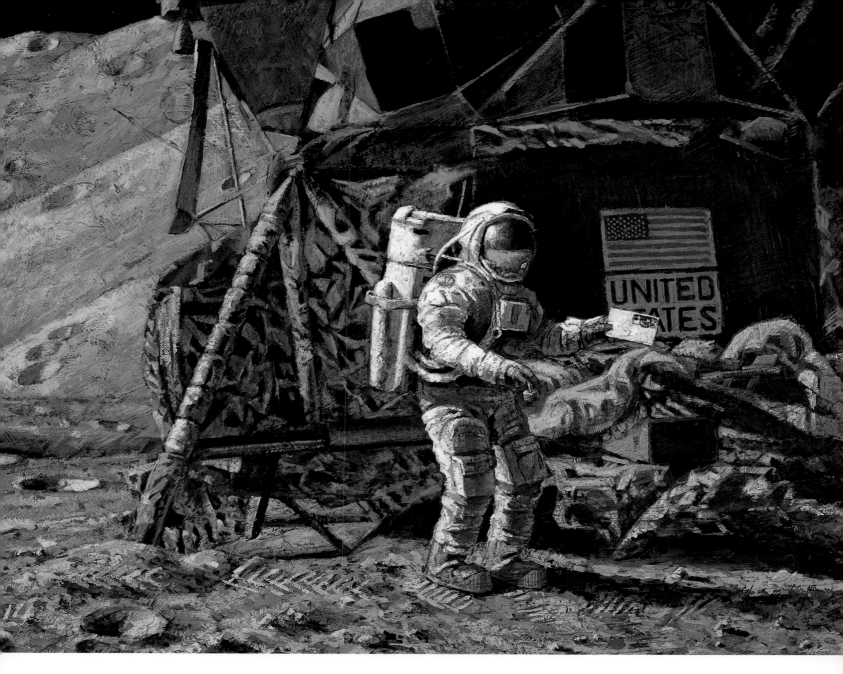

LUNAR POSTMAN

Near the end of his third moonwalk, Apollo 15 Commander Dave Scott was completing his final tasks at the lunar module's Modular Equipment Storage Assembly. Dave picked up a small pouch and placed it on the worktable. Inside were: a single envelope franked with a hand-perforated, die-proof pair of the new 8-cent postage stamps specifically designed for this historic occasion; a stamp pad; and two different rubber handstamps. Two handstamps were provided, as the exact date of the cancellation could not be set pre-flight: it would only take place when Dave had completed his scheduled tasks.

Dave began the ceremony. "Just to show that a good Postal Service takes care of the mail just about any place in the universe, I have the pleasant task of cancelling here on the moon the first stamp of a new issue to commemorate United States' achievements in space. I'm sure a lot of people have seen pictures of the stamp. The first one is here on an envelope. At the bottom is printed, 'United States In Space . . . a Decade of Achievement.' I'm very happy to play postman." Dave continued, "I'll pull out a cancellation device and . . . cancel this stamp. It is August the second, 1971, first day of issue. Where can be a better place to cancel a stamp than right here, at Hadley Rille?"

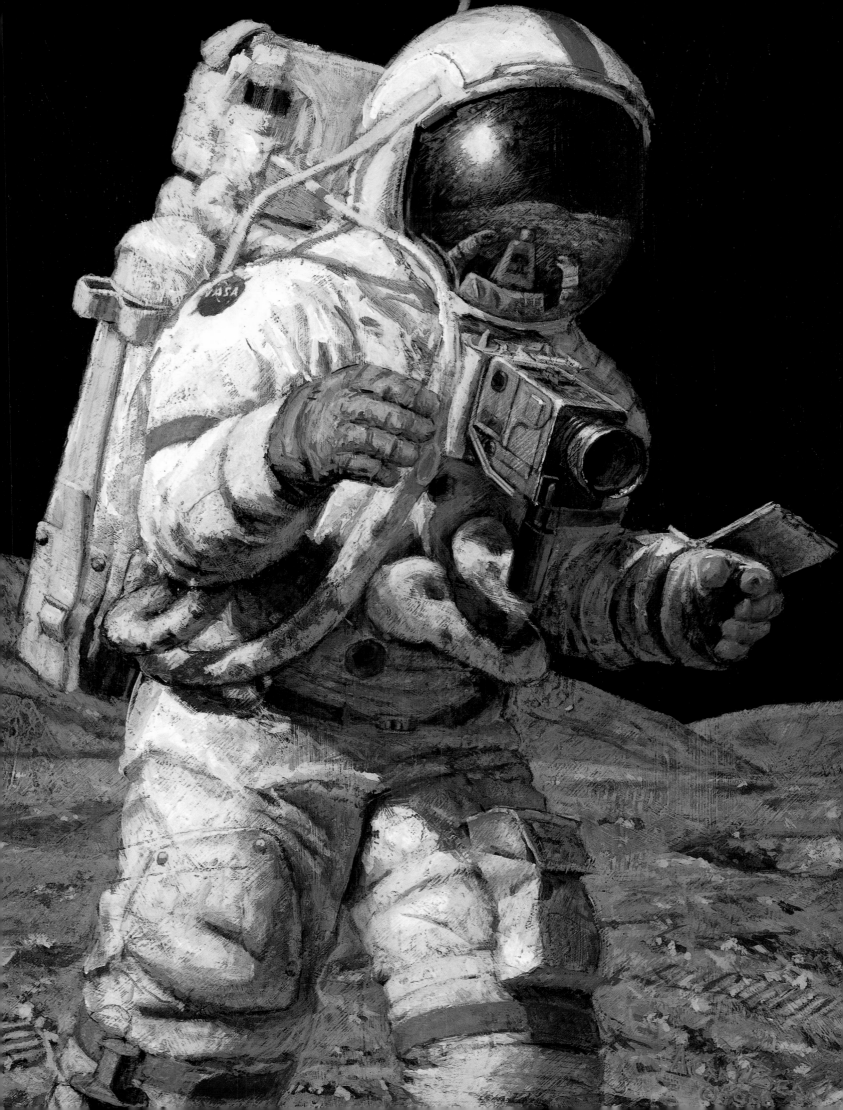

A DELICATE BALANCE

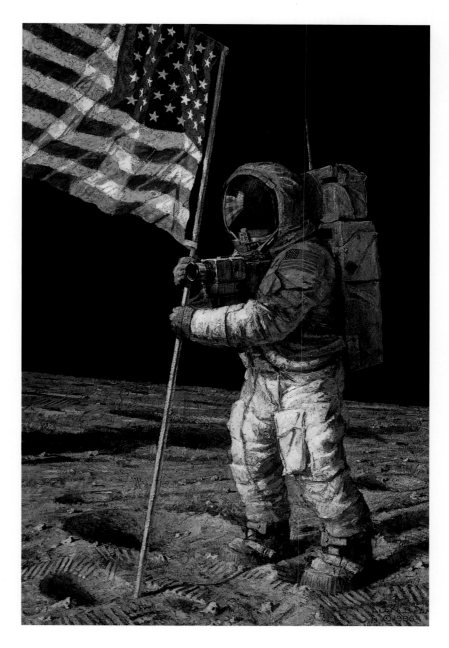

Apollo 11 Astronaut Neil Armstrong is trying to prevent the American flag from falling over into the lunar dust while most of the people on earth are watching him on television. It just isn't as easy as it was in practice just a few days ago.

His biggest frustration is that he cannot shove the flagstaff as deep into the soil as he would like to. "Six to eight inches was about as far as I could get it in," Neil commented later. Adding to this difficulty was his discovery that although the soil is hard to penetrate straight down, it can be shoved sideways rather easily. "The soil would not hold the flagstaff firmly in position and it took only a light push to tip it over." Unfortunately, the flagstaff was basically unbalanced because of the telescoping metal rod that stuck straight out from the top. This was a kind of curtain rod to support the flag, since there is no wind on the moon to blow the flag out.

Neil finally found a solution. "I pushed the flagstaff into the ground at a slight angle such that the center of gravity of the overall unit would be above the point at which the flagstaff was inserted in the lunar surface. That seemed to hold all right." It sure looked "all right" to all us watching in wonder in front of our television sets, Sunday night, July 20, 1969.

ON THE TIMELINE

[L E F T]

Astronaut John Young is moving fast in his bulky space suit. A glance at the checklist on his left wrist shows he is on time for starting his next task. This is great news because every minute on the lunar surface is rare and precious and he dearly wants to make each one count. But this is not easy because the array of tasks to be accomplished is unique to each mission. When training begins no one knows the best way to put all the tasks together so they can be achieved in the time available. The best work sequence can only be discovered by an iterative process.

The first step is to call a meeting for all interested parties (that's a whole lot of people), and together construct the "best guess" timeline. Next, we astronauts get into our suits and, using flight-like training equipment, follow the proposed timeline. We try to make it work. It never does. But afterward everyone is much smarter, and ready with improved ideas for the next simulation. And so it goes until everyone is satisfied that the timeline is the best task mix and sequence.

I talked with John Young about this painting and his feelings about the importance of staying on the timeline. He laughed, "Neil Armstrong's first thoughts might have been 'This is one small step for a man but a giant leap for mankind,' but I remember vividly that after climbing down the ladder and stepping on the lunar surface my first thought was 'We're 20 minutes behind now and we've got to catch up'."

[73]

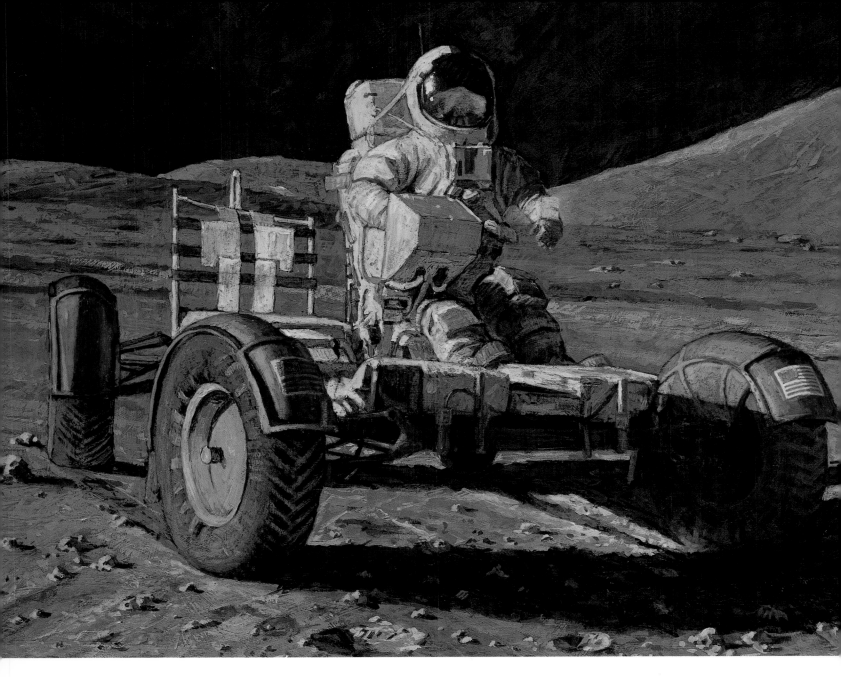

TEST DRIVE

Apollo 17 Astronaut Eugene Cernan is taking his brand new Lunar Rover for a quick test drive. He and Jack Schmitt have just lowered the Rover from its berth on the side of the lunar module where it was stowed, folded up.

The Rover looks a little different than a conventional automobile, but for a good reason. It's powered by batteries driving small electric motors on each wheel. An automobile engine wouldn't run up here because there is no air to mix with the gas. There is no steering wheel or accelerator or brake pedal either as they would be too tiring to work in the rigid space suit. All these control features are provided by a small control stick mounted between the seats. Gene has only to push the stick forward to go forward, push it to the right to go right, and so forth.

The Rover looks very sporty right now because most of its equipment has not yet been mounted. In a few minutes Gene and Jack will install the television camera and antenna on the front; the tool pallet and tools on the rear, and then all the rest of the gear that make the Rover a super work vehicle.

Gene is probably praying the Rover performs as expected because he and Jack need to travel their planned exploration routes over the next three days. On their longest excursion they will travel a total of 12 miles. The Rover comes with a written, one hundred-percent lifetime warranty. However, the vehicle must be returned to the original dealer, 239,000 miles away, to get anything fixed.

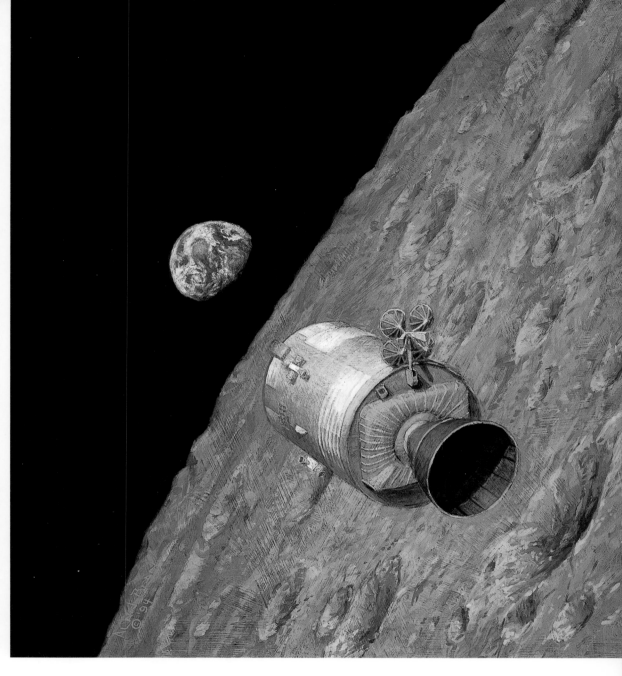

HOMEWARD BOUND

It is Christmas morning, 1968, and Frank Borman, Jim Lovell, and Bill Anders have been silently swinging around the moon for 20 hours. They are the first human beings to leave the gravitational influence of the earth and to see the moon close up, but it is time to burn the service module engine and kick the spacecraft out of lunar orbit to begin a 57-hour coasting voyage home.

Because of the laws of orbital mechanics, this trans-earth injection burn had to be performed on the side of the moon opposite the earth, thus out of communication with all of us here on earth. We would not know of their success or failure until they came into view of NASA's big antennas.

As an astronaut I was all too aware that this was only the second flight of a brand-new spacecraft, and its systems had to perform perfectly. There was no backup for the main rocket engine. If it did not work right, Frank, Jim, and Bill could remain in lunar orbit forever.

I painted the Apollo 8 spaceship as it emerges from behind the moon for the last time, following a successful burn, with the welcome voice of Jim Lovell announcing "Please be informed, there is a Santa Claus."

Bill Anders would comment during their last telecast as they hurried toward their rendezvous with earth, "I think I must have the feeling that the travelers in the old sailing ships used to have going on a very long voyage away from home and now we're headed back. I have a feeling of being proud of the trip but still happy to be going back home."

COSMIC JOURNEY

To go on a cosmic journey, one must leave the planet earth far behind, an idea more than a little frightening. But on the journey, one will be treated to an incomparable sight, the earth in its totality. It will not be possible to recognize the continents as we have learned them from geography books. North and South America, Asia, Australia, do not present their familiar contours because cloud patterns cover much of the Earth at any given time. Even where there are no clouds, land covered with green foliage, when viewed through our blue atmosphere, is not easily distinguished from the blue of the oceans. The only change to the delicate blue-and-white pattern is an occasional small yellow orange shape, a desert . . . but which one, the Sahara in Africa, the Gobi in Asia, or the great sandy desert in Australia? It is almost impossible to tell.

Apollo 17 Astronaut Jack Schmitt is taking a few photographs on a short cosmic journey. He is an astronaut—part explorer, part scientist and, however briefly, a wide-eyed tourist. As Jack would later say, "The scene is one of desert-like beauty . . . a land of extreme contrasts. A brilliant sun in a blacker-than-black sky. . . . Maybe most stimulating at that moment was being able to look up and see my home, the planet earth, hanging above the moon's mountains as a beautiful blue-and-white marble with desert areas just standing out like beacons. Seeing that scene for the first time, the act of being there, made it one of life's meaningful experiences."

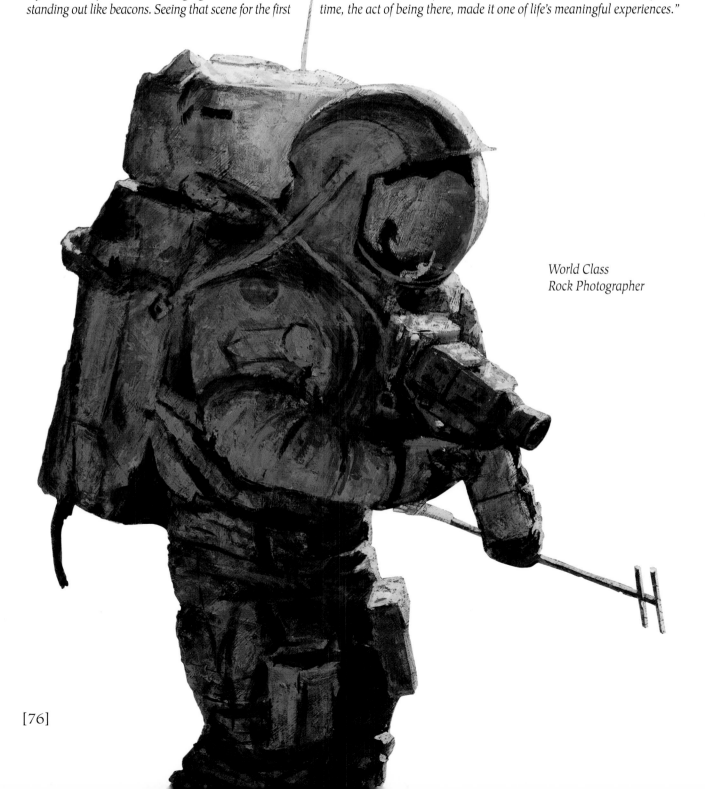

*World Class
Rock Photographer*

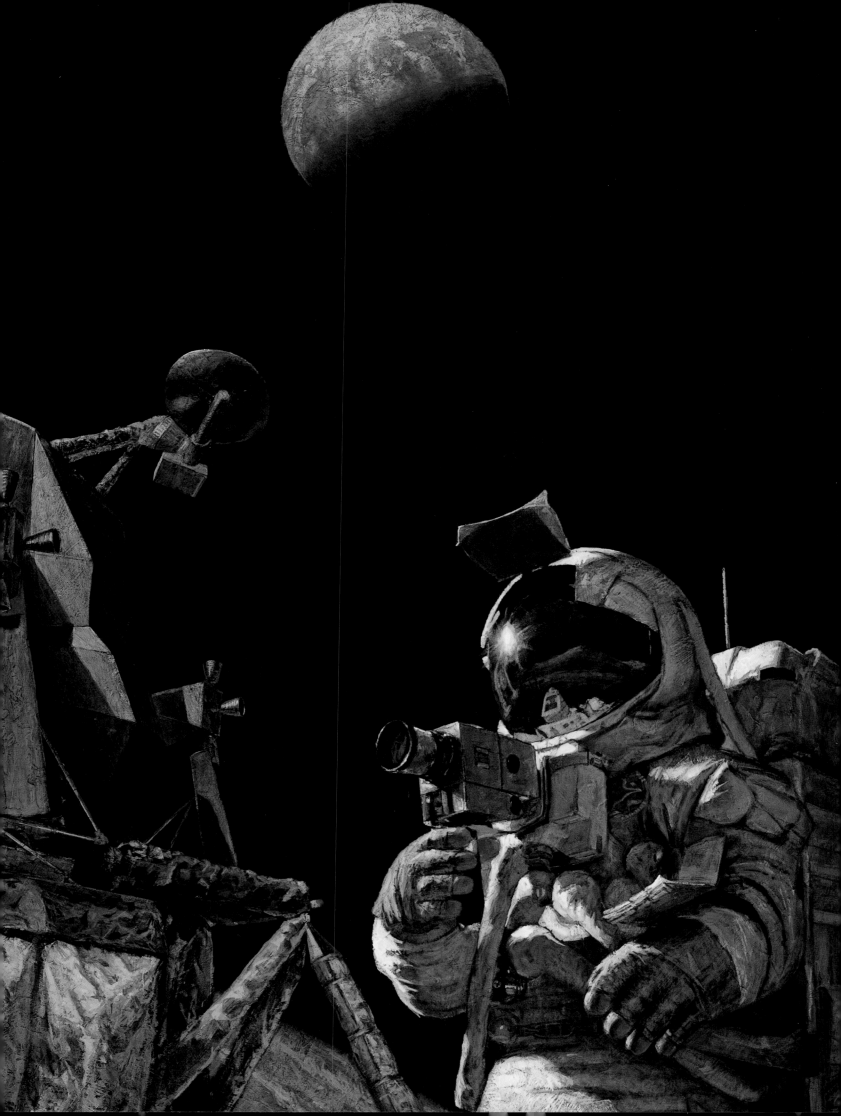

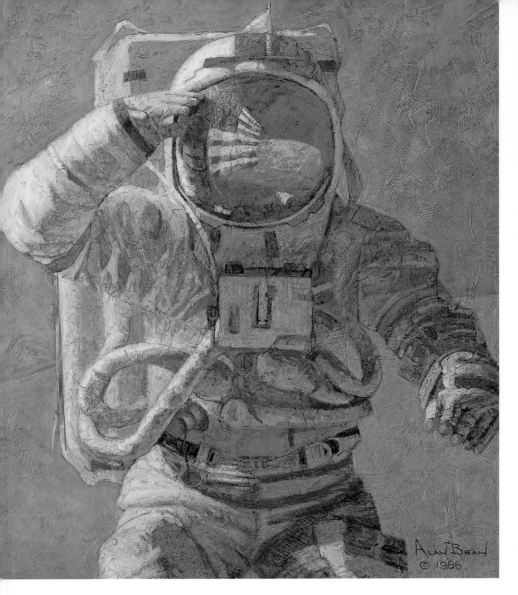

OUR OWN PERSONAL SPACESHIPS

Every human who walked on the moon did so in his own personal spaceship. We called them space suits and they performed brilliantly on all six lunar landings. I painted John Young all bundled up in his. John commented, "I can't speak too highly for the pressure suit. Boy, that thing really takes a beating."

The suit is airtight but it would be limp and useless without the connecting hoses reaching around from the back-pack we called the PLSS, the Portable Life Support System. Through one hose flows fresh life-sustaining oxygen while another removes the used atmosphere and maintains the suit pressure just above 3.5 pounds per square inch. Another hose circulates water through small tubes in John's underwear to carry away excess body heat. Radio communication is provided by another.

Many of the more important functions are monitored and controlled by the RCU, the Remote Control Unit resting squarely on the chest. Finally, a special hose is connected to the suit to give auxiliary oxygen flow in the event the primary oxygen supply were to fail or the suit were punctured and began to leak.

John later observed, "Since it's the only thing between you and that vacuum in plus or minus 250 degrees, it's a good piece of gear."

Our space suits were an incredible American technical achievement. They had to reliably provide all the functions of any spaceship with one small exception—they contained no rocket engine so we had to utilize our own two legs for propulsion.

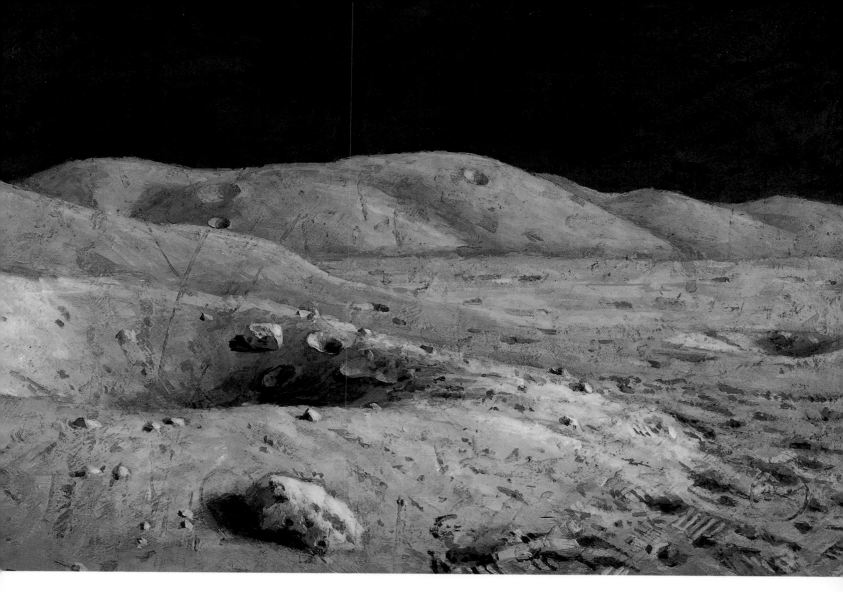

PORTRAIT OF A CRATER

The first time I saw it on television, this crater, and the undulating surface that surrounds it, attracted me. It represented perfectly the surface of the moon as I remembered it at its most typical and interesting: the rounded lip of the crater, the rolling lunar surface, nothing flat or horizontal, and the scattering of rocks mostly ejected from the surrounding craters. To me, it was a strangely beautiful and other-worldly visual experience.

This is Ballet Crater, about 30 meters in diameter, named by the Apollo 17 astronauts whose footprints we can still see. In fact, these foot-prints made by Gene Cernan and Jack Schmitt will remain essentially unchanged for the next 40 million years.

Ballet Crater is in the Taurus-Littrow Valley of the moon. As an astro-naut, I would observe that the rocks and surface material were dense fine-grained basalts ranging between a light and a dark gray, but as an artist I created a painting that is slightly warm green in the sun with cool, colorful, violet shadows.

THE PERSONAL TOUCH

(TOP LEFT) *I loved everything about being a naval aviator. The sights, sounds, and smells around high performance flying machines just felt right to me. I enjoyed being catapulted off of, and then landing on, aircraft carriers, formation flying, bombing, gunnery, all of it.*

I knew I had the best job in the world. That is, until I turned on the TV one day in the ready room after a test flight, and discovered that Astronaut John Glenn had orbited once around the Earth, 25,000 miles or so at 100 miles altitude, while in the same 90 minutes, I had gone maybe 600 miles, only 5 miles above earth. That was a life-changing experience for me. ∎

(TOP RIGHT) *My mother was by far the most influential person in my life. She died in 1981, and I think of her often. Growing up, I thought she was way too strict, much more so than any of my friends' mothers. It was only after having my own children, Clay and Amy, that I understood the depth of love it takes to be focused on, and raise, a child.*

Growing up, I always had chores to do. I kept my room straight, cooked my own breakfast (because I was up before anybody else in the family), washed the woodwork, dusted, and mopped. Mother taught me how to iron and mend my clothes, and a hundred other things most boys did not have to do. And I had to do them "right" or do them until they were right.

Thank God for my mother. Without her coaching and caring, I would never have had the wonderful life I enjoy now. One of the nicest things about being an astronaut is the wonderful effect it has on your parents. It validates them as good parents, and don't we all want that? ∎

(BOTTOM LEFT) *The Bean family, clockwise from left, Puff Wuff, Leslie, Fudgie, C.B. Wigglesworth, Doodlebug, me, Bunny Bunbumpers, J. Peeper Munchkin, Molly McMouse, and Fuzzerbear. All eight little girls are my companions while I paint. They scratch me on the back of my leg to remind me it's time for a cookie break. When Leslie arrives home from work at M.D. Anderson Cancer Center they tell me it's time to put my brushes away so we can all go to the back door to greet her.* ∎

(BOTTOM RIGHT, P. 80) *These are some of my Paschal High School friends in Fort Worth, Texas: Mickey Rose, Bill McMillan and Mel Haas. I think that people are often attracted to others that look like they do. Just take a look at the ears on these guys.* ■

(TOP LEFT) *This is a photograph of the Arnold and Frances Bean Family, complete with Alan and Paula. I am struck now by how serious our family looks. I wonder how they saw the world just after the Great Depression, as young parents way down in Texas, far from their parents in Michigan. Today, Americans are blessed to live in a golden age. Our chances to live the life of our dreams has never been greater in all of human history.* ■

(TOP RIGHT) *It was while working to become a competent athlete at the University of Texas, that I was introduced to the most just law of life. That law, stated simply, is: "If a person will give their best efforts every day, planning and working towards their dreams, in a surprisingly short time, they will notice that they have actually moved in the right direction and they will feel that*

they are not exactly the person they were at the outset but a different person, more like the one they need to be and want to be to accomplish their dreams." My personal understanding of the potential of this law was a life-changing, life-enhancing revelation for me. I could become a different person with more positive attitudes and with improved skills from the person I was at the outset if I was willing to pay the price. This law might even allow a person who was not born great, who had never done anything great, to do something great in the future if they were willing to work toward that future. Understanding and practicing this law has made all the difference in my life and I use it every single day. ■

(BOTTOM) *During the Apollo years, General Motors treated us like their senior executives. We received the use of two new cars of our choice each year. Most of us selected a Corvette and a family car.*

When you are training to fly to the moon, every day is like your birthday and Christmas all rolled into one. It probably looks that way on our faces in this photo. ■

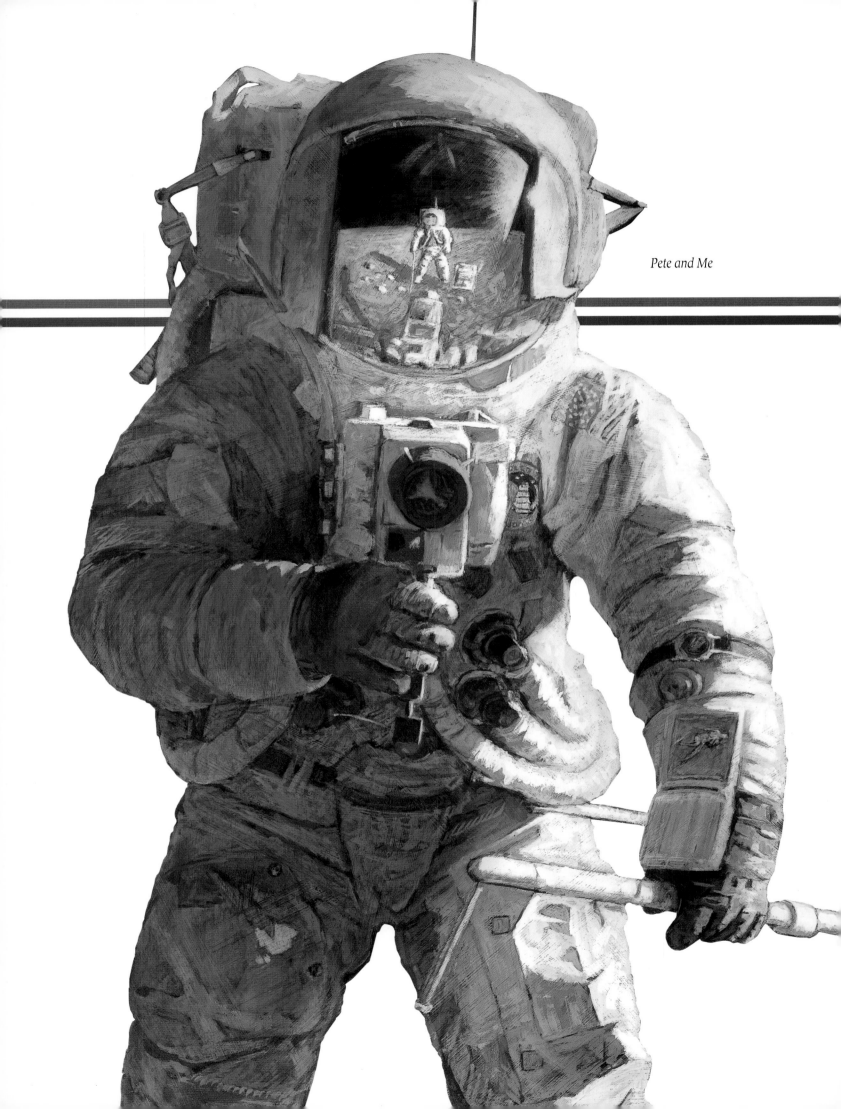

Pete and Me

· III ·
FAST TIMES ON THE OCEAN OF STORMS

The earth was like a radiant blue-and-white gemstone,
suspended in the blackness overhead. For Bean, seeing his home
world, tiny and beautiful, brought home the incredible reality
of what was happening. He said to himself, "This is the moon.
That is the earth. I'm really here."

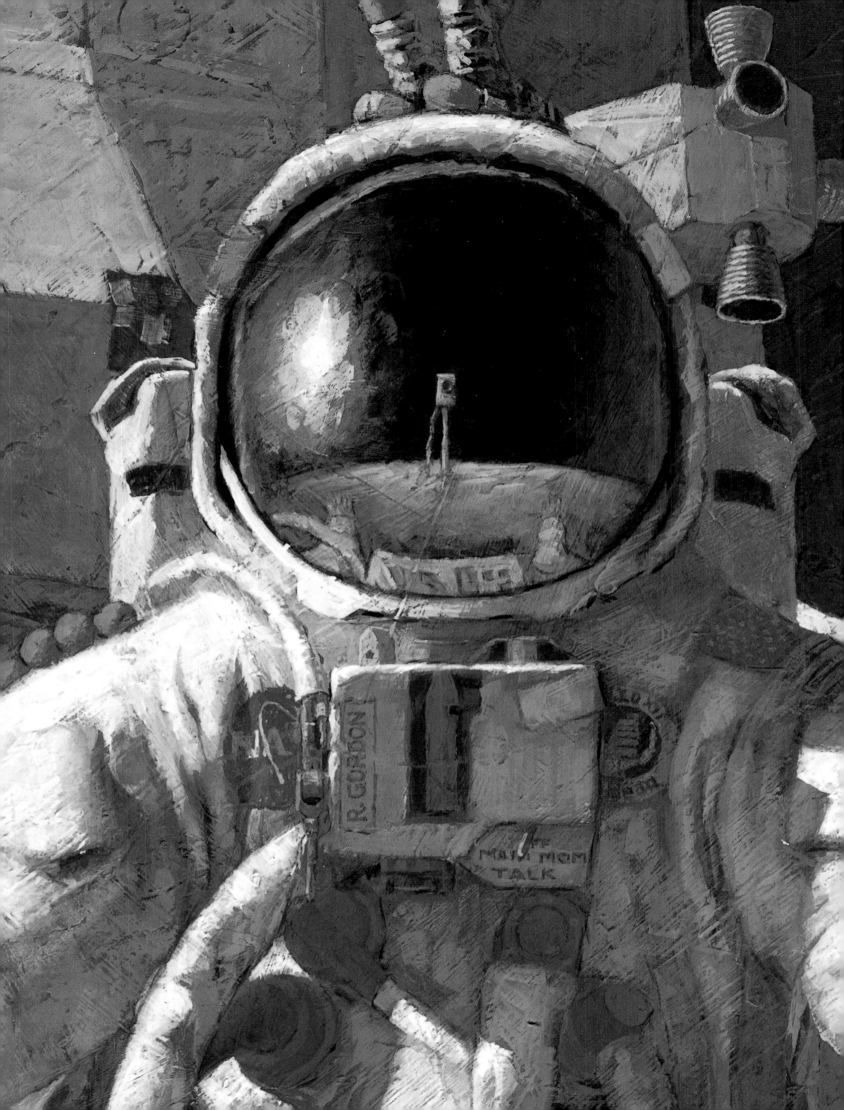

·III·
FAST TIMES ON THE OCEAN OF STORMS

The loud rush of oxygen filling *Intrepid*'s cabin penetrated Alan Bean's helmet. Once more he and Pete Conrad stood side by side in the tiny enclosure, but now their once-pristine space suits were blackened with lunar dust. As soon as they took off their helmets they were hit with a pungent odor that reminded them of spent gunpowder; in reality, it was the smell of moon dust. When Bean turned to look out on the bright, cratered ground of the Ocean of Storms, he saw something that hadn't been there a few hours earlier: their footprints. He and Conrad had done it. They'd spent more than 3 hours setting up scientific experiments, planting the American flag, collecting rock samples, and taking pictures. And everything had turned out beautifully—well, almost everything.

"Hey, Al Bean," Conrad said, "that was a hell of a show. Too bad the TV didn't work."

It was Bean's sole disappointment from this incredible day. Just minutes after setting foot on the moon, he pointed the television camera toward the sun while carrying it to a new location. Soon, instead of color pictures of the moonwalk, Houston saw only a meaningless jumble of light and dark. Nothing Bean tried—changing the lens setting, wiggling the wire in the back, even rapping the camera with his geology hammer—made any difference. Now that he was back inside, Bean wondered what had gone wrong.

Still, so much had gone right. They'd accomplished all the tasks on their checklists, and what's more, they'd had fun doing them. On this small world the pull of gravity was gentle; everything weighed only one-sixth of what it did on earth. In practice sessions at Cape Kennedy, Bean in his lunar space suit with its massive backpack had tipped the scales at about 300 pounds, but on the moon they weighed only 50 pounds. Tasks that had required great exertion in training were almost easy. Bean felt as if he'd suddenly become stronger. Every now and then, as he went about his work, he threw an unneeded piece of gear and watched it sail impossibly high into the black sky. It was fun enough when he threw something compact, like a rock, but even more when it was a large piece of foil. On earth, it would've flut-

tered to the ground a short distance away because of air resistance. On the moon, it seemed to surpass the greatest punt ever made in football. Someday, Bean would later muse, there will be Olympics on the moon—imagine the javelin throw, the high jump, and the pole vault!

When Bean stole a moment to look around, he saw a bright wilderness—nothing but craters and rocks, and that ancient dust, like powdered cement, everywhere he walked—and yet, despite its starkness, it was somehow beautiful. He'd been told that his footprints—as crisp as if they'd been chiseled in stone—could last for forty million years or more. That was as close as anyone might get to immortality. For the rest of his life, Bean would search for the right words and images to describe what he had just experienced. It was as if everything he'd done on earth was on one plane of existence, and the moonwalk was on another.

And his lunar adventure was far from over; in a few hours, after a sleep period, he and Conrad would go outside again. They would become the first people to take two moonwalks, and this time, they would visit Surveyor 3. For now, Bean ate dinner, and scored a first of his own. During training, he'd amazed his crewmates with his eating habits, which included spaghetti dinners almost every night of the week. Now, on the moon, Bean indulged his obsession with a freeze-dried packet that he reconstituted with an onboard water gun. Whatever else he accomplished on Apollo 12, he would always be proud of his status as the first person to eat spaghetti on the moon.

By now Conrad and Bean had been awake for more than 20 hours and it was time to get some sleep, so they rigged Beta-cloth hammocks across the cabin. In the light gravity their bodies barely sagged the fabric, making the hammocks more comfortable than they would have been on earth. But Bean found that sleeping on the moon did not come easily. He was too excited to sleep. His mind was too active. He thought ahead to the upcoming moonwalk, and wondered if he and Pete would be able to reach the Surveyor safely. From the looks of it, the probe was sitting on a steep slope. Bean wondered about the TV

[85]

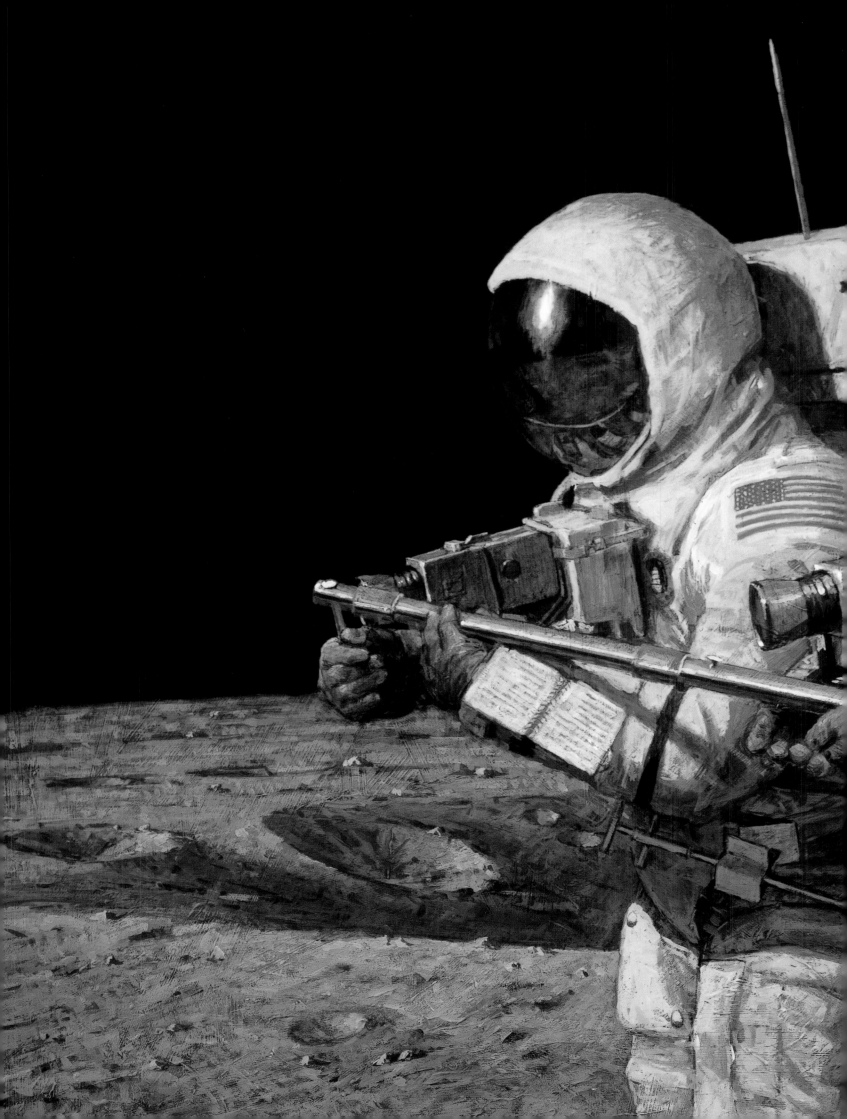

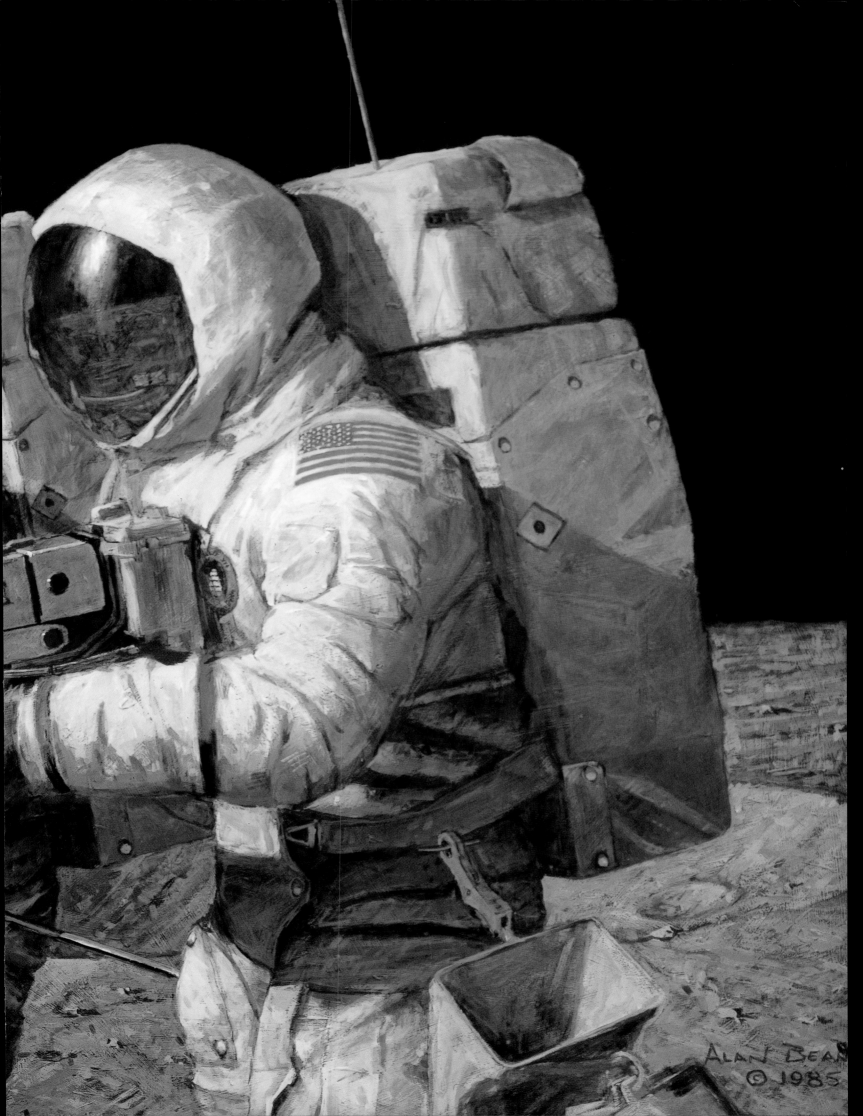

Alan Bean
© 1985

HELPING HANDS

[P R E V I O U S P A G E]

I remember during our landing at the Ocean of Storms on Apollo 12 Pete Conrad and I had hundreds of specific tasks to perform, some individually, some with each other and some with mission control on earth. We had switches to throw, voice transmissions to make and receive, computers to operate, instruments to monitor and buttons to push. It was like a concert where each musician has to play the right note at the appointed time. Sometimes it wasn't easy because of the incredible view. I found when I looked out the window and saw just where we were and what we were doing, I would become distracted and start to lose a beat or two. I had to keep telling myself to look inside and tend to business.

This painting is a favorite remembrance of Pete and me working together. I had just finished pounding a hollow core tube a foot or so down into the lunar soil with my hammer. When I pulled the core tube back out, it contained a continuous sample of surface and subsurface soil.

I painted Pete holding the tool extension handle with the full core tube attached while I unscrew the sharp-edged bit and replace it with a cap. I then removed the core tube from the tool extension and put it in the sample bag on my left hip.

When we finished the photography and voice reports associated with documenting this sample, I noticed I still had the bit in my hand so I stuck it in my pocket. I carried it back to earth where it rests on the mantel in my studio today. I use it to create interesting and totally unique texture in my paintings.

camera, and what had caused it to fail. (Only after he was back on earth would he learn that the full-strength sunlight had ruined the camera's light-sensitive element. He hadn't practiced enough the task of pointing it carefully during training.) Bean would later look back and wish he had taken a sleeping pill—but in Bean's mind, that was something astronauts just didn't do. And so now, laying in his hammock, he tried to be still. Every now and then he managed to drift off to sleep. Once during the night the whine from a fan in the lunar module's air conditioning system abruptly changed pitch and he and Conrad were immediately awakened. (There was no significant problem. Later they would find out that more water than expected had found its way into the system, causing the fan to slow down temporarily.) The knowledge of where they were—and of the risks they both were taking in being there—gave Conrad and Bean a heightened awareness of everything going on around them.

After a few hours Bean heard Pete Conrad's voice from the hammock above him. "Al, the right leg of my suit is too short, and it's killing me." Bean spent about an hour readjusting the suit, and then Conrad wasted no time getting started on the new day.

"Hello, Houston, *Intrepid*. How are you this morning?"

"Good morning, *Intrepid*," came the answer from earth. "How did you sleep?"

"Short, but sweet. We're hustling right now, and we're going to eat breakfast, have a little talk with you, and get about our business." It was classic Pete Conrad, and the unspoken message was, "We're on top of it—don't call us; we'll call you."

In Houston it was past ten o'clock in the evening, but on the Ocean of Storms it was still early morning. Bean, fully suited, was standing on the moon once more. Everything looked slightly different. For a while, he kept seeing rocks he hadn't noticed during the first moonwalk. Then he realized that the lighting had subtly changed. During the hours that he and Conrad had been eating and resting, the sun rose a few degrees higher, shifting the colors of rocks from neutral gray to a warmer tan-gray. And thankfully, this new illumination revealed that the

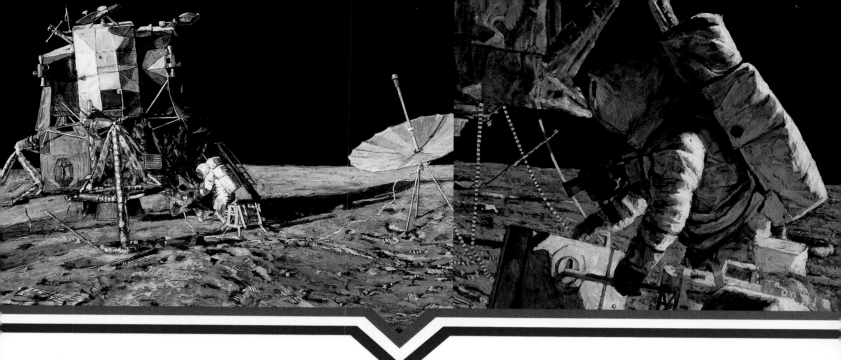

Surveyor was perched on a gentle slope; it would be easy to reach after all. First, though, the men would visit several craters to collect samples and take photographs. And they would have to do it all during a moonwalk lasting little more than three and a half hours. They would have to move quickly.

Before the flight, geologists prepared photo maps for Conrad and Bean to navigate from one crater to another. But map reading proved harder than anyone expected. From the surface, the craters didn't look the way they did in the photos which were taken from straight overhead. And in the undulating terrain, it was hard to spot landmarks unless you were right next to them. Hardest of all was judging distance. The moon had no trees or buildings, or familiar features. With no atmosphere, there wasn't any haze to hint that an object was far away. Even if they knew a crater was 150 yards away by looking at the map, they didn't know how many steps or minutes it would take to travel 150 yards on the moon. When they arrived at a crater they were never sure it was really the one on the map. Like visitors in a town with no street signs or house numbers, Conrad and Bean were rarely certain that they were exactly where they were supposed to be.

Being a lunar geologic observer wasn't that different, really, from doing things Bean already knew how to do. You had to be a careful observer, but as a pilot, Bean was already good at that. Flying jets, he'd learned to be attuned to subtle changes in the sound of an engine, or in the feel of a control stick. Now he kept his eye out for subtle differences in the shapes and colors of the rocks, and the textures of the soil. Even as he ran along, he scanned the ground, looking for the interesting or the unusual. All the rocks were covered with dust which made it hard to tell what they really looked like. Still, for the first two people to visit the Ocean of Storms, everything was a discovery. And even Pete Conrad, who had never been particularly turned on by geology, was excited by what they found.

"Gee, what a crater! Oh, boy! Hey, Al, come on over here!"

Standing at the edge of one crater—a deep pit as big as a football field—they saw boulders whose tops looked as if they'd been melted. Another crater looked so new that the men could still see debris from the blast that had formed it—but on the moon, "new" probably meant a few million years ago! Bean knew that he and Conrad were walking in a kind of cosmic museum, one whose collections stretched back into the early history of the solar system. They could have spent the whole moonwalk exploring one crater—but that was a luxury they simply could not afford. The geologists on earth wanted them to bring home samples with as much variety as possible. Since the pressurized suits were too stiff for them to bend, Conrad carried a pair of long-handled tongs, and for lunar soil, he had a scoop.

Still, getting those samples wasn't always easy in one-sixth gravity. If Conrad wasn't thinking about keeping his grip, he found that dust sprayed out of his scoop and sailed past Bean's collection bag. Furthermore, gripping a tool meant constantly squeezing the pressurized glove. If Conrad wasn't paying attention, his glove would open slightly, and the tool would drop from his hand. Fortunately, it fell slowly enough so that he could snatch it before it hit the ground.

In this light gravity, Conrad and Bean found even falling down fun. Like everything else, it happened in slow motion. Even if they fell backwards, they had time to turn their bodies and land gently on their hands. Then all they had to do was a push-up, and they were back on their feet. Sometimes they could avert a fall with a few quick footsteps. The only drawback was the dirt; it clung to their suits and anything else that touched it. By the middle of the second moonwalk the Hasselblad camera mounted on Bean's chest was so covered with black dust that he could barely read the settings. Working in one-sixth gravity and tenacious moondust ate into the commodity more precious to them than oxygen on the moon—time. And Pete Conrad was impatient to get to the Surveyor, which in his mind was the moonwalk's most important goal.

"Come on, Al," Conrad said, "we're wasting time."

Bean asked his commander, "Is the front of my lens clean?"

"Relatively speaking," Conrad said. "Nothing else is."

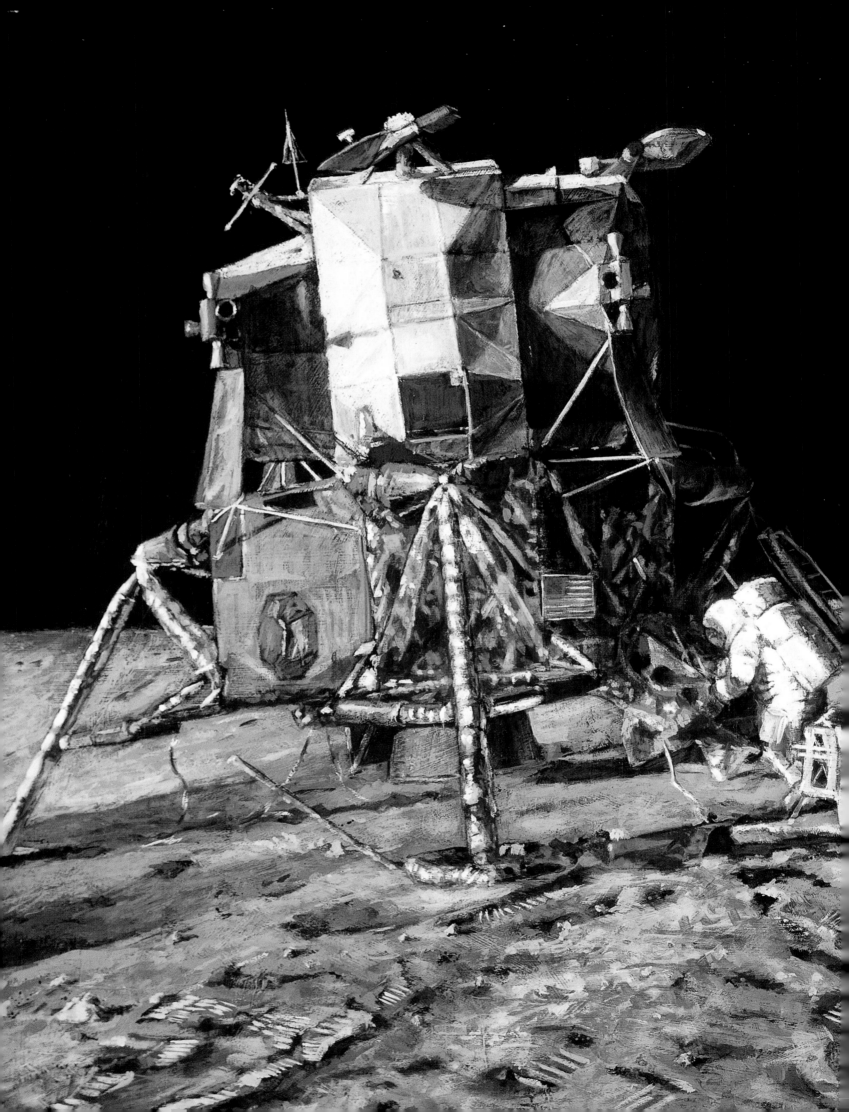

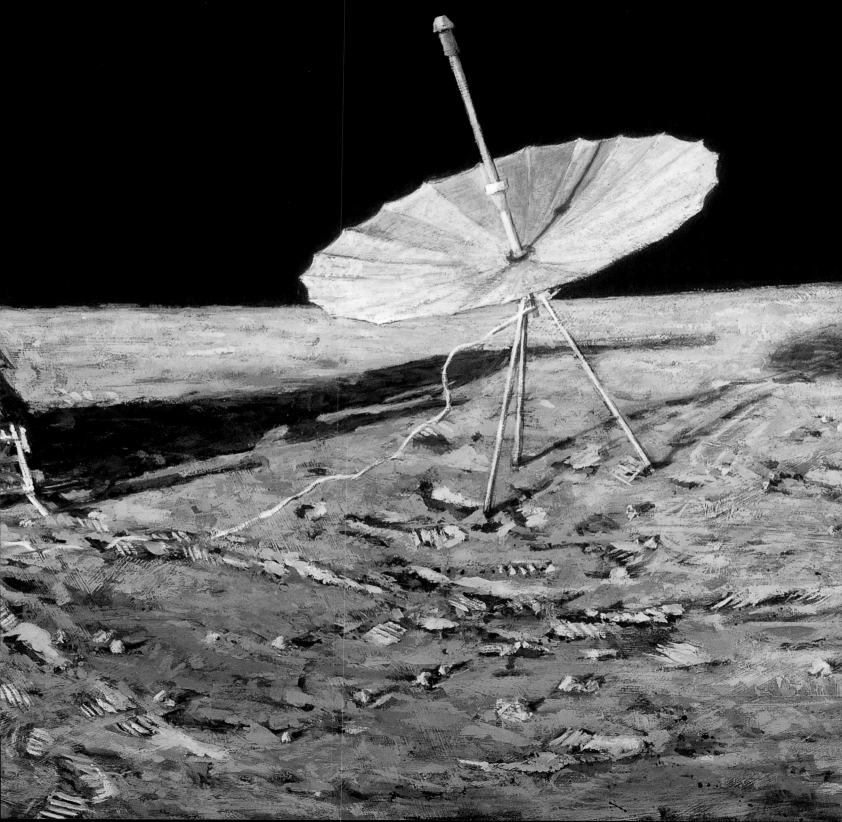

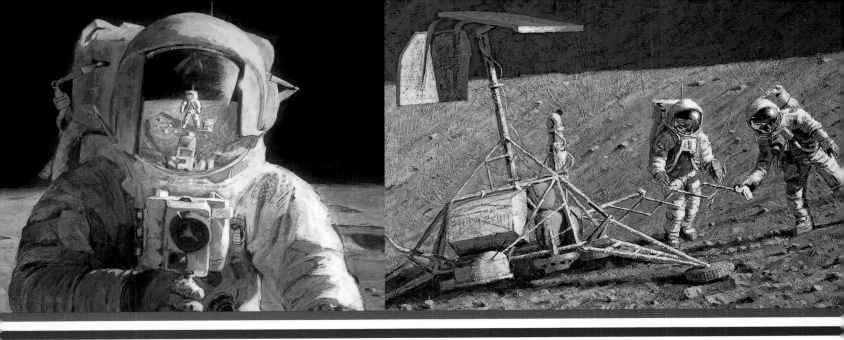

HOME SWEET HOME

[P R E V I O U S P A G E]

When Pete Conrad and I came down the ladder for our first walk on the moon, about all we had with us were the clothes (and backpacks) on our backs. If we were to do our planned scientific work, we were going to need equipment, and a lot of it. Most of this equipment was stored in fold-down compartments on the sides of the lunar module descent stage.

Pete is working at the right front fold-down compartment, the Modular Equipment Stowage Assembly, the MESA, offloading some of the things we will need for the first exploration period. Meanwhile, Pete and I have already set up the large s-band antenna so we have better voice and television communications with earth. I had unstowed it from a smaller compartment on the left front side of the descent stage. On other missions, the Rover, the electrically powered moon buggy, would be mounted, all folded up, in this same stowage area.

This painting emphasizes the size of the lunar module. As I looked at it on the moon it seemed much, much bigger than I remembered just four days previously back on the launch pad of Kennedy Space Center. It was a friendly home in a faraway world.

The two men took off running into the blinding glare of the sun. It was so bright that Conrad and Bean couldn't see features until they were right on top of them. They were afraid that by the time they could clearly see a crater, they would not be able to keep from falling into it, especially since it took 10 to 15 feet to stop. They could climb out of a small crater, but any astronaut who fell into one of those big ones would have more than enough time to think about his mistake. To avoid heading directly up-sun, Conrad and Bean ran in an elongated, zig-zag pattern, like sailboats tacking as they head into a wind.

Running on the moon was a strange experience, challenging and fun at the same time. Bean's massive backpack threw off his center of gravity, and his pressurized space suit was stiff and somewhat clumsy. Bending at the waist and the knee was harder than bending at the ankle, which meant Bean ran mostly by pushing off with his toes. With each step, he sailed into space for what seemed like a long time. The challenge was to avoid coming down with one foot on a rock or in a small crater. To make the game even tougher, every step set his body slowly rotating to one side or the other. He often found himself thinking, "I hope I land soon. If I don't, I'm going to rotate too far sideways, and when I push off on the next step, I'm liable to go off in some crazy direction." He was careening across the moon, bouncing from one foot to another on a giant, rocky, extra-springy trampoline. Bean imagined he was covering 10 feet with each stride, but when he dropped back and looked down at Conrad's footprints, he realized this was just an illusion; they were about the same distance apart as if Conrad had been running on earth, without the space suit. And though he could jump high, he couldn't run very fast. He would realize later that in the light gravity, his feet didn't have enough friction with the ground to propel himself forward at high speed. Still, to be encased in so much gear and run so effortlessly was almost magical. Conrad had his own description.

"You know what I feel like, Al?"

"What?"

"Did you ever see those pictures of giraffes running in slow motion?"

Bean laughed. "That's about right."

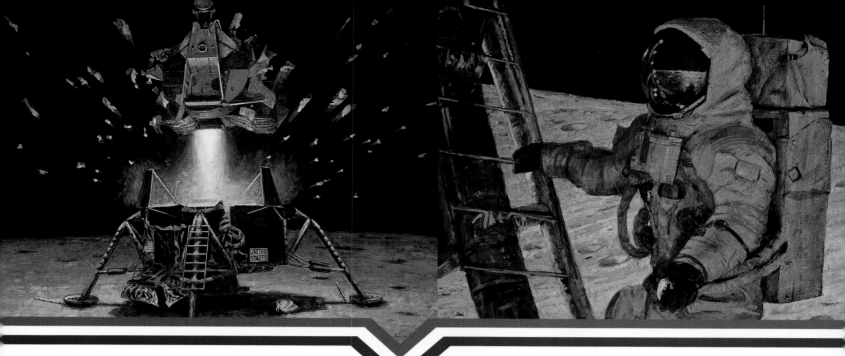

"That's exactly what I feel like."

"Say," came a voice from earth, "would you giraffes give us some comment on your boot penetration as you move across there?" Yes, mission control was listening to everything, and watching Conrad and Bean like a hawk. Every detail of the men's condition—from the temperatures inside their suits to their heart rates—was displayed on monitors in Houston. They were running slightly uphill now, and were beginning to feel winded. In Houston, astronaut Ed Gibson was the Capcom, and he could hear Conrad and Bean breathing hard. "I've got the decided feeling I'm going to sleep tonight," Conrad said. When the flight surgeon became concerned, Conrad and Bean got a discreet request from Gibson to take a break. His voice in Bean's headset was just as clear as if he were around the corner, instead of 239,000 miles away.

There was one thing that left no doubt in Bean's mind of where he was. As he ran, he stole a moment to look up at it. The earth was like a radiant blue-and-white gemstone, suspended in the blackness overhead. Just as the moon always keeps the same face toward the earth, so the earth never moves in the lunar sky. And, as we see the moon change from full to new and back to full, the earth does the reverse, waxing and waning in the lunar sky like a blue-and-white eye opening and closing. Bean would ponder what life would have been like if humans had been born on the moon. Would they have thought earth was the eye of God? Priests in ancient times would have forbidden fun and merriment for the masses when the eye was open (when the earth was full); everybody would have had to wait for "new earth." For Bean, seeing his home world, tiny and beautiful, brought home the reality of what was happening. He said to himself, *This is the moon. That is the earth. I'm really here.*

Suddenly Bean felt his ears "pop"—was his suit losing pressure? Astronauts are people who have learned to put fear out of their minds in order to accomplish dangerous tasks. Bean could keep it there, until something unexpected happened. His heart pounded with alarm as he came to a halt and checked the gauge on his wrist, saying nothing. Seeing him, Pete Conrad felt appre-

Hi, Mom

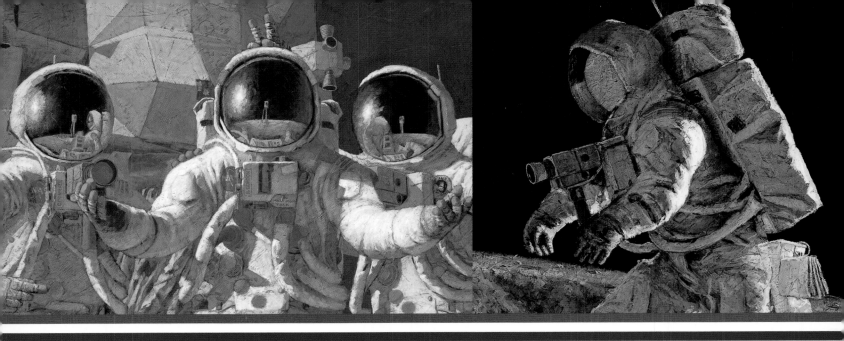

hension for his lunar module pilot. "I'll tell you what I'm going to do, Houston," Conrad radioed, not letting on. "I'm going to take a break. How are you doing, Al?"

"Okay," Bean answered. The gauge read normally; it was just a false alarm. (Later, engineers would decide that as he ran Bean's body had bounced against the exhaust port within the suit, blocking the outflow of air and causing a momentary increase in pressure.) Still, it gave Bean a shot of adrenalin.

Meanwhile, Surveyor 3 sat patiently on the slopes of an old crater, 656 feet across. Thirty-one months earlier it had arrived there, a robotic emissary from earth, to help pave the way for human beings. A spindly white collection of tubes, fuel tanks, and solar panels, Surveyor 3 was equipped with a remotely controlled television camera and a scoop on the end of a mechanical arm, to investigate its surroundings. For 2 weeks it had radioed back information, until a night lasting 14 earth days fell on the Ocean of Storms. Now it was about to receive its first visitors.

As Conrad led a path along the slope of the crater, Bean followed, holding a special tool carrier. In mission control there was some concern that the men might find it difficult to reach the probe, but now Conrad reassured them. "Don't worry about it, Houston," Conrad said, "because, really, it's no strain." The slope was just as they had been briefed. Carefully, they approached the probe. "Let's just make sure we don't get any dirt down there on it," Conrad said.

"Okay," Bean replied. "We'll walk real slow." Surveyor looked just the way it had almost three years earlier, its mechanical arm still reaching out toward the dust. Bean was fascinated to see that the probe's white paint had turned tan; perhaps it had been baked by the sun, or perhaps it was a fine coating of dust that had been kicked up by *Intrepid's* descent rocket. He and Conrad would take pictures to document any changes, and then they would cut off pieces, including the TV camera, for the engineers to study the effects of Surveyor's time on the moon.

First, though, Conrad and Bean had some personal business to take care of. Before the flight, Conrad had asked one of the

support engineers to obtain a small automatic timer that would attach to a Hasselblad camera. He would mount the camera on the tool carrier, and the timer would let the two men pose in front of the Surveyor. "Maybe *Life* magazine will put it on the cover," Conrad told Bean, "and everybody's going to say, 'Who took the picture?'" But now the timer was in the bottom of a bag full of moon rocks. No one in mission control knew about the caper, so Bean rummaged quietly among the samples in their teflon bags. The chrome-plated timer was lost among the rocks and moondust, impossible to see, and impossible to feel through the gloves. This was one picture Conrad and Bean would not get. The pictures they did get—including one Bean snapped showing his commander with the Surveyor, with *Intrepid* visible less than 600 feet away—were a stunning trophy of Apollo 12's achievement. So were the parts and pieces that Conrad managed to cut from Surveyor 3. (As a bonus for the scientists and engineers, the men had also snipped off the craft's scoop, which still had moon dust inside.) And then there were the hundreds of photographs and more than 75 pounds of samples he and Conrad had collected on their two moonwalks. And though fatigue had begun to overtake them as they climbed back into *Intrepid*, Bean felt a sense of satisfaction that they had completed all their mission objectives, and at the treasure trove of new data that Apollo 12 would bring back to earth.

That is, assuming nothing prevented them from getting back to earth. Ever since the lunar module had come to a stop on the Ocean of Storms, Bean had been aware of what it would take to leave. He and Conrad were like a pair of motorists trying to cross the Sahara, who had stopped their car for 30 hours, ate, had a look around, and took a nap. Now they were going to try to start the engine again—with no one to give a jump start if it didn't work.

As he and Conrad made their preparations for launch, Bean could not help but think of *Intrepid's* ascent rocket. It would have to work perfectly, or almost perfectly, to propel him and Conrad back into the proper orbit to rendezvous with Dick Gordon. It was designed to be as reliable as humanly possible, yet Bean knew that even the best machines eventually fail, and if it did, there was no backup. Conrad joked, "If it doesn't work,

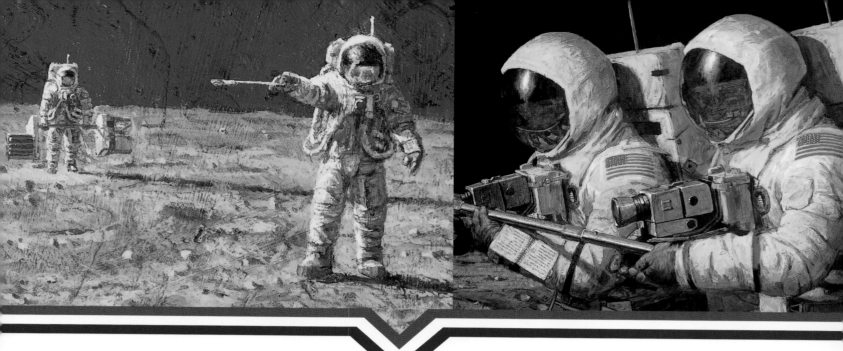

you and I are going to be the first permanent monuments to the space program on the moon."

Conrad counted down the final seconds—"Three, two, one . . ." At zero there was a loud bang as explosive bolts fired to separate *Intrepid*'s ascent stage from the descent stage. "Liftoff," Conrad announced. "And away we go."

Boy, did it fire," Bean said. Through his window the Ocean of Storms fell away. Only seconds after liftoff, the ascent stage pitched forward 60 degrees to fly a more fuel efficient trajectory. It was breathtaking, even a little alarming—but everything was happening just as it should. *Intrepid* was adjusting its flight path to follow the moon's curvature. The ride was amazingly quiet, except for occasional loud bangs as the maneuvering thrusters fired to correct the craft's trajectory. Each minute brought the men closer to the relative safety of lunar orbit. "We're going fast again," Bean thought. "If we can just get going a little faster, we'll be okay." Finally, after 6 minutes, the men reached orbit and began a game of catch-up that was necessary to reach the command module. Bean was working harder than ever, updating the backup computer and comparing its data with onboard charts in preparation for an upcoming course correction maneuver. Conrad said, "Why don't you quit working so hard after this next burn? We're right on course, and the computer is working perfectly." Bean was surprised by his commander's words, but even more by what Conrad said when the burn was finished: "Would you like to fly the lunar module?"

Bean was wary. He knew that in maneuvering the spacecraft he might add some unwanted speed. "Don't worry," Conrad told him. "We'll monitor with the computer, and we'll zero it out when your finished."

"What about mission control," Bean asked. "I don't think they are going to like this."

"We're over the back side of the moon," Conrad said. "They won't know a thing about it." And so, for a few minutes, Bean took the controls of the ascent stage. He would always be grateful that even in this highly demanding situation Conrad had thought about him, and had found a way to make Apollo 12

even more memorable. It was the mark of a great leader.

Soon the men saw what looked like a bright star out ahead, growing slowly until it was clearly recognizable as *Yankee Clipper*. Bean savored the beauty of the rendezvous, watching the command ship drift silently through shadow and brilliant sunlight. *Intrepid* closed in as if it were riding on rails, and then Dick Gordon steered *Yankee Clipper* to a perfect docking. The most difficult part of Apollo 12 was over. All that remained was to transfer rock samples and other gear to the command module, cast off *Intrepid*, spend an additional day photographing specific areas of the moon, and head back to earth. But first, it was time for three Navy aviators to be reunited.

Dick Gordon opened the tunnel to *Intrepid*, saw his companions floating in a dirty cloud of moondust, and slammed the hatch again. He called out, "You guys ain't gonna mess up my nice clean spacecraft!" This was not the welcome home Conrad and Bean had hoped for. But they shared his concern for avoiding contamination of the command module environmental control system. Gordon asked them to take off their dirty space suits and put them into stowage bags. Then, at last, they floated naked through the tunnel to *Yankee Clipper*.

Gordon was happier than Bean had ever seen him. "Let me help you with that," he was saying. "Do you want a drink of water?" Bean felt the bond with his crewmates stronger than ever. They had been through an incredible experience, and they were together again. Bean was coming home with a new feeling about himself: he was beginning to feel like a real astronaut. In his first moments on the Ocean of Storms, he had reached into the pocket of his space suit and pulled out a special memento he had carried from earth. At the edge of the Surveyor crater, he hurled it into the black sky. In a few seconds it was lost in the sun's glare as it sailed into the crater. The memento was his silver astronaut pin, the one he had worn during his long years as a rookie, waiting for his chance to fly in space. It would remain on the moon forever. After all, Bean wouldn't be needing it any more. The gold pin of a flight astronaut, a real astronaut, was safely in another pocket.

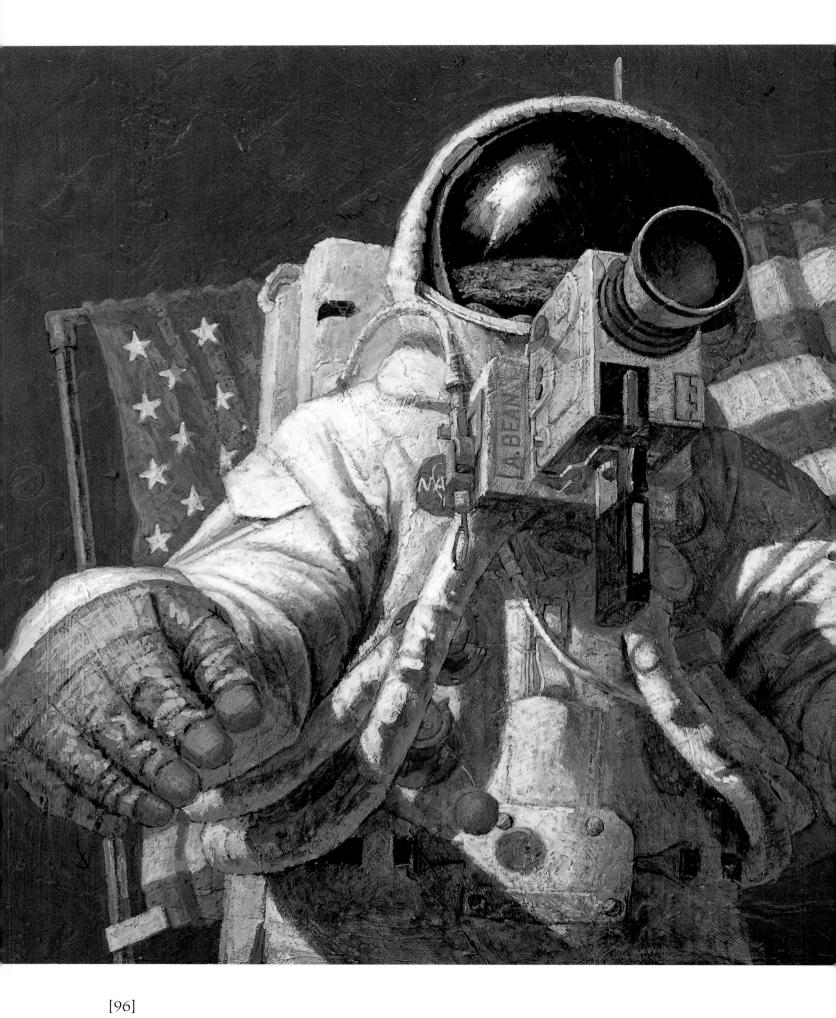

CLAN MacBEAN ARRIVES ON THE MOON

The official records show that when Apollo 12 flew to the moon the crew was Pete Conrad, Dick Gordon, and Alan Bean. That's true . . . as far as it goes.

We also represented the hopes and dreams of the scientists and engineers who designed the rockets, spacecraft, and experiments. Our skilled instructors and the flight controllers were there, too, as were our families and friends and all the American taxpayers who paid the bill. I found out later that as I stepped on the moon on the morning of November 19, 1969, I represented my forefathers of the Clan MacBean.

The first mention of the Clan MacBean in Scottish history occurred about A.D. 1300. The word "Bean," at that time, meant "the lively one," and the "Mac" signified "the son of Bean." I think my mother would have agreed, when I was in my twos and threes, that she had a lively one.

The clan flourished in the Scottish highlands. John MacBean brought the clan to the new world, but not by choice. He was in the ranks, fighting for the Scottish King Charles II against Cromwell, the British dictator, at the Battle of Worcester. The Scots lost the battle and John MacBean was deported to Boston as a prisoner, arriving there on February 24, 1652.

John Bean (the ship's clerk had anglicized his name) was sold as an indentured servant to a sawmill operator in Exeter, New Hampshire. The boss's daughter quickly fell in love with him and a short while later they were married. Pete and Dick have laughed at this story and said, "The gift of great good luck was in the Bean genes even way back then."

MY FIRST STEP

As I painted this memory, it brought back a variety of thoughts and emotions. Some I had turned over in my mind once or twice every week since November 19, 1969, and others that hadn't crossed my mind at all.

I've been asked many times, "What were your thoughts as you made your first step on the moon?" Only three other humans in all history had done it before me, the most recent being Pete Conrad a few minutes earlier.

On my cuff checklist I could read that in the first 5 minutes I had to practice my mobility and stability, arm motion, and downward reach. I needed to make some observations about boot penetration, soil scattering, and adhesion. I had to practice jumping back up to the bottom rung of the ladder to ensure I could easily get back in later.

For me, personally, this moment was the culmination of many dreams and fears, successes and failures, rewards and frustrations. It was an event made possible by all I had learned before in my professional life. But, this wasn't on my mind at all. I can still clearly remember thinking that I had to learn to move about in the one-sixth gravity of the moon as fast as I could because until I could move with ease and familiarity, I couldn't begin to gather the rocks, deploy the experiments, and do the other things that I had been trained to do. Any philosophic musings would have to come later.

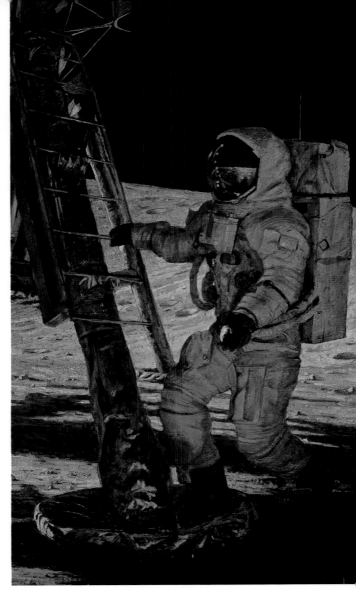

THE FLAG BEARER

This is a painting of me proudly carrying our American flag on the Ocean of Storms in November 1969. Just a few hours earlier Pete Conrad and I had made man's second landing on the moon, and now we were busy with the things we had to do on our first moonwalk. This painting brings back a lot of good feelings for me but it didn't happen exactly as I've shown.

Pete and I worked together to erect the flag. I took the lower section of the flagstaff and hammered it into the lunar surface with the very same hammer that made many of the marks you see in the texture of this painting. While I worked, Pete unfolded the flag which was attached to the upper section of the flagstaff and brought it over to where I had hammered in the lower section.

It's easy to paint exactly what happened, how it actually looked. It's not so easy to capture the emotion, the poetry of the event. I don't believe I actually carried our flag as I have shown, but this is the way I felt. Some years ago when I began painting the Apollo adventure I would not have had the understanding or confidence to create this image. But I knew I was one of the three luckiest members of a team of 400,000 men and women who showed the world that Americans can make the impossible dream a reality when we all dedicate our hearts and minds to accomplishing that dream.

[98]

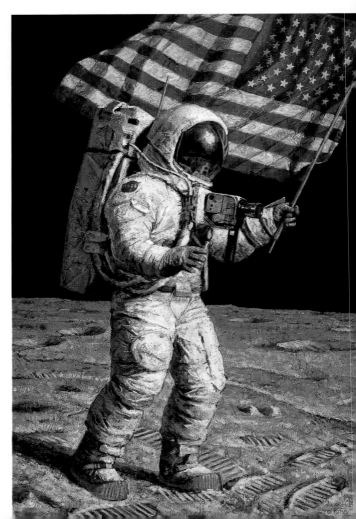

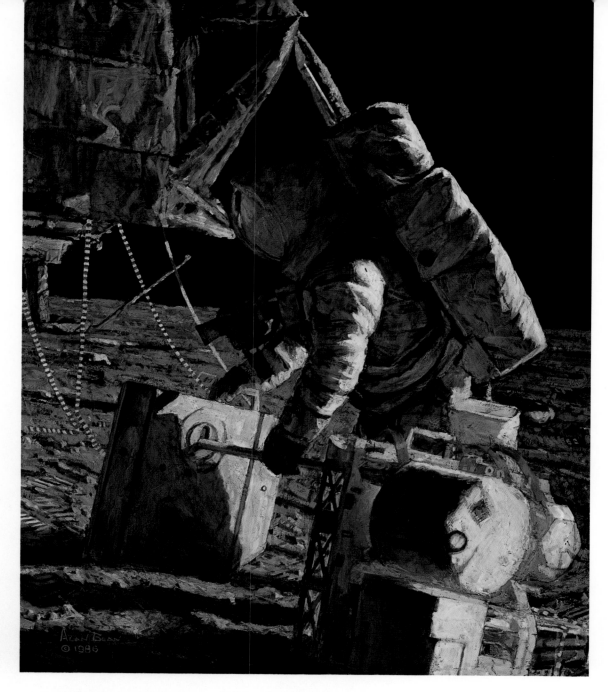

LOAD 'EM UP . . . MOVE 'EM OUT

The highest priority task Pete Conrad and I were scheduled to accomplish during our first moonwalk on Apollo 12 was the deployment of an unmanned geophysical station. We called it ALSEP, an acronym for Apollo Lunar Surface Experiments Package, and it consisted of a cluster of six experiments all connected to a central command and control station and powered by the first thermonuclear electrical power generator on the moon.

I have painted myself attaching the ALSEP components to either end of a lightweight metal bar. This "high tech barbell" was the best way we could think of to carry all this hardware to a relatively flat spot 300 feet away so the experiments wouldn't be blown over or covered with dust when we blasted off the moon the next day. The waste-basket-shaped object on the near end of the bar is the seismometer. It measures moonquakes or meteoroid impacts; and, as surprised scientists discovered, our footsteps as we moved about our tasks. The magnetometer with its gold foil-covered sensor arms is just below.

In my right hand you can see the bottom of the thermonuclear electric power generator. I can distinctly remember feeling the intense heat from the decaying plutonium fuel element—even through my heavily insulated suit. I wondered if the dedicated and able suit makers on earth had anticipated this heat and built the suit to withstand it. But I didn't have time to worry about it then. We had to get on with our work. It was time to "load 'em up, and move 'em out."

SURVEYOR III, I PRESUME

In the early 1960s the surface properties of the moon were largely unknown. Most astronauts thought that walking on the moon was going to be a fun but dusty experience. And some scientists thought that our lunar module, with us inside, might sink out of sight in deep dust. Others thought that electrostatically charged dust might leap up and cover the windows, making it impossible to land safely. The only way to answer these critical questions was to send unmanned explorers to the moon first.

Surveyor 3, the second of five unmanned explorers to land on the moon, touched firmly down on the Ocean of Storms in April 1967. Its television camera took 6,000 photographs and soil mechanics/surface sampler scoop performed a number of successful experiments. Its mission completed, Surveyor 3 rested quietly on the 13-degree slope of a 656-foot-diameter crater.

In the early morning hours of November 19, 1969, a strange bug-like spaceship landed just beyond the far rim of the Surveyor crater. A short time later two creatures in bulky white suits crawled out of the spaceship and began to move about on the surface. Two human explorers from earth were there to find Surveyor and bring some key pieces—the television, the scoop, a piece of cable, and an unpainted support strut—back to earth for evaluation. It was a unique opportunity to evaluate the influence of prolonged exposure to the lunar environment on typical spacecraft systems.

I have painted a perfect storybook moment as Pete Conrad and I approached Surveyor 3. We had traveled a long way, 239,000 miles. A friendly but historic greeting between explorers seemed in order.

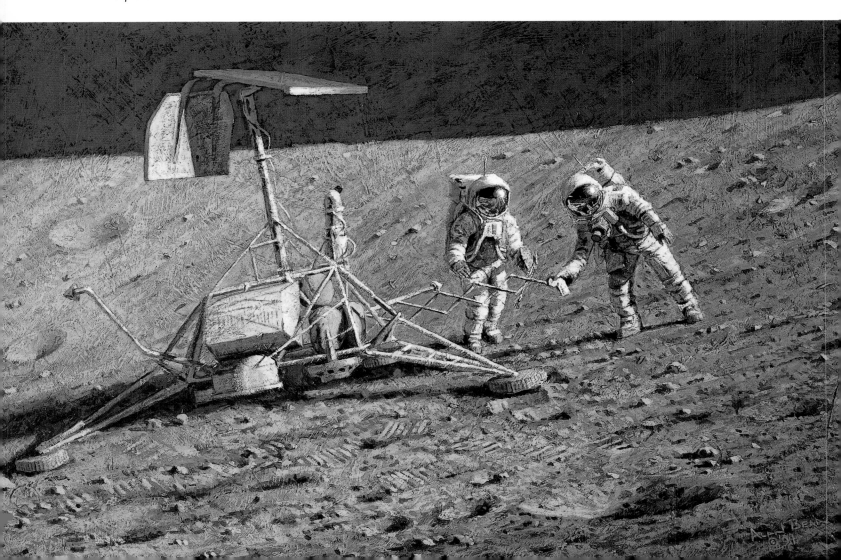

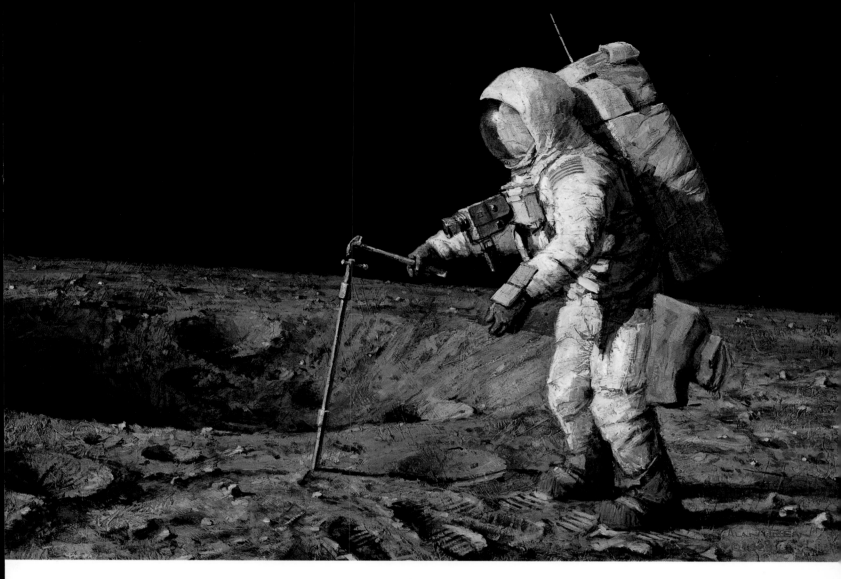

DRIVING THE DOUBLE CORE TUBE

I vividly remember standing near Halo Crater and hammering this core tube into the moon. Even though my arm swing was somewhat awkward because of the restricted motion in the spacesuit I was hitting the target most of the time.

Astronaut Buzz Aldrin had driven two single core tubes on his Apollo 11 moonwalk just four months earlier. Buzz found that the first few inches were fairly easy, then the resistance built up rapidly, preventing further penetration. The bits Buzz used were flared inward 15 degrees, probably forcing the soil to deform and compress as it filled the tube. With a simple modification, our bit had a straight inside wall, the same diameter as the tube. We hoped to go deeper. The modification worked! The driving wasn't easy, but I was able to drive the double core tube to a depth of 28 inches.

Later, back on earth, we would find out that although there was some change in grain size and color, the granular material remained remarkably consistent with depth. Twenty-eight inches doesn't seem like much as I write this now, but it took all the energy I had in me to drive that far, back in November of 1969, on the moon's Ocean of Storms.

THE EAGLE IS HEADED HOME

The Apollo 11 lunar module Eagle *has just made history's first lunar liftoff. Neil Armstrong at the left-hand window and Buzz Aldrin at the other, are ascending from Tranquillity Base to rendezvous with Mike Collins in the orbiting command module* Columbia. *After transferring themselves and their treasure of moon rocks to the command module, they will head for home.*

I remember the liftoff from the moon as a big bang followed by what felt like a super-fast and quiet elevator ride. The big bang was the sound of the explosive bolts separating the ascent stage from the descent stage, and the quiet ride occurred because in the airless environment of the moon, the rocket makes no sound.

I recall looking out of my window, the right-hand one, during liftoff and seeing a ring of bright orange, silver, and black flashes of light expanding rapidly outward. It reminded me of the effect of dropping a rock into calm water. It took me a moment to realize that the bright flashes were glints from pieces of the metal foil insulation blasted from the descent stage by the ascent engine. I have accentuated the glows from the rocket engine to give the viewer the feel of one of the most exciting moments in spaceflight.

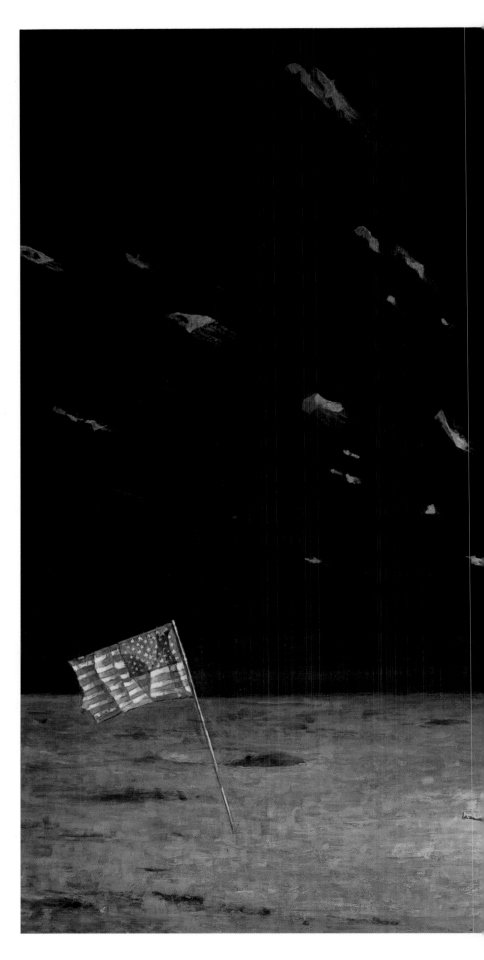

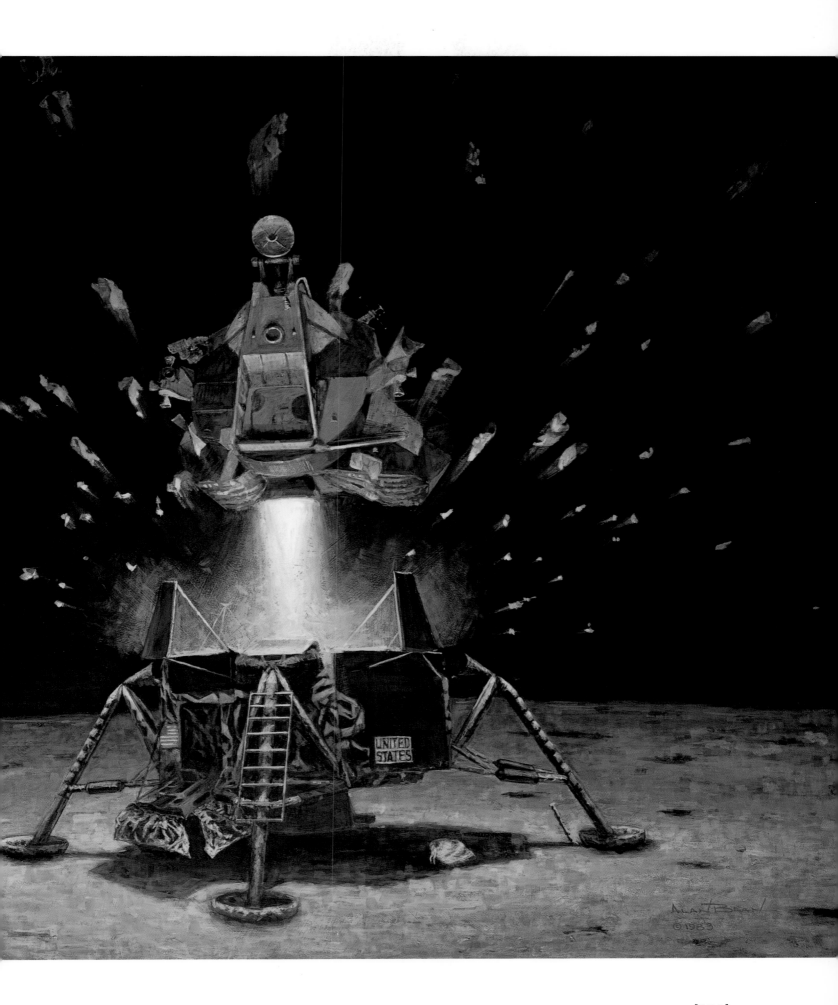

PETE AND ME

Of all astronauts who have ever put on a space suit, Pete Conrad is my absolute favorite. He is the best seat-of-the-pants man I have ever known. His instincts are usually right, he stays on course, and he always gives his best shot.

On the flight of Apollo 12, he knew when to hustle and when to slow down and enjoy the view. Right now Pete is taking my photograph with his chest-mounted Hasselblad camera. We used the camera mostly for scientific documentation, but as often as we could think of it, we also used it as tourists in a strange and wonderful world.

We had a cuff-mounted checklist to tell us what we were to do next and to keep us on time. We had developed and refined the checklist as we used it almost daily during the long pre-flight training moonwalk and there was a Playboy centerfold complete with a time. Knowing there were some people on earth who wouldn't see the over the radio but hopped over to Pete and gave him a look. He too. Our backup crew of Dave Scott and Jim Irwin hadn't forgotten period. I recall turning the page about 3 hours into my first caption entirely apropos to what I should be doing at that humor of these little additional illustrations, I said nothing laughed and said nothing but pointed to his checklist, either of us.

Documenting the Sample

[104]

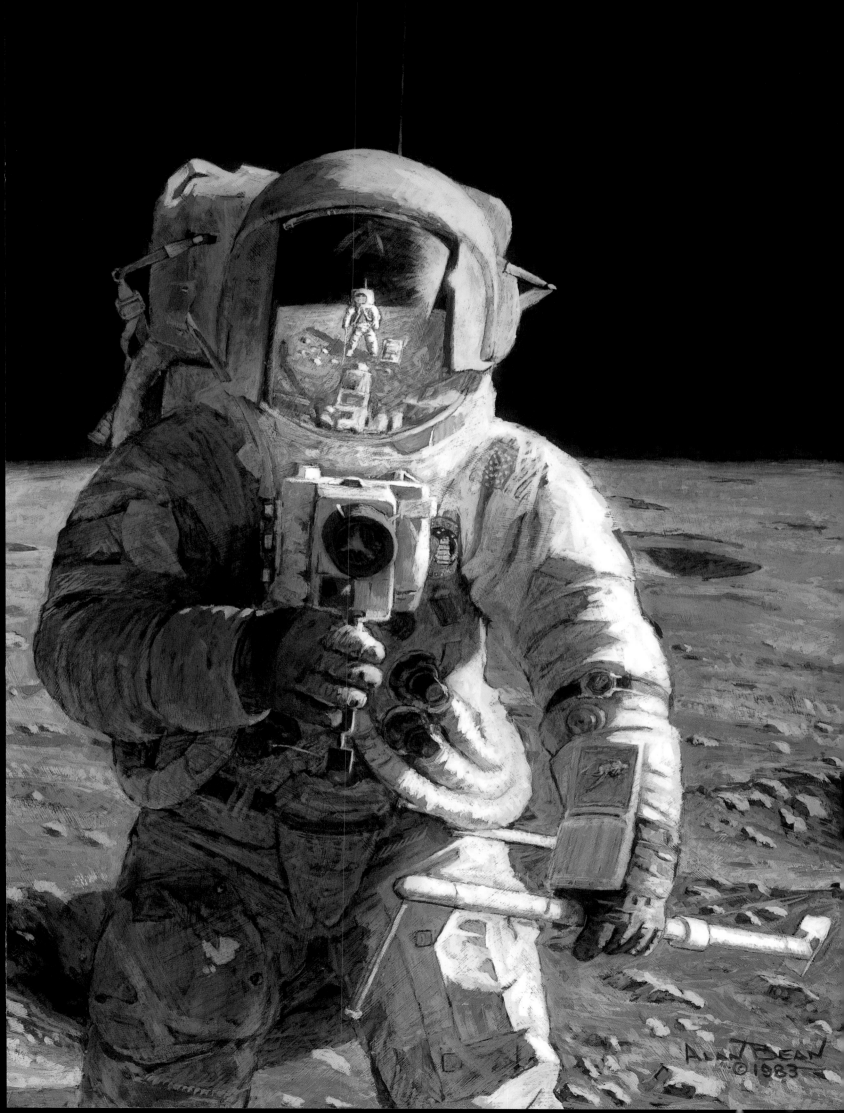

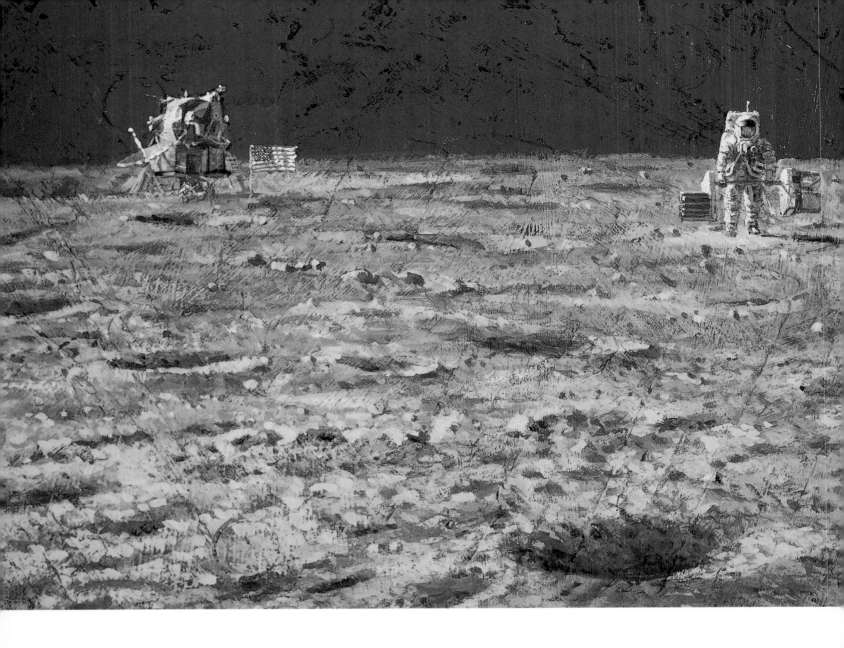

FAST TIMES ON THE OCEAN OF STORMS

[R I G H T]

I have painted myself almost flying over the surface of the moon. Running on the moon isn't like running on earth, mostly because the pull of gravity is only one-sixth of what we feel down here. I was light on my feet, much as I expected. When I pushed off with one foot, there was a long pause before I landed on the other foot, like running in slow motion. I could feel my leg muscles completely relax as I glided along to the next step. I seemed to float just above the surface.

I vividly recall one instance as I was running near a large crater. I felt I must look like a gazelle, leaping long distances with each bound. I looked over at my partner, Pete Conrad, as he ran nearby. His leaps were graceful and he was spaceborne for a long time but, to my surprise, he wasn't rising very high or leaping far at all. Then I realized that in the moon's light gravity, we did not have the traction to push hard backwards with our boots. We couldn't leap like gazelles—it only felt that way.

Running on the Ocean of Storms was relatively easy and a whole lot of fun. I was always in a hurry to get to the next exploration site because, like many things in life, there was so much to do and so little time to do it.

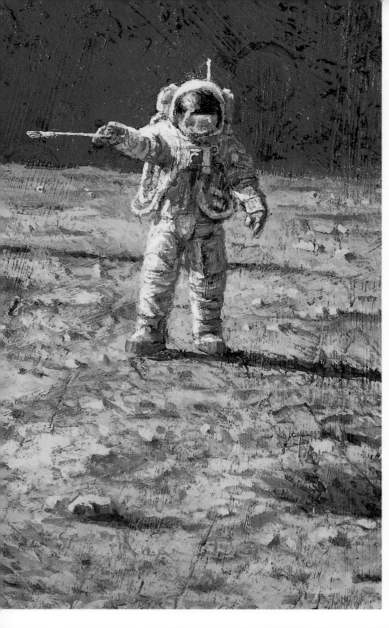

SCOUTING FOR THE RIGHT SPOT

Pete Conrad had run ahead to find a place to deploy the experiments we would leave on the moon. He was searching for a suitable, relatively flat area about 50 feet in diameter and at least 300 feet from the lunar module.

We knew it wouldn't be an easy task for Pete because there were craters as far as we could see in every direction. Little craters, big craters, and medium-sized ones, and the lunar surface between them was uneven and undulating. Pete finally spotted a perfect area about 600 feet from our home on the moon.

In the painting, I am carrying our ALSEP experiments which include a seismometer, a magnetometer, solar wind spectrometer, suprathermal ion detector, and a cold cathode gauge. These are mounted on one end of a barbell carry pole with their nuclear electrical power source on the other end.

Three things about this walk remain in my mind. The thin pole was difficult to carry even in the light lunar gravity because it was hard to keep my hands closed around it—the pressure inside the suit tended to force the gloves open. Also, I could feel the heat, radiated by the thermonuclear power unit, on my right leg even through my suit. Finally, the pole was so flexible that as I walked, the ends would bounce up and down and the experiments and power unit would keep coming partly off the pole.

It took us about 2 hours to unpack, set up, and align the five experiments. When ALSEP was activated, the first thing it recorded was our own footfalls as we loped back to the lunar module.

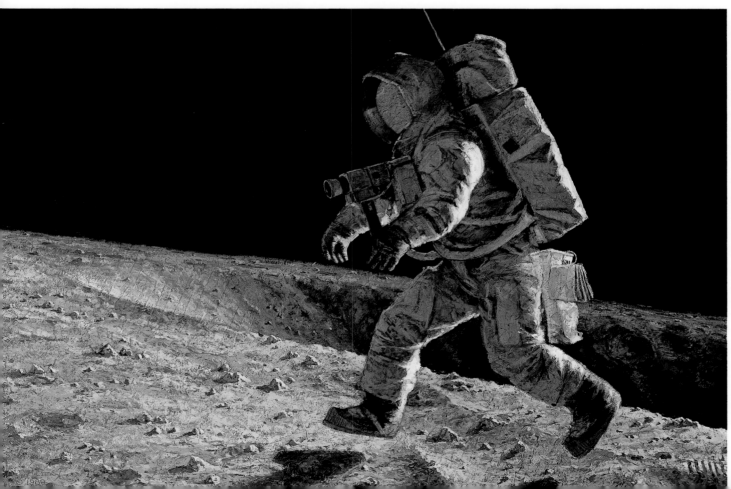

CONRAD, GORDON, AND BEAN: THE FANTASY

Pete Conrad, Dick Gordon, and I were assigned by Head Astronaut Deke Slayton as the backup crew for Apollo 9. This was super news because previous rotation indicated we would then fly Apollo 12, and therefore, make one of the first moon landings.

The most experienced astronaut was designated Commander, in charge of all aspects of the mission including flying the lunar module. Prudent thinking suggested that the next most experienced crew member be assigned to take care of the command module since it had a heat shield and was our only way back home. This left the least experienced to accompany the Commander on the moonwalk. Pete Conrad had flown two Gemini flights, the second with Dick Gordon as his crewmate. I had not flown in space at all.

During training, Pete and I frequently practiced our lunar surface activities such as emplacing experiments, gathering rock samples, and making observations. We were excited. We were going to have the ultimate adventure someone in our profession could experience. But while we did, Dick Gordon would be orbiting 60 miles above us. We often fantasized Dick joining us on the moon, and now that I'm an artist, in my paintings I can have it my way. At last, our best friend has come the last 60 miles.

Dick was the more experienced astronaut, yet I got the prize assignment. In the three years of training preceding our mission, he never once said, "It's not fair, I wish I could walk on the moon, too." I do not have his unwavering discipline or strength of character.

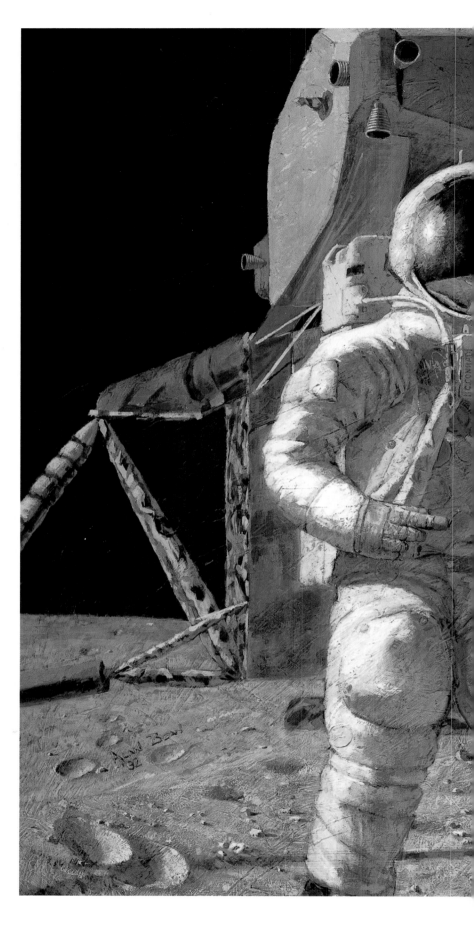

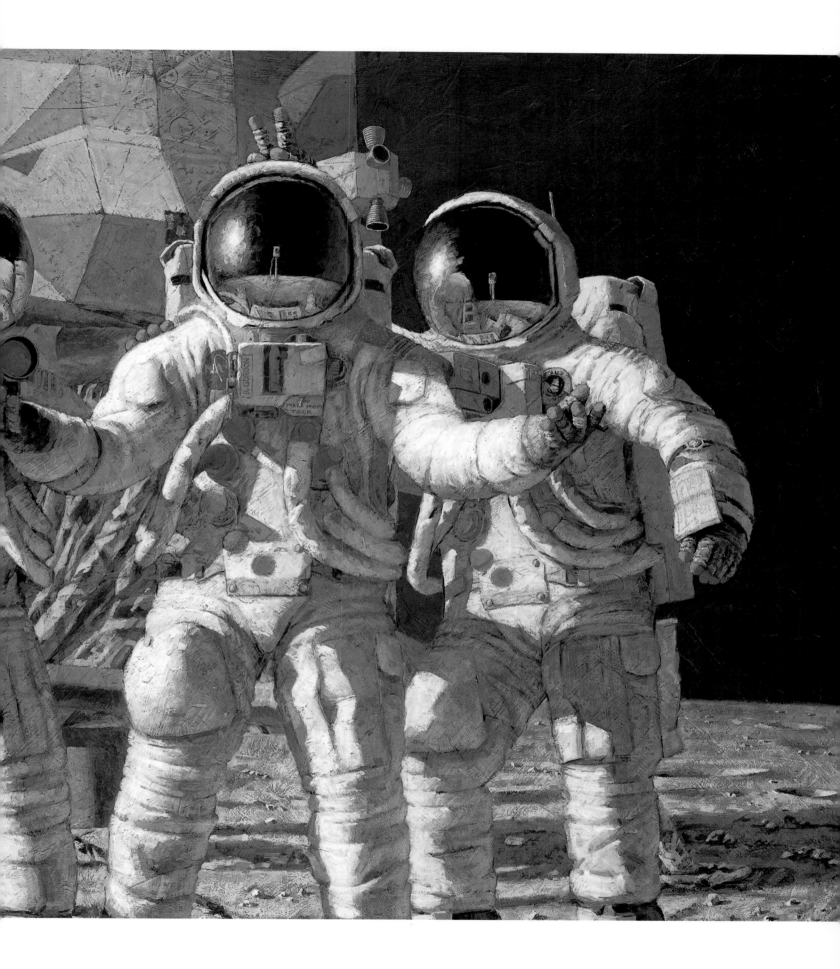

REMEMBRANCES OF A MOONWALK: SELF-PORTRAIT IN THE DUST

These three paintings make up a series relating to some of my feelings while I was on the moon. As you can imagine, there were many varied and vivid impressions and remembrances during the 33 hours spent on the Ocean of Storms with Pete Conrad, while Dick Gordon orbited 60 miles above us in the command module. The flight at times seemed unreal and perhaps a little like a dream. Careful, considered actions gave way to instinctive reactions honed by years of intense training. Words and logic can't explain these paintings completely, since they represent my feelings.

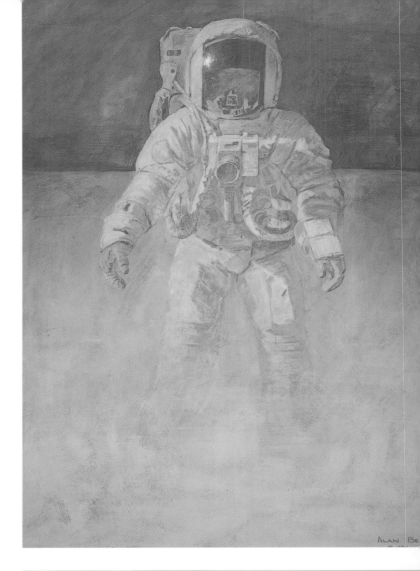

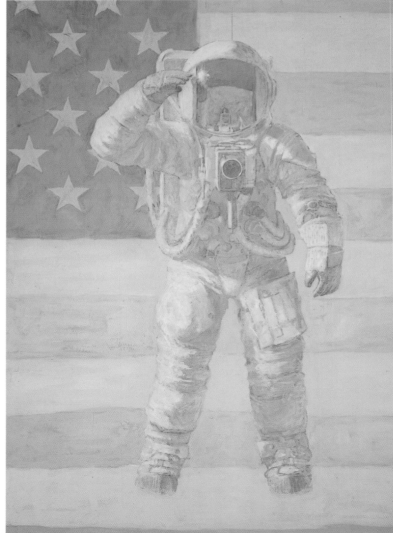

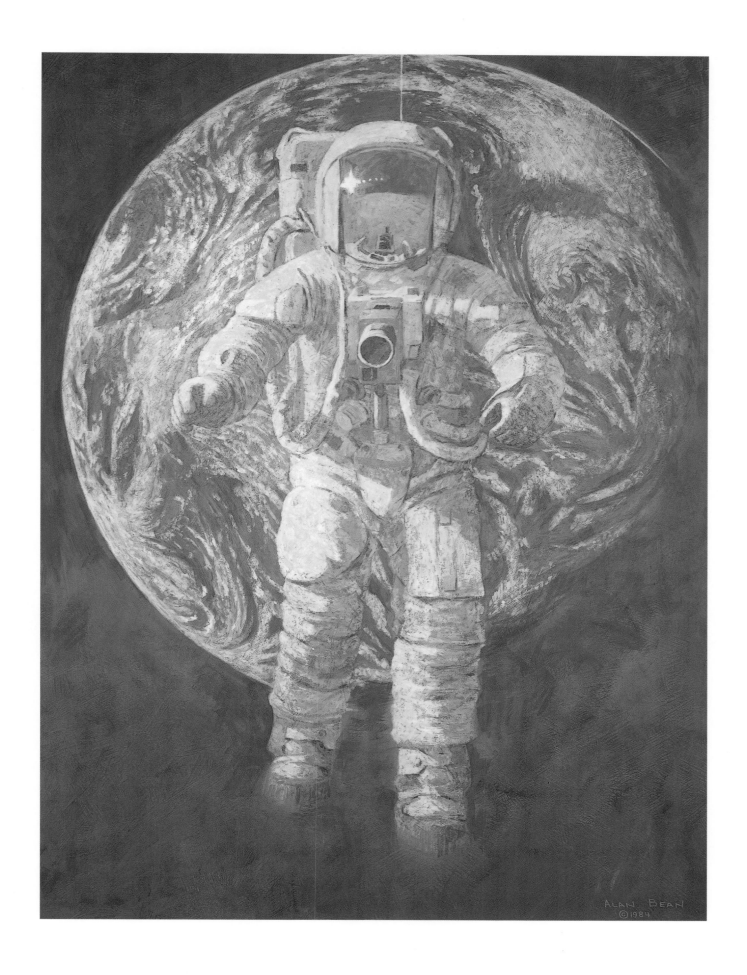

Alan Bean
©1984

WHAT TO DO WHEN YOU CAN'T GO

I resigned from NASA in June of 1981, to paint my experiences and those of my fellow astronauts in the first exploration of another world, Project Apollo. My paintings would celebrate the awesome accomplishment from the point of view of someone who had been one of the explorers. I flew the spaceships, I donned the space suit, I felt the excitement, the apprehension, the fear, the surprise, the elation when it all worked out OK. I had the "right stuff" but most importantly I knew the stories and folklore that only a person inside an adventure knows. My first question was how to paint these stories beautifully and accurately, and in a way that would connect with people?

If a realist artist paints from imagination or memory, the painting often suffers. Even a poor artist like Vincent Van Gogh would use what little money he had to hire models to pose for him. If he had no money, he went out into the field around his home and painted landscapes. The artists I know do life drawings with models, or use photography to capture subjects, and then interpret what they actually see, with their own artistic vision.

I could not do that. I couldn't go back to the moon, pose astronauts, observe the interaction of light and shadow, and a plethora of other things important to creating a beautiful painting.

At first I studied the NASA photographs from the moon, looking for reference material for the stories I wanted to tell. I tried to find a way to paint white subjects under intense lighting conditions, in a gray landscape, with a black sky, and to somehow create beautiful paintings all at the same time. Progress was slow and uncertain.

As my skills and understanding increased, I began using photos taken of astronauts training on earth. Then I painted them and their hardware as they would appear up on the moon. Only I knew when a figure in a moon painting looked right. About the same time I started taking my own photos of NASA suit technicians in space suits in a NASA studio. I could pose them in the ways I needed to tell my stories. I photographed space vehicles and hardware in museums, too. I then began painting them together as they would be on the

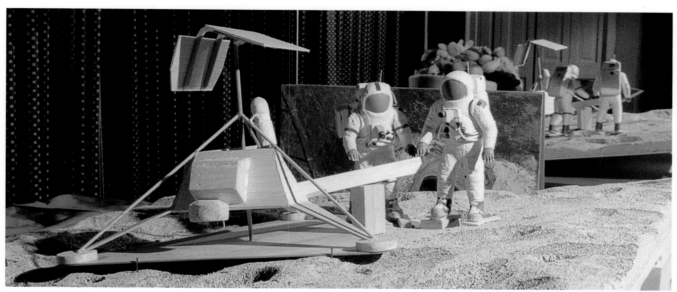

BACK TO THE MOON

moon, taking care to make the lighting and perspective consistent.

With each painting I completed, my understanding of lunar lighting, space suits, lunar modules, rovers, rocks, and dirt increased. With my experience as an astronaut, I could create real, lifelike paintings with a combination of accurate resource material.

For more complex paintings, I also constructed small model astronauts, Rovers, Surveyors, and other space hardware and built a simulated lunar surface. Now I can position my models in a way that tells the story I am painting, shows the spatial relationships, and helps me compose the painting. My two astronaut models are 10.2 inches high, and one wears the suit used on Apollos 11 and 12. The design of the space suit changed for Apollos 15, 16, and 17; this is the suit worn by the other model. (The Apollo 14 suit was a combination of these two versions.) I built all other equipment to the exact same scale. There are no commercial models available to this scale, so I built them from scratch. Although the key dimensions have to be built precisely (the exact height, width, wheel size, antenna placement, etc.), the models don't have to

look all that perfect. I can paint in how the hardware really looks and add such items as fuel tanks, lunar tools, and fenders.

I illuminate the models with a single high-intensity light and I adjust its position to exactly duplicate the sun angle that was present at the time of the story. I can then observe the form shadows and the shadows cast from one astronaut onto another, or on the Rover, or rocks and craters. It is almost impossible to imagine the visor reflection accurately because it is a compound curved mirror. After considerable trial and error I found a shiny brass cabinet knob—just the right size. When I placed it in the same spot as the model astronaut's helmet, I could step back and find just the right angle to paint accurate visor reflections.

This was the last piece of the puzzle of "what to do if you can't go back to the moon." With these techniques I can recreate any lunar surface activity that occurred during Apollo or even create events from my imagination, and feel confident that my paintings show them as they actually were or would have been.

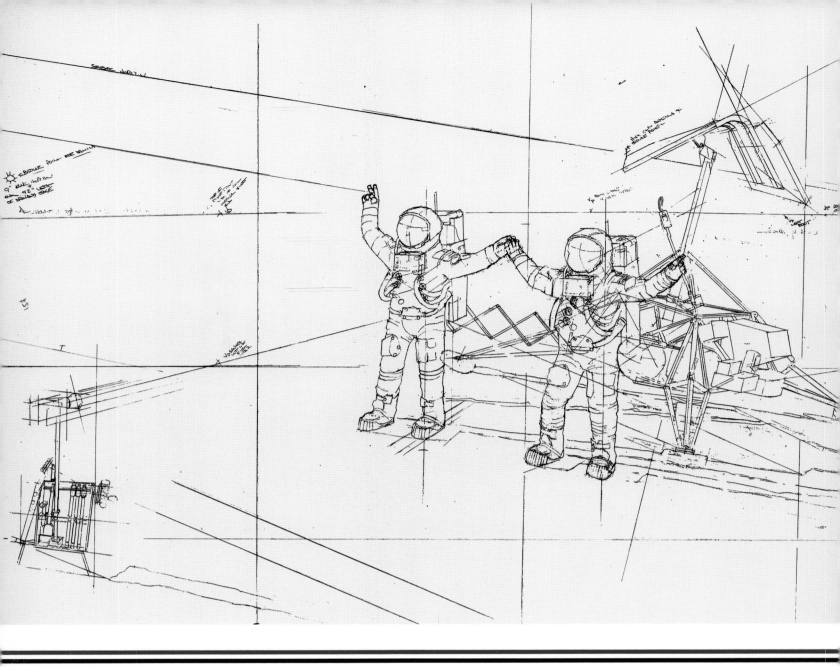

"THE PHOTO WE NEVER TOOK" DRAWING

This is a drawing of a painting in progress in 1998. Pete Conrad is on the right and I am on the left as we stand in front of Surveyor, celebrating the pinpoint landing which was our primary objective. During training we thought it would be wonderful if we could find a way to take a photo of us together on the moon, so we so found an automatic release with a self-timer for the Hasselblad. We practiced taking this picture in simulations on earth a number of times and it worked just great. We mounted the Hasselblad camera on the tool carrier that you see in the lower left-hand corner of the painting, and we put the self-timer in the rock sample bag with the rocks just as we had done in training.

When we got to the Surveyor's site, I tried to reach in the bag to find this little chrome timer release but the dust on the moon was

so tenacious, and the shadows in the bag were so dark that I couldn't see the timer, and I certainly couldn't feel it through my gloves. I got down on my hands and knees and began taking out the rock samples we had collected and placed in numbered bags, but I was afraid that I would lose them. Pete helped me look for a couple of minutes but we could not find the timer, so we put all the rocks back in the bag. There would be no photo of two Apollo 12 astronauts together on the moon.

Later, when Pete turned the rock sample bag upside down to pour its contents into the rock box for storage, the self-timer was sitting right on the top. But we were out of time. It was a great idea but like many things in life, circumstances didn't work out exactly as planned. ■

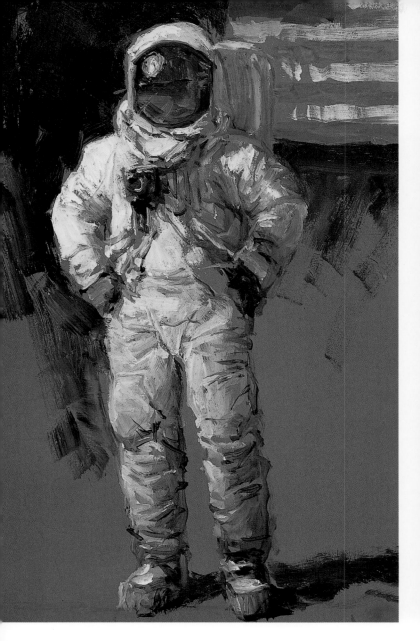
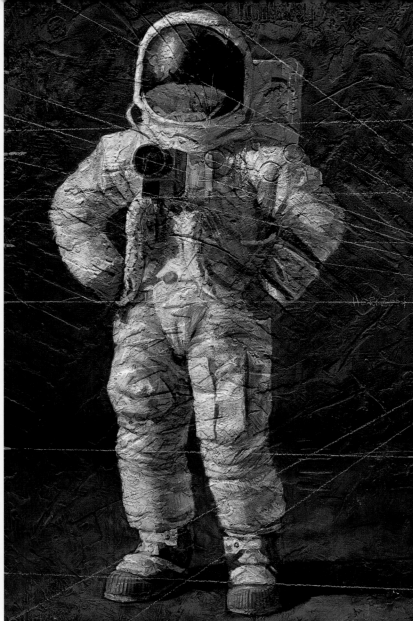

"FEELIN' FINE" STUDY
AND "FEELIN' FINE" WORK IN PROGRESS

The study, above left, is an astronaut in a relaxed, impressionist manner. One of the strange things about my very detailed paintings is that when I first begin to paint they have a certain surprising look, as if they are going to be finished very quickly. That's the stage that this painting is in after three or four hours of painting. I love it, but if I want to make it more accurate I need to get the details in there of the gloves, the camera, the real reflection in the visor, the boots, all those things that lend credibility to a painting. As I add them, they seem to destroy the casual, wonderful feel of the painting. I see many of my paintings go through this stage. I'm tempted to leave them that way, but I can't because I also want my paintings to represent how we really looked on the moon.

Part of the mystery of art, and part of the difficulty as an artist, is to decide what the goals are for a painting, what details to show, or not show.

This is one of my favorite images of an astronaut because I felt just like this so many times on the moon even though I didn't have time to stop and "assume the position." I think it takes a certain attitude of cockiness to be an astronaut and it's hard to show those emotions when I am painting people in suits and their faces can't be seen behind their gold visors.

I haven't worked on the painting on the right in two years. The visible lines on it are vanishing points for parts of the body which I drew even though I worked from the studio photograph. I like to work on the technical aspects of painting, such as locating vanishing points, so that when the painting is completed, it looks like a real person. I used a warmer background here than I usually do, so the colors, once again, aren't typical of what you would see on the moon. Part of the artist's role is to communicate an emotional experience to people in more ways than a photograph could. ∎

[115]

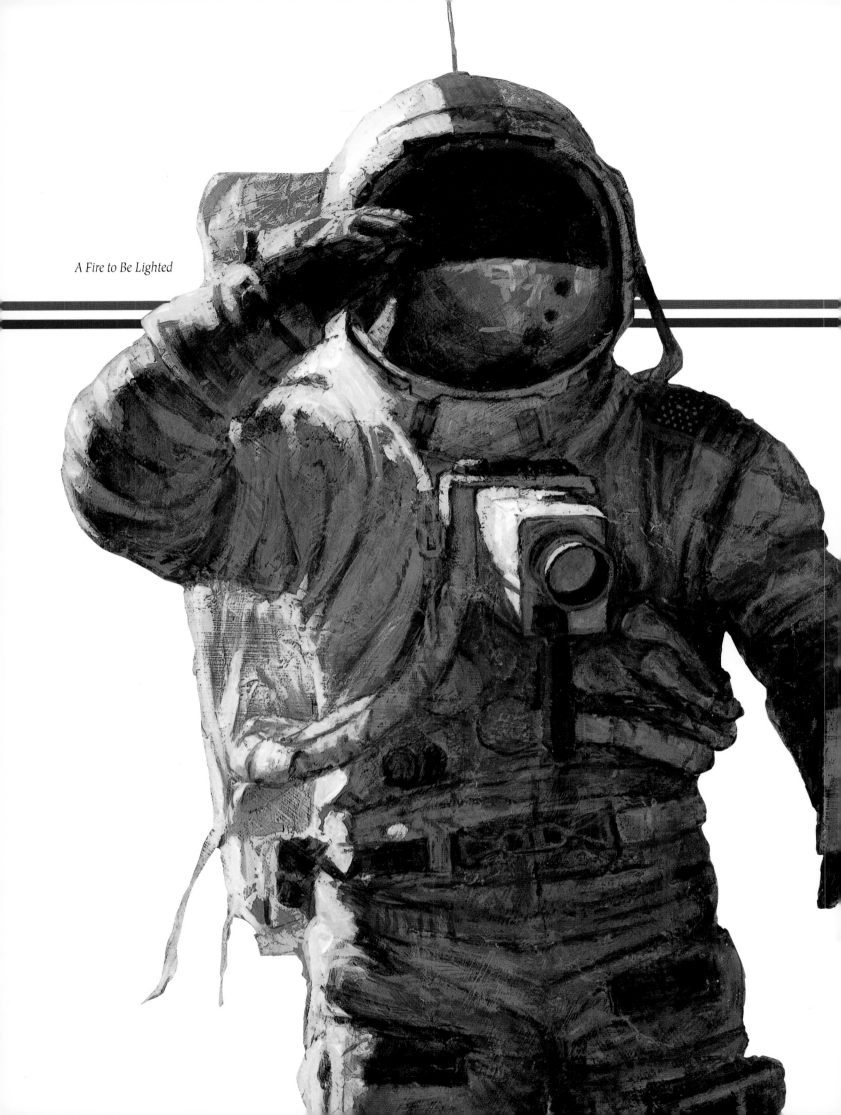

A Fire to Be Lighted

·IV·
WHAT DO YOU DO FOR AN ENCORE?

Bean looked outside and saw that the command
module was surrounded by a pulsating, eerie light caused
by friction with gas molecules in the tenuous upper atmosphere.
It was like flying inside a neon tube. When the maneuvering
thrusters fired, their flame momentarily disturbed the
wake, and the craft's turning motions twisted the unearthly
trail into a glowing corkscrew. "Mama mia,"
Bean exclaimed. "That is fantastic!"

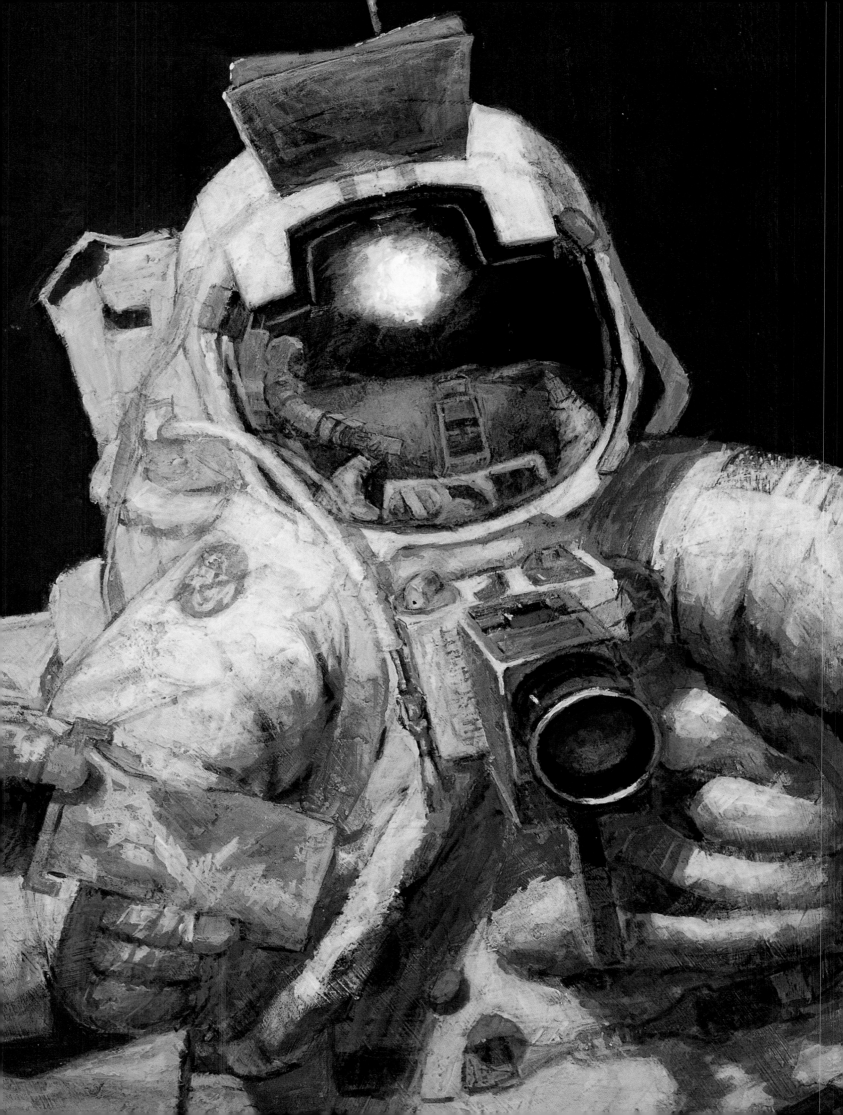

·IV·
WHAT DO YOU DO
FOR AN ENCORE?

ey, there's the horizon. Hot damn." For the first time in ten days, the earth loomed large beyond *Yankee Clipper's* windows, and Pete Conrad was glad to see it. "Hello, world!" Conrad, who had flown twice in earth orbit, knew they were traveling much faster than he ever had on Gemini. "We is flat smokin' the biscuit!"

Bean glanced out and saw the Hawaiian Islands moving past with astonishing swiftness. "Look out your side window," he told Dick Gordon. "Son of a gun!"

Gordon said, "Making knots, aren't we?" That was an understatement. Ten days ago, a Saturn V rocket had catapulted Bean and his crewmates out of earth's gravitational clutches. Now their home planet was pulling them back at more than 24,000 miles per hour—twelve times faster than a high-speed rifle bullet. "Boy," said Bean, "we are really hauling!"

"You're going to slow down in just a minute," Gordon said. "Fifteen seconds."

"Okay," Bean said, "standing by."

"Ten seconds. Five, three, two, one—" On the instrument panel a light labeled "0.05g" signaled that *Yankee Clipper* was beginning to decelerate. Bean looked outside and saw that the command module was surrounded by a pulsating, eerie light caused by friction with gas molecules in the tenuous upper atmosphere. It was like flying inside a neon tube. When the maneuvering thrusters fired, their flame momentarily disturbed the wake, and the craft's turning motions twisted the unearthly trail into a glowing corkscrew. "Mama mia," Bean exclaimed. "That is fantastic!"

"Hang onto your hat, ears, and overcoat, gang," Dick Gordon announced. G-forces built up rapidly as the command module slammed into the denser layers of air, pressing the three men into their couches. Outside, temperatures built up to thousands of degrees Fahrenheit; only the command module's heat shield saved the men from incineration. Inside, they barely noticed any change in temperature. During the trip back to earth moisture had condensed in the command module's docking tunnel; now the return of gravity sent it raining down on Pete Conrad, who was in the line of fire. "I'm getting soaking wet," Conrad laughed.

To Bean *Yankee Clipper* decelerated for what seemed like a small eternity. He realized, for the first time, how fast 24,000 miles per hour really was. As g-forces built up to six and a half times normal gravity—after ten days in weightlessness it felt like a ton—the onboard computer steered the command module on a precise path through the atmosphere. Everyone knew that an error of even a fraction of a degree would send the spacecraft skipping out of the atmosphere like a flat stone flung across waters of the pond. Gordon was ready to take over in case the computer failed, but that was something he would rather not have to do. As satisfying as it would be to fly the reentry, Gordon knew it would also be risky: without the computer, there would be no backup system. Now Gordon talked to the computer as if it were a real crew member. "Hold that lift vector down, *hold it down.*"

The glowing sheath of ionized gas surrounding *Yankee Clipper* had blocked out radio contact with mission control, but now, as the spacecraft slowed to a fraction of its original approach speed, communications returned. "Hello, Houston," Conrad said. "You read Apollo 12 out of blackout?"

"Roger, 12. Reading you loud and clear now."

"Okay," Conrad said. "It's right on the money."

ow the altimeter began to register their diminishing altitude. "Fifty K," Conrad reported. At 30,000 feet, explosive charges would jettison the command module's apex cover and deploy a set of drogue parachutes—that is, if the lightning strike from ten days earlier hadn't signed them up for a bad day.

"Stand by for drogues," Gordon called. There was a loud bang, and Bean saw the apex cover fly away. The drogue chutes streamed upwards, pulling their lines taut as they slowed the falling command module. Dick Gordon told Houston, "Those drogues look gorgeous."

"Okay," Conrad said, "stand by for the mains." As Bean watched, the drogues cut loose and three main parachutes appeared. Long moments passed as he waited to see them fully

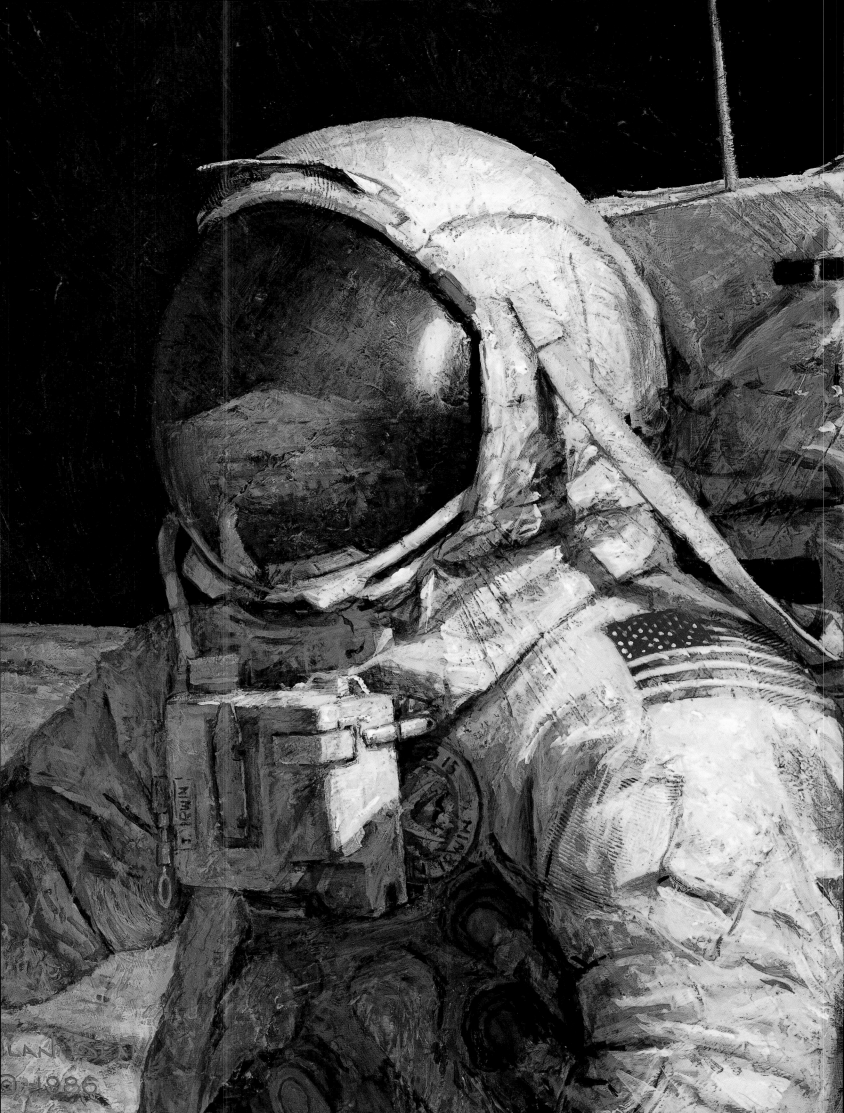

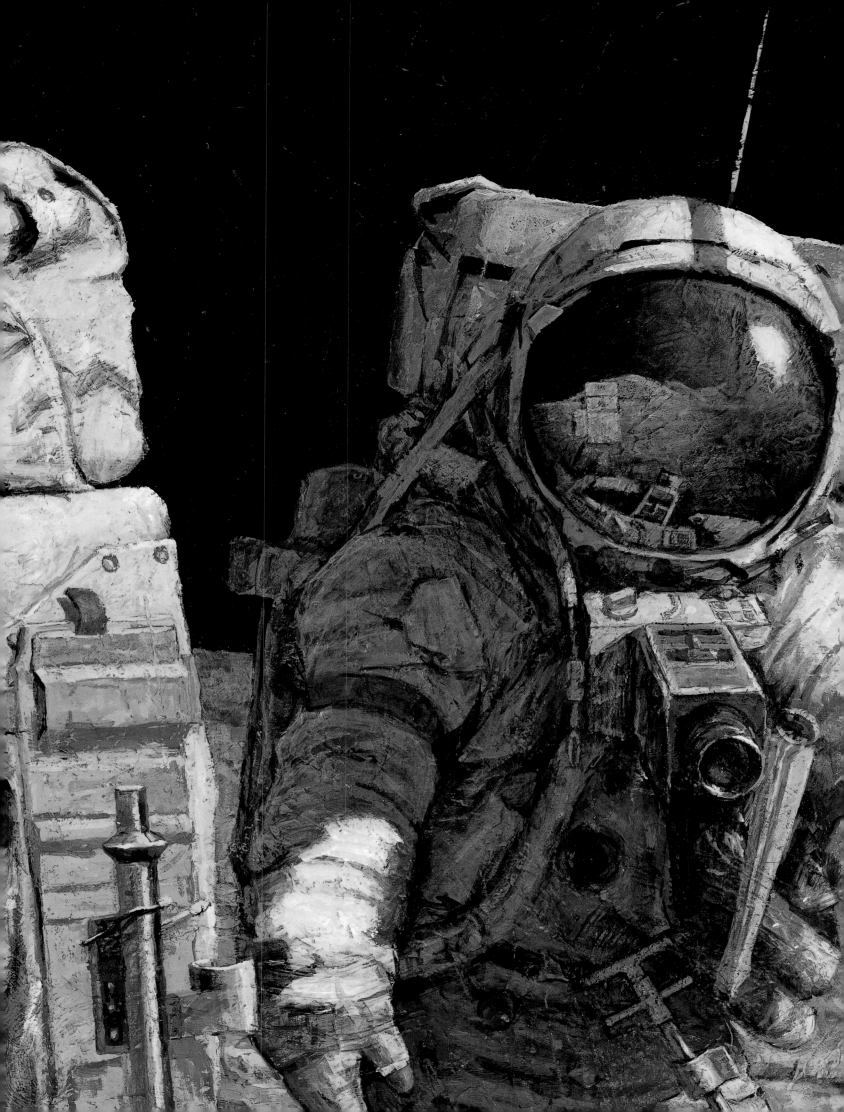

CONQUISTADORS

[PREVIOUS PAGE]
I painted Apollo 15 Astronaut Jim Irwin leading Dave Scott as they move about their work on the moon. Dave observed, "As we advance, we are surrounded by stillness. No wind blows, no sound echoes. Only shadows move." Dave continued, "I hear the reassuring purr of the miniature machines that supply vital oxygen and shield me from the blistering 250-degree Fahrenheit surface heat of lunar morning."

Explorers throughout history have probably looked strange and unreal to the natives of the new lands they visited. But we were different. There were no natives and enclosed in our space suits we looked like creatures from other planets to our own friends and families.

As I worked on this painting I was continually reminded how much astronauts on the moon looked like sixteenth-century conquistadors depicted in earlier paintings. Like them, we came in ships. Theirs were of wood, powered by wind and sail . . . ours were made of advanced metals and plastics and were moved by rocket engines. We both used the best technology of our age.

But here the similarity ended. Conquistadors came to claim lands and gold and precious gems for their King or Queen. We came for knowledge and understanding. A few rocks and a little dust were all we took. We carried no weapons, just tools for digging and measuring. We were space-age conquistadors and we truly came in peace for all mankind.

open. At last they did, blossoming into a trio of orange and white canopies. "Hello, Houston," Gordon announced. "Three gorgeous, beautiful chutes."

As *Yankee Clipper* descended, Conrad, Gordon, and Bean went through their checklist for landing, including dumping the command module's excess thruster fuel overboard. For a few seconds, the thrusters spat flames that danced alarmingly close to the parachute lines. "I don't go for that jazz," Conrad said.

Now the men could hear the transmissions from the approaching recovery helicopter. "We have a visual on you . . . passing through 4,000 feet." Meanwhile, out in the Pacific, the aircraft carrier USS *Hornet* was steaming toward the splashdown point. With only a few hundred feet to go, Bean was ready to perform an important task. After the moment of splashdown he would punch two circuit breakers, allowing Gordon to cast off the parachutes. Otherwise, the wind could drag the command module through the water, causing it to turn on edge. If that happened, the men would have to wait for long minutes while a set of inflatable bags on the spacecraft nose righted them.

With a powerful slap, the command module struck the water. Bean felt a jolt, as if he had been tackled. He felt a little dizzy, but he wasn't going to let that interfere with doing the job. Bean heard Dick Gordon say, "Hey, Al, hit the breakers."

But it was too late. By the time Bean pushed in the breakers and Gordon cut the parachutes loose, the command module was already turning over. Gordon said, "Al, what happened?"

"Nothing happened. What are you talking about?" Bean looked over at his surprised crewmates.

"You're bleeding," Conrad said. "The movie camera came loose when we hit, and it conked you on the head. I saw it go whistling down, out of the corner of my eye."

"It must have knocked me out for a few seconds," Bean said. "I didn't even know it."

Now there was nothing to do but wait for the recovery swimmers

The Hoer

to arrive. Bean looked at the expanse of sky and ocean outside his window, entranced by the motions of waves and clouds. He realized that for the last ten days he hadn't seen anything move except his crewmates and their spacecraft. Even out here, in the middle of the Pacific, his home planet was a sensory feast.

But he did not have the luxury of enjoying it, not yet. Onboard the USS *Hornet*, Conrad, Gordon, and Bean were sealed in a special quarantine trailer for the trip back to Houston. There they would wait out the balance of a twenty-day quarantine in the space center's Lunar Receiving Laboratory.

For now, aboard the USS *Hornet*, the three men were just happy to be back on earth. Pete and Dick sipped martinis, watching the flight surgeon sew up the cut above Bean's eye, and lent a hand by sterilizing the wound with the contents of their glasses. As if they needed a reason to be any happier, they received a phone call from President Nixon, who told them, "I'm promoting you to Captain Conrad, Captain Gordon, and Captain Bean."

Quarantine passed easily. Bean realized it was a good idea, not because he and his crewmates had any "moon germs," but because it gave them a chance to get through their post-mission reports and debriefings without everyday distractions. Soon they emerged into bright December sunshine to begin a round of parades, dinner at the White House, and a world tour for the president aboard Air Force One. It was all wonderful, but it gave Bean a new appreciation of his normal life. After dining with kings and prime ministers, Bean returned to Houston glad to simply have a chat with his next-door neighbors.

Back in Houston, Bean's mind soon focused on one question: What to do next? There was only one great space adventure available to him, and that was Skylab, the earth-orbit space station he had worked on while still a rookie. Constructed out of Apollo hardware, Skylab was NASA's first experience building and operating a space station. In the process, scientists would learn about the effects on humans of long-duration spaceflight, paving the way for journeys to the planets.

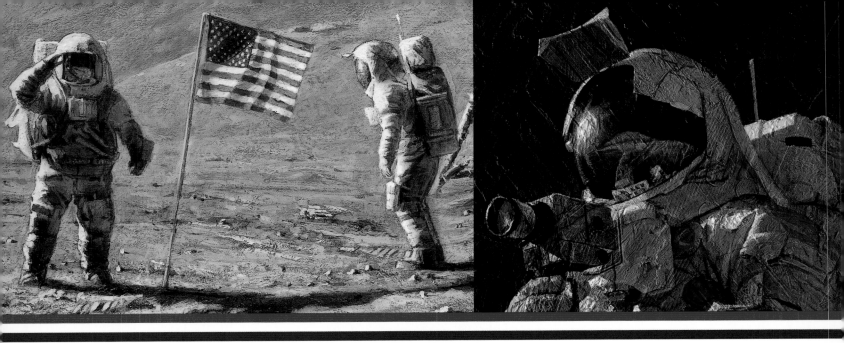

FENDER LOVIN' CARE

[PREVIOUS PAGE]
Apollo 17 Astronauts Gene Cernan and Jack Schmitt are doing some "low-tech" body work on their high-tech Lunar Rover. During their first moonwalk Gene accidentally hooked the hammer he carried in his right leg pocket on the Rover's right rear fender extension, knocking it off. He fixed it temporarily by taping it back on using gray duct tape. Unfortunately, somewhere on their lunar drive the tape gave way and the fender extension fell off and was lost for good. Losing a part of a fender, a minor problem on planet earth, is a serious one in the light gravity of the moon. Gene would report, "Oh, it pretty near makes me sick at losing that fender."
Gene later said, "With the loss of any of the fender extensions the dust generated by the wheels is intolerable. Not just the crew gets dusty, but everything mechanical on the Rover is subject to dust. I think dust is probably one of our greatest inhibitors to a normal operation on the moon."
Back on planet earth, Astronaut John Young and other friends in mission control conceived a nifty repair. After wake-up the next morning, Gene and Jack would select four plasticized maps already used on the mission and tape them together. Back with the Rover on the surface that morning, they could continue with the repair.
I painted Gene and Jack aligning the maps to the fiberglass fender. When Gene is satisfied, Jack will hold the maps steady as Gene secures them using two small clamps normally used to mount auxiliary lights inside the lunar module cabin. The fix worked!

Skylab crews would also look down at the earth with special cameras, and out at the sun and the heavens with an array of telescopes. Bean hoped to command one of the upcoming visits to the station. And he got his wish: Deke Slayton informed him that he would lead the second mission, which was slated for a record-breaking fifty-six days in orbit.

As Bean went into training for Skylab, other astronauts followed in his lunar footsteps and racked up a host of accomplishments. After the "successful failure" of Apollo 13's aborted mission, (which tested astronauts and flight controllers alike in what many termed NASA's finest hour), Alan Shepard and his Apollo 14 crew visited the moon's Fra Mauro highlands. For Shepard, the flight marked the end of a ten-year absence from spaceflight caused by an inner-ear disorder. On Apollo 15, Dave Scott and Jim Irwin visited the mountains of the moon, where they drove a battery-powered Lunar Rover. John Young and Charlie Duke were an exuberant pair of explorers on Apollo 16's mission to the moon's southern highlands. Then, in December 1972, Gene Cernan and Astronaut-Geologist Jack Schmitt explored the moon's Taurus-Littrow valley and brought the Apollo program to a spectacular conclusion.

By that time Bean was deep into his role as Skylab 2 spacecraft commander. He had two fine rookies on his crew. Jack Lousma, a former Marine and a superb athlete, was dedicated and hard-working. Bean could imagine him in the jungles of Vietnam listening to his platoon decide it was too dangerous to rescue a wounded Marine under heavy enemy fire—and then being the guy who crawls out of his foxhole and does it anyway. Owen Garriott was the ideal scientist, with an unceasing curiosity about the world and the universe, and an agile mind capable of solving complex problems on the back of an envelope. Now veteran astronaut Bean was in command of two rookies. He had always thought that would mean passing on everything Pete Conrad had taught him. Instead, he remembered a story he'd read about the ancient Greek philosopher Diogenes. In the story as Bean learned it, Alexander the Great

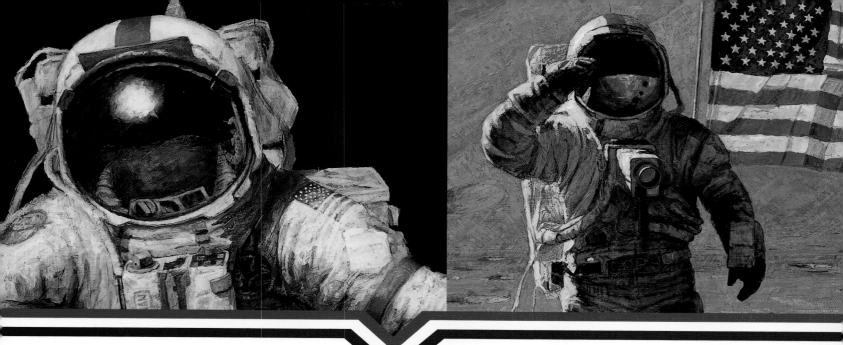

brings his son to the great philosopher, to be educated. Leaving the boy, he asks Diogenes if there is anything he can do to help. Diogenes replies, "Stand out of my light." Bean realized that his role with Garriott and Lousma was to stand out of their light.

In July 1973 Bean, Garriott, and Lousma rode a Saturn 1B rocket into earth orbit and linked up with Skylab. As they set up shop aboard the station, Bean's biggest concern was keeping strong and healthy despite the toll taken by weightlessness on the body, which includes weakening of the cardiovascular system. Bean made sure he and his crew exercised 90 minutes each day, including rides on a stationary bicycle. (Bean once stayed on the bike for an entire orbit, allowing him to claim the title of first person to pedal a bicycle around the world.) And it paid off. Three days before they returned to earth, after almost two months in orbit, Bean and Garriott took a spacewalk to retrieve film from Skylab's solar telescope. They had no difficulties working in their pressurized space suits. And during a lull in the activities, Bean scored a first that topped anything he'd done as a college gymnast: a weightlessness handstand atop the solar telescope 270 miles up, at 17,500 miles per hour. Most of all, as he and his crew returned to earth, Bean was proud of the amount of work they'd done. By asking for extra tasks, they'd logged 150 percent of their pre-flight goals for the mission, an achievement that to this day has never been surpassed. Back on earth, Bean felt a sense of accomplishment that outshone even the glow from Apollo 12.

Before he'd returned to earth, Bean had thought about the planned joint U.S.-Soviet spaceflight, the Apollo-Soyuz Test Project (ASTP). The American crew—Tom Stafford, Vance Brand, and Deke Slayton—had already been chosen, but Bean had his eye on the backup commander post. It was only a few days after he was back in Houston that he got a phone call from Stafford offering Bean the assignment. Bean accepted, and was invited to bring Jack Lousma onto the crew with him. As glad as Bean was to be working on the mission, he knew no one was happier about ASTP than Deke Slayton. For Slayton, flying in space would mean the end of a 16-year ordeal as a grounded astronaut. Still, Bean would always be thankful that providence put Slayton and his fellow "wounded eagle" Al Shepard in leadership positions that, while so difficult for them, were so crucial to the success of the space program. Bean would always feel that for each of them, it had been their finest hour.

Meanwhile, learning to speak Russian was anything but easy for Bean, but going to Russia to work with their space teams was a wonderful experience. The Soviet prime crew was Alexei Leonov and Valeri Kubasov, and the backup crew was Anatoly Filipchenko and Nikolai Rukavishnikov. Everyone was friendly, and eager to put aside political differences for the sake of personal feelings. The success of the ASTP mission showed, in Bean's mind, that despite our countries' differences we can, and should, work together.

By then work was underway on NASA's most important venture since Apollo, a reusable Space Shuttle. Bean oversaw the training of a new crop of astronauts, selected for shuttle missions in 1978, including the first women and minorities to join the astronaut corps. Had he wished, he would surely have commanded one of the shuttle's first flights—and he would have loved to do that. But for the first time in his professional life, something had become more important to Bean than flying.

By this time, most of Bean's fellow lunar voyagers had left NASA. Many, including Pete Conrad, had become aerospace executives. Dick Gordon had served as Executive Vice President of the New Orleans Saints football team. Jack Swigert had been elected to Congress before he was claimed by cancer. And then there was Jim Irwin, who was devoting his life to a Christian ministry. There were almost as many answers to the question, "What do you do after you've been to the moon?" as there were astronauts. Bean had known for a long time what he wanted to do.

As early as 1962, when he was a test pilot at Pax River, Bean had taken night classes in art, including some work in drawing and watercolor. In those first years at NASA, he'd kept up with it whenever his demanding schedule would allow. After ASTP, with no space missions in sight for

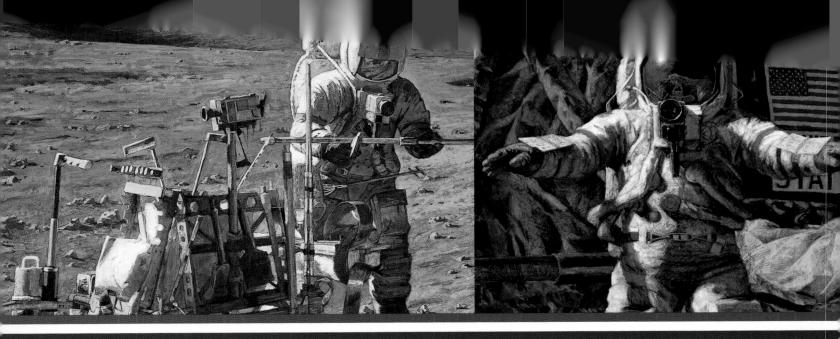

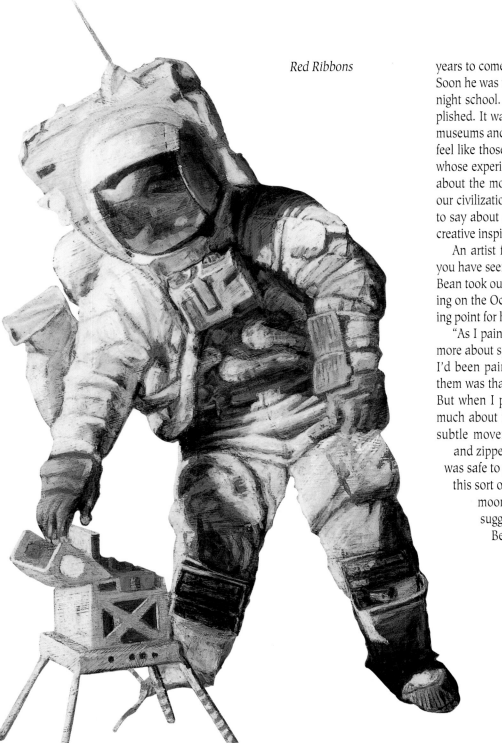

Red Ribbons

years to come, Bean paid his old interest a little more attention. Soon he was taking classes at the Houston Museum of Fine Arts night school. Technically, his work was becoming more accomplished. It was beginning to look more like paintings he saw in museums and art books, but something wasn't right. Bean didn't feel like those artists who lived one hundred or more years ago whose experiences were from this planet only. He thought a lot about the moon. It was our generation's frontier. It was one of our civilization's and century's greatest adventures. He had lots to say about Apollo but Bean loved color. Where could he find creative inspiration in a black-and-white world?

An artist friend in Houston encouraged him to "paint what you have seen, what is special in you." So one weekend in 1974 Bean took out a photograph he had taken of Pete Conrad standing on the Ocean of Storms. He would use this photo as a starting point for his first lunar surface painting.

"As I painted," Bean recalls, "I realized that I knew so much more about space exploration than about any other subject that I'd been painting. When I painted flowers, all I knew about them was that they had petals and stems and leaves and roots. But when I painted Pete Conrad in his space suit, I knew so much about it. I knew how it felt, how difficult it was to make subtle movements. I knew what each connector and fitting and zipper was for. I knew how to connect all the parts so it was safe to go outside. I had spent 18 years at NASA learning this sort of thing. And that's what I knew best." Painting the moon became a wonderful hobby. When a close friend suggested that he should become a professional artist, Bean thought it was a joke. And then thought again. He knew that it was one thing to paint on weekends, and quite another to make it his profession. Over the next few years, he would occasionally take a week or two off to live the life of an artist, spending each day at the easel. True to his NASA roots, he was simulating his upcoming mission. It was different than he imagined,

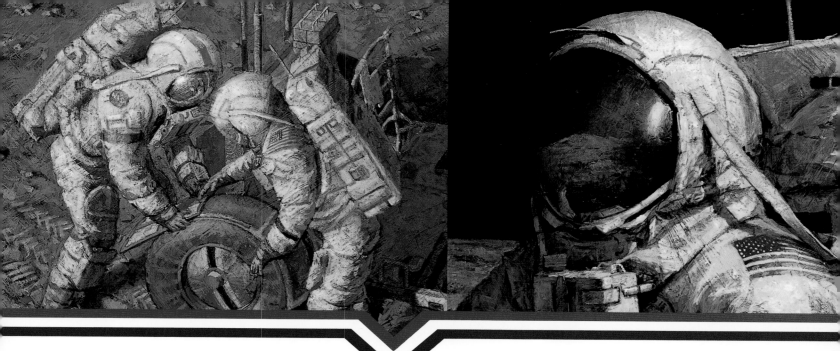

but just as enjoyable as he'd hoped. By the time the shuttle was being readied for its first flight, Bean realized it was time to keep a promise he had made to himself as he circled the moon in Apollo 12. Looking down at that barren world, fully aware of the risks he and his crewmates had taken to get there, Bean had told himself, "If I get home, I'm going to live my life the way I want to." Late in 1981, a few months after the Space Shuttle scored a near-perfect space debut, Bean made an announcement that caught his fellow astronauts by surprise. He was one of the most experienced astronauts in the world. Now, at the age of forty-nine, he was going to give it all up. He was leaving NASA to pursue a career as a professional artist.

There was much about the image of an artist, Bean knew, that didn't set well with the kind of person he had spent his life trying to be. Jet pilots don't paint. Astronauts aren't supposed to be "sensitive." But that contrast, Bean says, is part of who he is—and one of the main reasons he was driven to trade the demands of the cockpit for the easel. And Bean had come to realize that even in history's most elite fraternity, he was unique: he was the only moonwalker who felt compelled to record the first explorations of another world in art.

"I was handed a gift that I've never heard of being given to any other artist in history," Bean says. "No other artist who has ever lived has had a planet all his own."

Bean expected that the other astronauts might raise a few eyebrows at his new career. He laughs when he recalls their reactions: "I'd say sixty percent of them thought maybe I was having a mid-life crisis." But even the ones who seemed to accept it asked, "Can you make a living doing that?"

Bean had no illusions about what that would take. In his first career he had reached the top; he would have to start his second one at the bottom. It would take a different kind of bravery than climbing onto a Saturn rocket and being fired off to the moon. Art was not a risk of life and limb, but of reputation and acceptance. The experience of leaving the safety of his home world and venturing to another had given him the courage he needed.

"I just felt, 'If can go to the moon, I can certainly learn to be a good artist.'" In Bean's mind, eighty percent of talent is a willingness to work hard enough to master a new skill. He'd done that in the Navy, and at NASA, and now he would do it at the easel. Bean knew he would need help from master artists who could be his mentors. He found it in the persons of Houston-based artists Lajos Markos, Evelyn Stebbins, and Glenn Bahm, and California artist Neil Boyle. He also attended a number of art workshops given by Howard Terpning, Jim Christensen, Ron McKee, and other artists.

The more Bean painted, the more he realized that piloting and painting weren't so far apart. "They're not at all incompatible. Flying skills are so much like painting skills, it's amazing. All the good artists I know are observant and logical about everything. I never knew you had to be this way. People don't realize that you've got to be very smart to be a good artist. And I think the same way about pilots. You've got to be pretty smart to be a surviving pilot." But to Bean, achieving excellence in the air was not nearly as difficult as it is in the studio. "There are many people who can fly airplanes well," he says, "but there aren't that many people who can paint well."

Bean brought the same single-mindedness to his new life that he had brought to his piloting career. He would make the hour-long drive to the Johnson Space Center outside Houston, to study the Apollo artifacts they had on display, or consult a debriefing in the history office, or stop in to ask the advice of a fellow moonwalker. With the diligence of a medieval scholar, he made himself an expert on the variations in the space suits, and the lunar module, and the tools that were carried on the six lunar landings.

"For the kind of art I'm doing, which is historical in nature, the number one consideration is accuracy. If I'm painting John Young on the moon," Bean says, "I paint him so that his suit fits right, and he's the right size relative to other astronauts, and he has the right things in his pockets. I don't think this is nitpicking; this is what I believe my art needs."

Bean rediscovered Apollo, as a visual adventure. His own memories of Apollo 12, many of which had lain dormant, now came to the surface. He delved into the in-flight transcripts and post-flight debriefings from his own mission, and the other lunar landings. He studied what his colleagues had said about the moon's appearance, and colors. And what he found surprised him. "What I found was, even though I didn't realize it at the time, I made so many more comments about the colors of things, and the lights or darkness of things than anybody on any mission. And it was just because those are the things I care about and notice. It's what I'm interested in. Only I didn't even know it showed."

One thing he didn't do on the moon was to attempt to create some artistic record, however small, of the experience. "I should've taken along some acryllics and some paper, and then at night before I went to bed, I could have looked out the window and painted just what I saw out there, real quickly—a ten- or fifteen-minute sketch." Smiling, Bean adds, "Maybe it would be in the National Gallery right now as the first piece of art ever done on another planet. But it never dawned on me. I was thinking about spaceflight and doing that job right, and it just never dawned on me to think about art." Bean also admits he wished Pete and he had taken a football along.

Now he was thinking about art, and about the moon. Initially, the scientist in him wouldn't think of departing from the views in his memory. "When I would paint anything different from the way it actually was, I wasn't satisfied." But as his painting progressed, he began to experiment with adding more and more color, much as Claude Monet did with seemingly monochromatic objects like grainstacks. Bean had long admired Monet's use of light and color. Today, Bean never creates a painting that isn't as colorful as he believes it can be, and still feel like the moon.

"You know, people romanticize the moon. But I've been there, and I can tell you that it's mostly black dirt. But I want it to be the most beautiful black dirt that's ever been painted in the history of art. I may be the most diligent and caring dirt artist there ever was."

For Bean, every day begins at the easel. It takes him between six and eight weeks, and sometimes longer, to finish a painting. ("Much longer than most artists," Bean says.) And each one tests him in a way that even being an astronaut did not. "It's different from flying airplanes or spaceships. You never get it down." The goal Bean sets for himself is simple, but not easy: to make each new painting as beautiful as he can. "Right off the bat, that means I'm at the edge of my ability. I know I can create a beautiful painting. But at the same time I know it's going to be a struggle. I never felt that way about flying." But all the hard work has paid off, Bean says. "I can't complete a painting as fast as I thought I would be able to. But I'm painting better than I ever dreamed I would when I left the space program."

And Bean is glad he took the risk of embarking on this new voyage, of keeping the promise he made to himself as he circled the moon. It has paid dividends Bean feels each day of his life. "I feel happy each and every day. I've had all this tremendous luck. I've been blessed beyond most men, way more than I deserve. I'm really content and happy to be alive on this planet earth every day."

I've had several astronauts say that they're very proud of my new career. I found it kind of surprising, because it's not the kind of talk astronauts give one another. I guess they feel I'm helping to preserve something that means a lot to all of us." It makes Bean even more conscious of what he is striving for in the paintings: to reflect the same excellence that characterized Apollo itself.

"I think of myself not as an astronaut who paints, but as an artist who was once an astronaut. I see myself beginning a little branch on the tree of art that's called, 'Art off this earth.' I'm just at the very bud of this branch. It will grow as space exploration continues." When people are finally living in bases on the moon, and in colonies on Mars, Bean predicts, there will be artists among them. Bean hopes that in the future his paintings will be seen in

museums on the moon and Mars, perhaps alongside works created by shuttle astronauts, and even veterans of the first voyages to the other planets.

For now, we have only to look at the moon, the way Bean sometimes does. "It seems so far away. I think it's because no one is building spaceships to go there, the way they were thirty years ago. When I looked at the moon back then, I knew I was going there in six months, and then one week, and then one day. It seems a lot farther today because no one is doing that."

The sense of distance only emphasizes for Bean what a momentous achievement Apollo really was. Humans are fallible, and so are their machines. But to reach the moon, it all had to work almost perfectly. "We said at the time, that when you see astronauts walking around on the moon, it will be because 400,000 Americans cared enough to give the best effort they could give." The fact that no one has been back to the moon, or is likely to be within the foreseeable future,

only makes Bean's sense of amazement stronger. "I think it becomes a bigger accomplishment as the years pass."

Sometimes, when Bean thinks about his walks on the moon, he wonders what it would be like if he could go back. "I would leave a little more time to understand the feelings of being there. The awe, the amazement. That would've been a nice thing to do. I would say to myself, 'I'm going to remember this moment. I'm just going to enjoy it'."

Me and the Moon

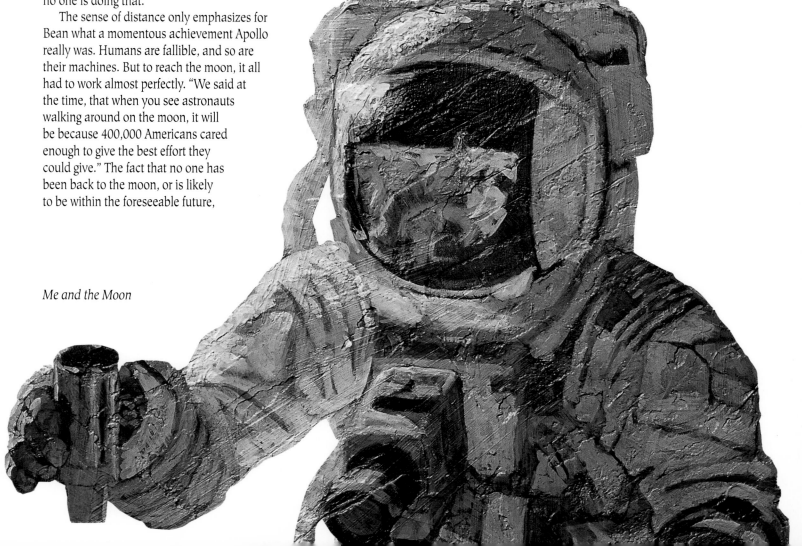

BIG AL AND HIS RICKSHAW

In this painting Al Shepard is assembling a double core tube. The core tube is a hollow pipe with a sharp front edge so that it can be pounded down into the lunar soil. After Al pounds the core tube down as far as he can, he will withdraw it, and with any luck at all, the subsurface soil will come up inside the tube in layers in the same order they actually are under the lunar surface. When it is returned to earth, the geologists can tell more about the history of that area than using surface samples alone.

The Modularized Equipment Transporter or MET in the foreground was the first wheeled vehicle on the

moon. It was designed to carry tools and equipment to the work sites and return the rock and soil samples to
the lunar module. Al and Ed Mitchell took turns pulling it as they moved about the moon. It was easy to pull
as long as the surface was level and the dust was thin, but the going got tough in the deep dust leading up to
the top of Cone Crater. Al said, "I would pull for awhile while Ed lifted and shoved from the back. After awhile
we would change places—he'd pull and I'd carry." The MET was difficult to draw and paint, too. It took me
one whole week to complete the drawing before I began to paint it.

CHARLIE DUKE, SOIL SCIENTIST: THE MAXIMUM PUSH

Apollo 16 Astronaut Charlie Duke is a long way from his hometown of Lancaster, South Carolina. Even though that is Stone Mountain in the background, he's not in Georgia, either. I painted him giving a maximum push to his self-recording penetrometer.

The penetrometer consists of a metal shaft with a precisely designed cone and removable reference plate on one end and a recording drum on the other. As Charlie pushes in on the drum end, the cone and shaft penetrate the lunar soil, recording the force and the depth. The recorder will be brought back to earth to better understand the mechanical properties of the lunar soil.

These mechanical properties, for example, bearing strength, are studied for both engineering and scientific reasons. Future design of spacecraft, surface vehicles, and habitats will be based, in part, on understanding the properties of lunar soil. Charlie would later say, "The penetrometer worked as advertised, but I couldn't apply a steady force. I'd start leaning on it and lose my balance. I tried two or three little techniques, and every time it worked the same way."

Charlie's maximum push is not without complications. He will shortly lose his balance and fall to the lunar surface. But not to worry! Except for getting a little dusty, Charlie will be able to do a simple push-up to his knees, then a quick knee-hop back to his feet.

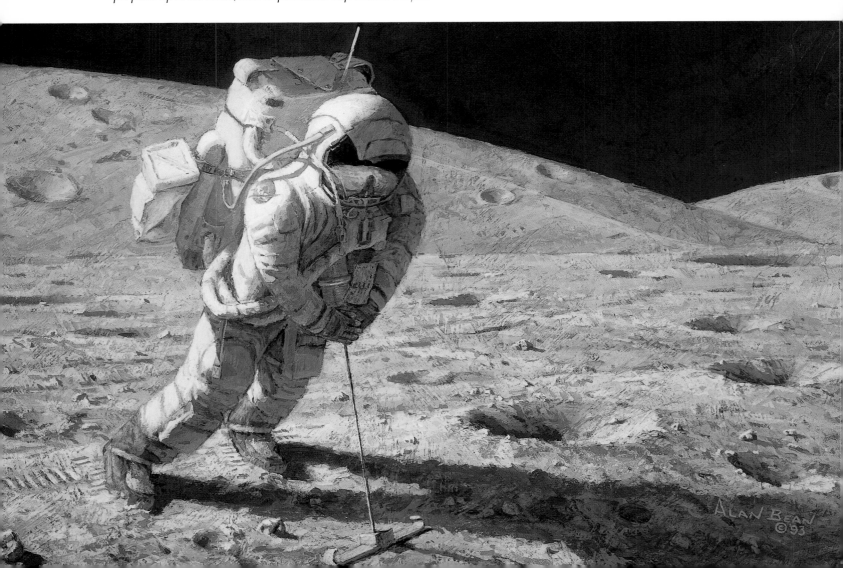

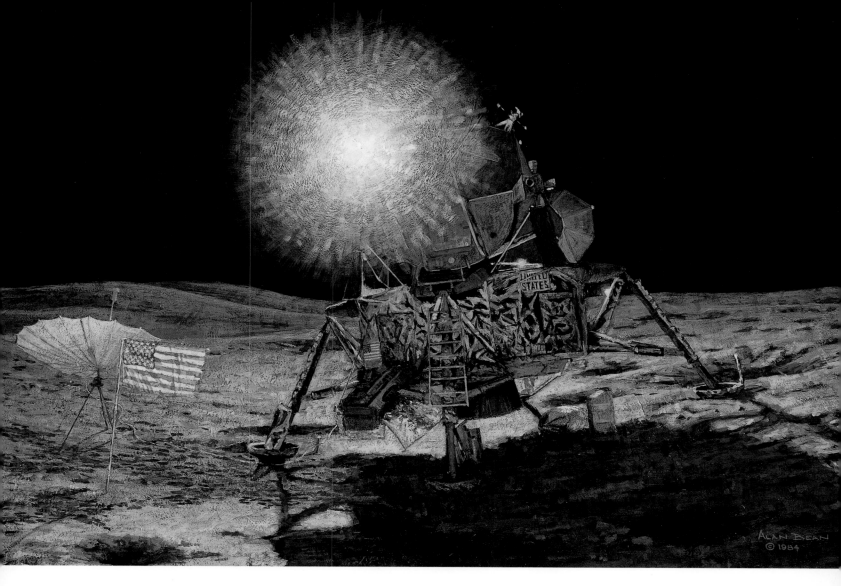

SUNRISE OVER ANTARES

I painted the moonscape Alan Shepard and Ed Mitchell saw in a final look back at their lunar module Antares as they began their trek toward Cone Crater. The sun is just peeking over the top of their spaceship, making it difficult, even painful, to look that way. It's the same sun we see here on earth, but it appears much brighter because there is no atmosphere on the moon to partially screen its brilliant rays. Even with their gold visors in place they try to avoid looking in the direction of the sun.

Al and Ed made their landing descent with the sun at their backs; this was an important consideration in planning the time of landing because it was necessary to land when the sun was relatively low in the lunar sky, so that the long shadows would help Al and Ed spot craters and rocks to avoid. Without shadows as a visual aid, accurately judging height to make a safe touchdown would have been an even more difficult and dangerous task.

The sky is painted just the way it looks up there, black. Not a flat black, but a shiny, patent leather black. I could not see the stars while walking on the moon because the sun made the surface so bright that the irises of my eyes closed way down. It's a little like walking out of a brightly lit room and looking up at a dark clear night sky.

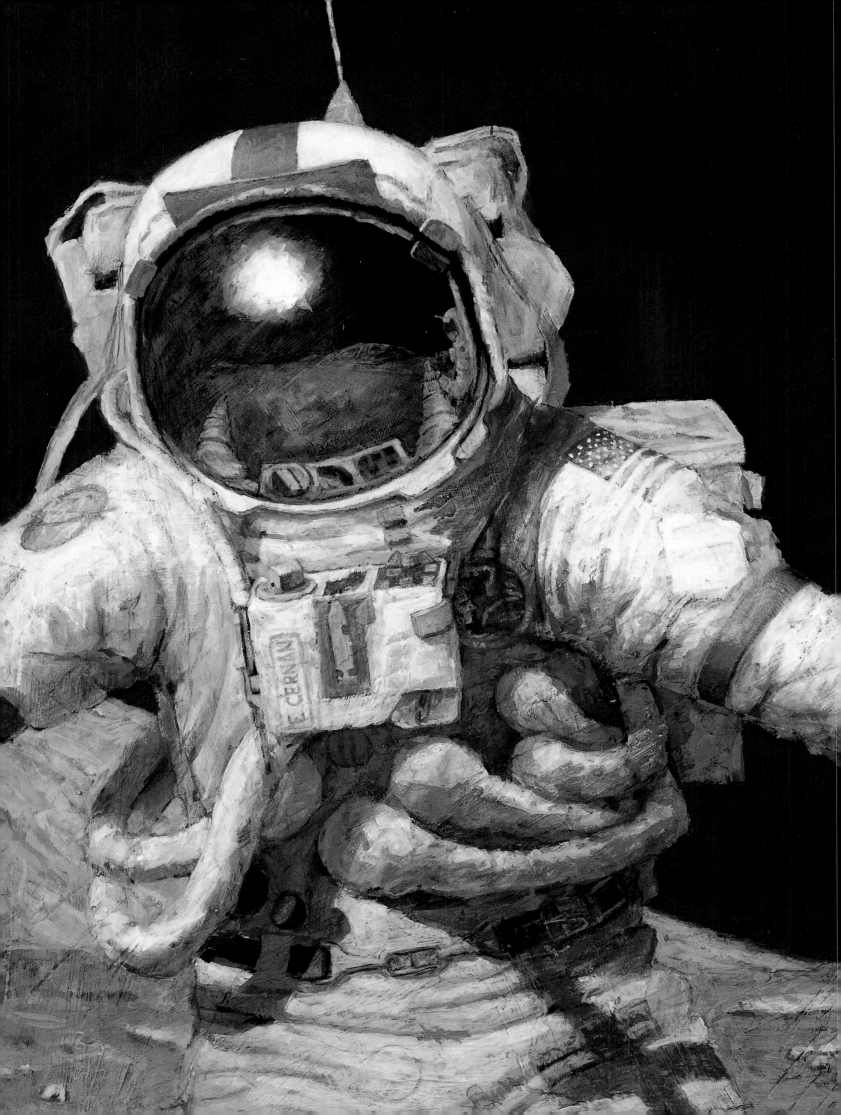

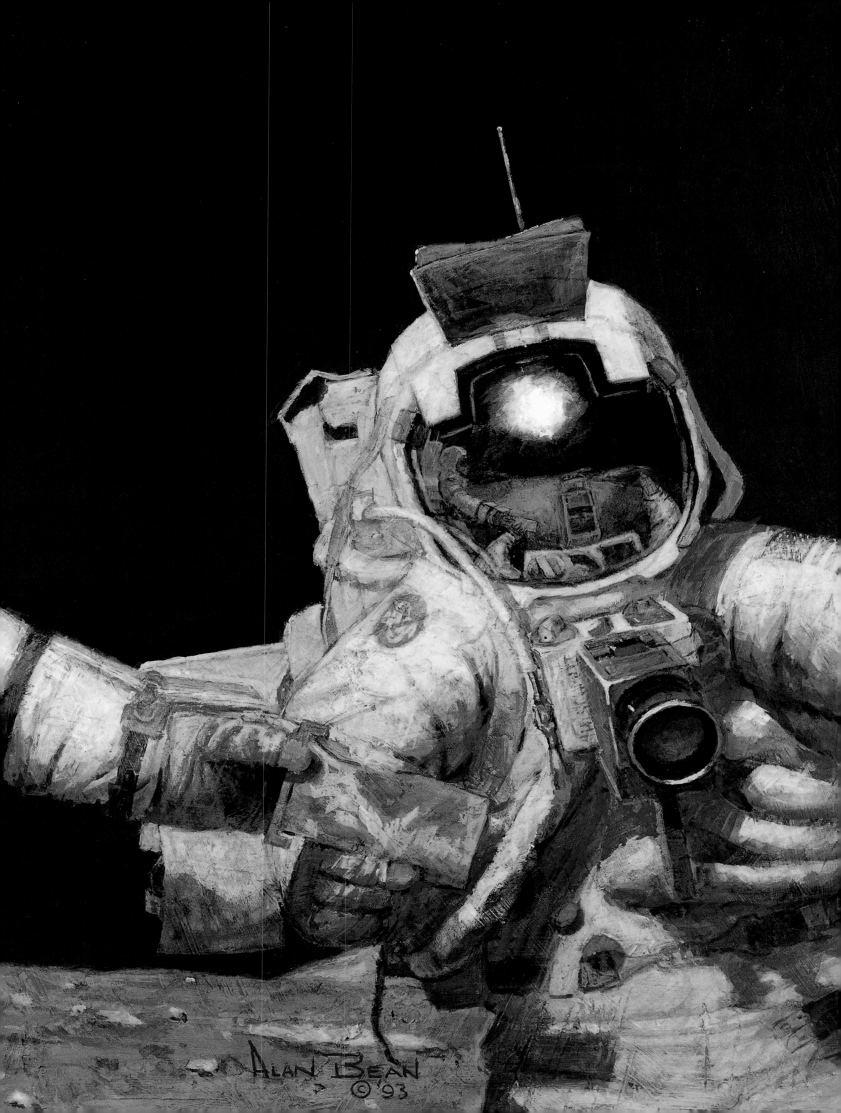

RIGHT STUFF
FIELD GEOLOGISTS

[P R E V I O U S P A G E]

Apollo 17 Astronaut Jack Schmitt says he needs an extra sample bag. Mission Commander Gene Cernan is not at all surprised that Jack has found another interesting rock, and hands him the bag. After all, Jack was a geologist by profession before he was selected as an astronaut. He even has a doctorate in geology from Harvard.

Gene Cernan's background is in military aviation. All of us who have flown in space have a background similar to Gene's because the skills needed to fly spaceships are an extension of those needed to fly high performance aircraft. But getting there and back is not enough. We needed astronauts who could make the best scientific observations once they were actually on the moon.

NASA was faced with the question, "Do we take test pilots and teach them geology or do we take geologists and teach them to fly?" They decided to try both. Jack was sent to Air Force pilot training immediately after his selection. The rest of us received hundreds of hours of geology training in the classroom, in the laboratory, and in the field.

As Gene would say, "I don't think either one of us outdid each other. We used our individual background and expertise where it had to be used. I took extra care of the off loading of the Rover and during that period Jack had time to look around, survey the situation, plan our next move. Then we both went to work."

SENATOR SCHMITT
SAMPLES SUBSURFACE SOIL

[R I G H T]

Astronaut Harrison "Jack" Schmitt is taking a scoop of lunar material from the lip of a small crater. Behind him, Apollo 17 Commander Gene Cernan is readying two sample bags to contain the soil for the quarter million-mile journey to earth.

I phoned Jack one morning as I was working on this painting. He recalled trenching into a crater at one point during his lunar surface exploration. "Many craters are formed when meteoroids coming in from deep space strike the moon's surface at very high speeds, say 10,000 miles per hour or more. At the point of impact the soil and rocks are ejected up and out resulting in the deepest and oldest material coming to rest at the surface. It's similar to the effect experienced when one turns back the bed covers, the sheet rests on top of the bedspread. By returning samples of soil from a variety of depths, we begin to understand how long ago the crater was formed, and the subsequent cosmic ray and solar wind activity."

Jack continued, "I could see light and dark layering in the trench wall. This was a first, and a readily visible profile suggesting the different ages of the subsurface soil."

Jack is the only practicing professional geologist in all history to make first-hand observations any place other than our good old planet earth. He was a superb scientist and a great astronaut. After the Apollo Program was completed, the people of New Mexico elected Jack to the United States Senate.

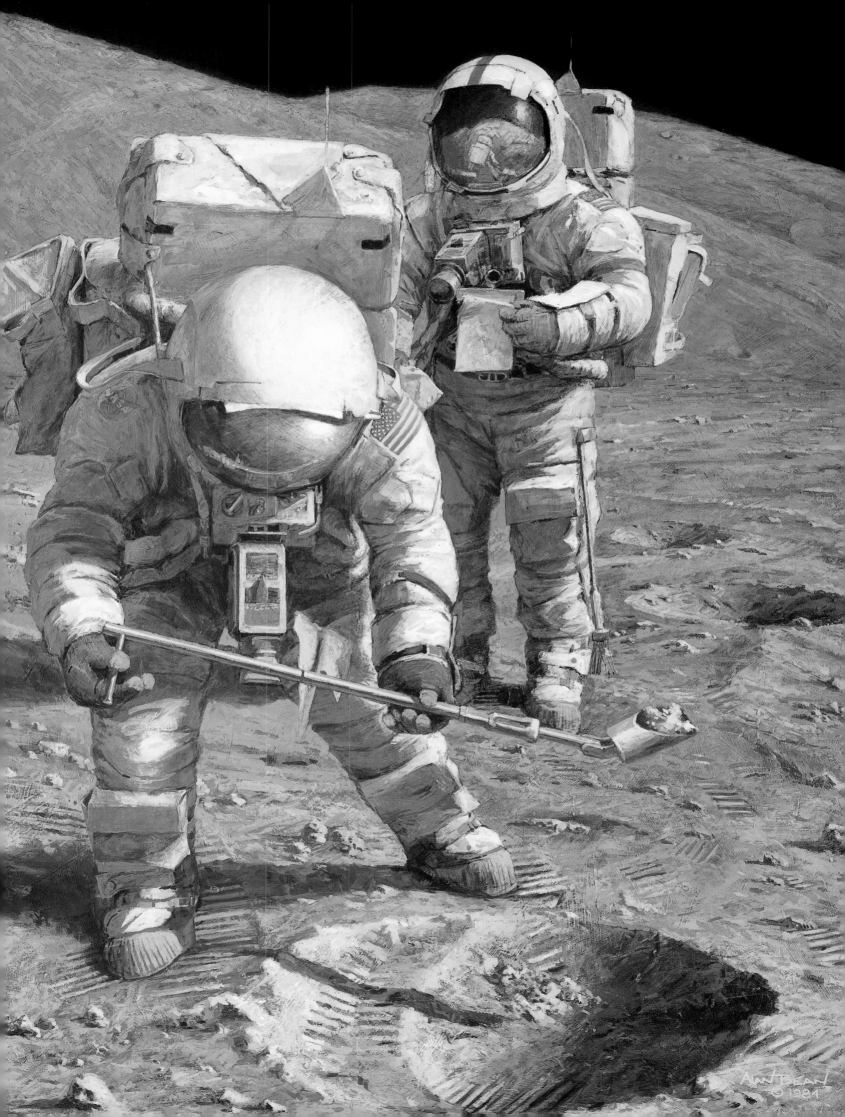

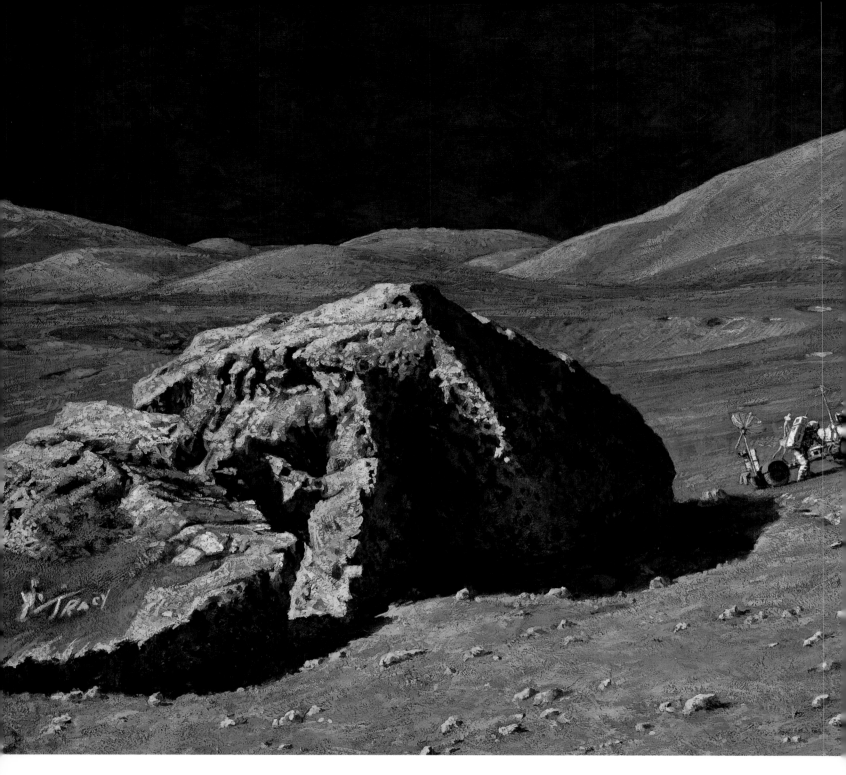

TRACY'S BOULDER

Gene Cernan and Jack Schmitt have finished their work at Station Six and are loading the Lunar Rover with their rock samples and experiments. Although our planet earth is not visible in this painting, it is some 239,000 miles away in the direction the Rover antenna is pointing.

This panoramic view of the Taurus-Littrow Valley with South Massif to the right and East Massif to the left gives an idea of the majestic vistas that await earthlings of future generations. Someday, this might be the site of a scientific station, or maybe a shopping center or housing development. When I showed this painting to Gene Cernan, he told me how he had scooped a dirt and dust sample from the left side of this massive boulder. He said he wishes he had thought of writing his daughter's name in the dust but the idea didn't come until he got back home.

The sheer romance of Gene's idea was so appealing that I gave him a blank sheet of paper and asked him to write Tracy's name the way he would have wanted it in the dust on the moon. Then I got to work with my paint brushes. As Gene's friend, I have employed artistic license to save him the long trip back to Station Six, not to mention the monumental savings to all us taxpayers.

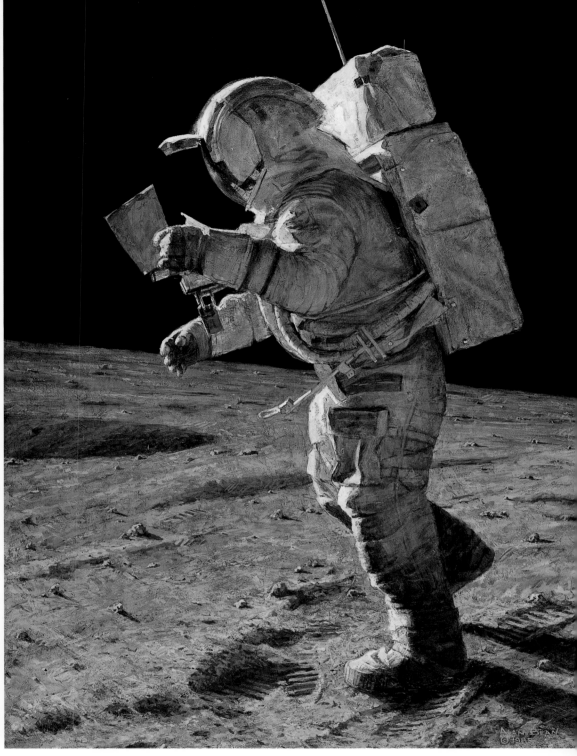

GALACTIC NAVIGATOR

Apollo 14 Astronaut Ed Mitchell is having the same lost feelings all moon explorers experience. He doesn't know exactly where he is right now. Lunar maps are made using photographs taken from lunar orbit, and the most noticeable features from orbit are craters. Unfortunately, the view changes at ground level. As Ed observed, "Al Shepard and I couldn't see our next set of landmarks from our present position. Large craters we expected to be able to see were hidden behind other craters, ridges, old worn-down mounds." It is difficult to judge distances because there is no atmosphere. Al reported, "It's so crystal clear up there it just looks a lot closer than it is."

Moving about on the moon is so different from walking or running on earth that estimating how far one has moved during a certain period is impossible. Ed is wondering, "Have I gone 500 feet or 1,500 feet?"

When Ed arrives at a crater or boulder, there are no signs to confirm that it's the right one. He said, "I never knew what to expect when I went over the ridge, what I was going to see on the other side." Although he may not know exactly where he is, he's not lost. Ed and Al can always trace their footsteps back to the lunar module and then back home.

A FIRE TO BE LIGHTED

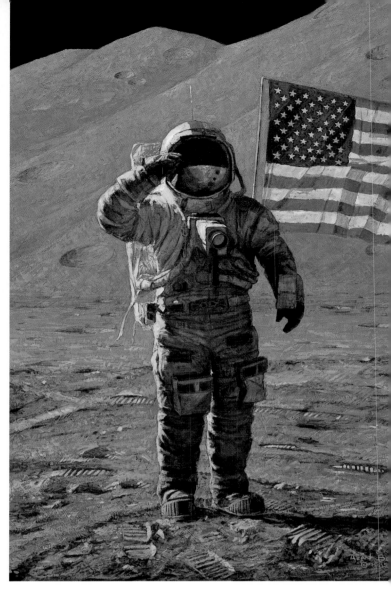

"Falcon is on the plain at Hadley." These were the first words heard back on earth when Dave Scott and Jim Irwin made their landing in July 1971. Falcon had alighted them on a scientific bonanza. As Dave looked around from Falcon's overhead hatch, he thought, "No place on earth has such a concentration of features." There were mountains taller than Mount Everest (relative to their surroundings) and a meandering gorge a mile across, a thousand feet deep and seventy miles long.

Lunar exploration had come a long way since Neil and Buzz made their first moonwalk just two years earlier. Dave and Jim had the Lunar Rover, a moon car that would make possible five times the total surface exploration of the three previous missions, and they had improved space suit backpacks which allowed them to stay outside of their spacecraft nearly twice as long as any of us who had flown earlier.

I have painted Dave Scott, a good friend and skilled explorer, at the pinnacle of his astronaut career. In his own words, "We went to the moon as trained observers in order to gather data, not only with our instruments on board, but also with our minds. Plutarch, a wise man who lived a long time ago, expressed the feelings of the crew of Apollo 15 when he wrote 'The mind is not a vessel to be filled, but a fire to be lighted.'"

DRILLING FOR KNOWLEDGE

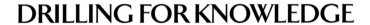

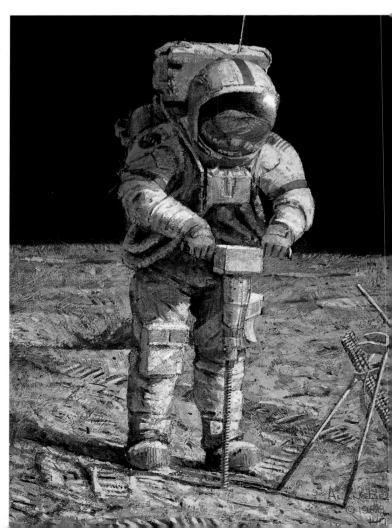

Apollo 15 Astronaut Dave Scott is using his new lunar surface drill. He is planning on drilling two holes, each 10 feet deep, to be used in an experiment that will measure the rate of heat flow from the interior of the moon. Knowledge of this heat flow rate may allow scientists to understand why we see evidence of volcanos on the moon yet we see no volcanic activity.

Dave had some difficulty. "When I got the first two borestems in, it was apparent I was hitting something very hard. The first 3 feet or so was quite easy to drill and then it was difficult to get it in any further. We'd never seen this in training nor had we ever seen any material that was compacted as hard as this material." Although Dave could not drill either hole to the planned 10-foot depth, the holes were deep enough to allow him to partially insert the temperature sensors.

Results from this experiment indicated that the heat generated in the interior of the moon is about one-fourth that produced by our planet earth. This is completely consistent with our observation that there was abundant volcanic activity during the early formation of the moon, some 3 to 4.5 billion years ago, but as the natural radioactive elements decayed and the moon cooled to its present level, there is no longer enough heat to create volcanic eruptions. This is unfortunate for us earthlings. Wouldn't it be exciting to look up at night and see the bright fires and dark smoke plumes of active volcanos scattered across the moon?

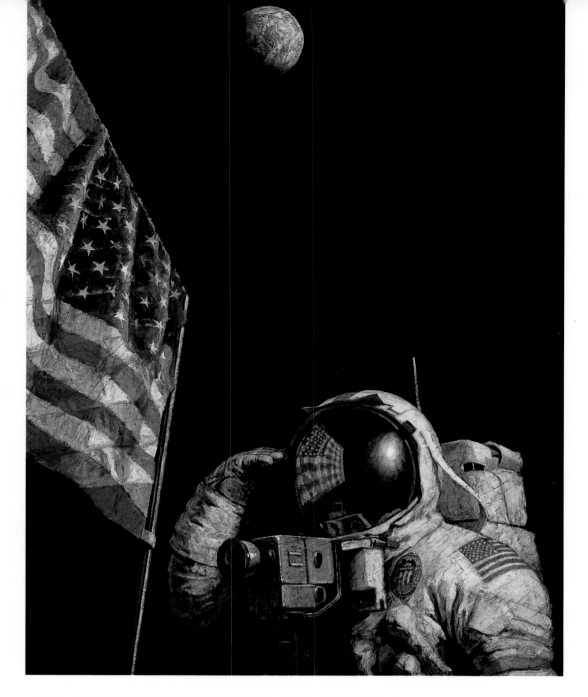

AN AMERICAN SUCCESS STORY

I painted Astronaut John Young as he stood proudly on the moon, but for a while it didn't look like he and Charlie Duke would even land there at all. Earlier, as they had been orbiting the moon in their lunar module preparing for descent, a call came from Ken Mattingly in the command module reporting an unexpected oscillation in the backup steering system for the rocket engine. They all knew that if this oscillation prevented the backup system from controlling the rocket properly then all three crew members would have to return to earth as soon as possible. If the primary and backup systems both failed, there would be no way to steer the rocket engine, and Apollo 16 and her crew would orbit the moon forever.

Immediately, engineers and technicians at mission control in Houston and at other key locations were alerted. Could they determine if the oscillations would prevent the backup steering system from doing its job? From North American Rockwell in California to the Kennedy Space Center in Florida, records were searched, simulations were run, and tests were conducted. In less than 6 hours the results were in. The oscillations would damp out as rocket thrust built up at engine start. The mission could continue. We all breathed a collective sigh of relief.

As John Young would say later, "It was a cliff-hanger from where we were sitting in the cockpit. But the ground, who were calling in data from all over the country, really came through. With a couple of clutch hits they put us right back in the ball game. It was a superb performance."

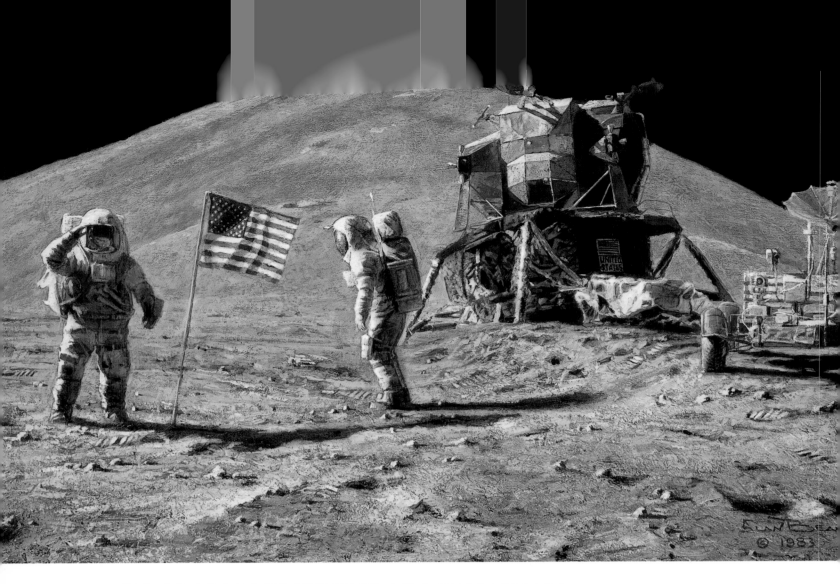

CEREMONY ON THE PLAIN AT HADLEY

"Falcon is on the plain at Hadley," reported the excited Apollo 15 Commander David R. Scott on July 30, 1971. Dave and lunar module pilot Jim Irwin were on the surface of the moon at a site rich with scientific potential. They would be able to make observations and gather samples for some three and a half days and would have for their use the first car on the moon, an electric dune buggy.

But first, the matter of the ceremony. Planting the flag, or perhaps a stick or spear before flags were created, has been a tradition in exploration since ancient times, and moon exploration was no exception. They couldn't, however, count on the wind blowing out the flag since there is no air on the moon. So they used a small metal snap-up curtain rod along the top edge of the flag.

Why had we gone to the moon at all? Was it worth the cost? There may be no single answer to these questions, which we all must decide for ourselves. The spirit of exploration is either in your heart or it is not. Dave Scott spoke eloquently when he said, "As I stand out here in the wonders of the unknown at Hadley, I try to realize there is a fundamental truth to our nature. Man must explore. And this is exploration at its greatest."

MOONROCK—EARTHBOUND

Collecting moonrocks was more than just reaching down and grabbing pieces we happened to like. The first problem was knowing which rocks, of the many that can be seen, are worth the time and energy to document, collect, and return. But we learned a lot about rocks in the six years of geology training on earth prior to going to the moon.

It wasn't easy for hot, right-stuff test pilots to sit through the hours and hours of classroom geology lectures and laboratory demonstrations. We did, however, take right well to the field trips to Arizona, Oregon, Iceland, Hawaii, and so forth, locations where the geology was thought to be similar to the moon. Field training was where we honed our skills.

The first rock we were taught to select was one that looked most like all the other rock in the area. This "typical" rock was photographed from two positions before we disturbed the ground. Picking up the rock was not simple either. In this painting, John Young is using the long tweezer-like tongs at a site near where Apollo 16 landed.

Charlie Duke is inspecting the rock, making specific comments to listeners on earth, then placing the rock in a numbered sample bag. This is a big day for the selected rock, as it has probably been sitting right here for at least 3 billion years, just waiting for some human being to single it out for a quick trip to planet earth.

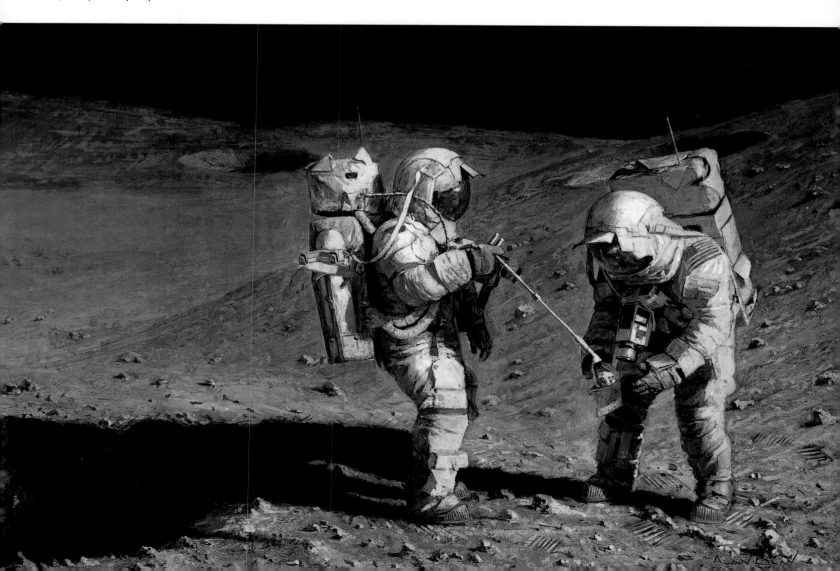

THE HAMMER AND THE FEATHER

I was watching Apollo 15 Astronauts Dave Scott and Jim Irwin busily loading the lunar module with exposed film and dusty moon rocks. As if cued by an invisible director, Dave turned and moved toward the television camera. "Well, in my left hand I have a feather; in my right hand a hammer. I guess one of the reasons we got here today was because of a gentleman named Galileo. A long time ago he made a rather significant discovery about falling objects in gravity fields, and we thought—where would be a better place to confirm his findings than on the moon? And so we thought we'd try it here for you. The feather is, appropriately, from an Air Force Academy falcon. I'll drop the hammer and the feather and, hopefully, they'll hit the ground at the same time."

Well, Dave let them go and since there is no atmosphere on the moon, they fell side by side. They did fall more slowly than on earth because the gravity is one-sixth that of earth's.

Dave continued, "How about that, this proves that Mr. Galileo was correct in his findings."

After more than three and one half centuries, at a distance of 239,000 miles give or take a few, from his home in Florence, Italy, Galileo Galilei's discovery that "gravity pulls all bodies equally regardless of their weight" was clearly and vividly demonstrated before a television audience that spanned the planet earth. He would have loved it.

Cernan, Gnomon,
& Crater #1

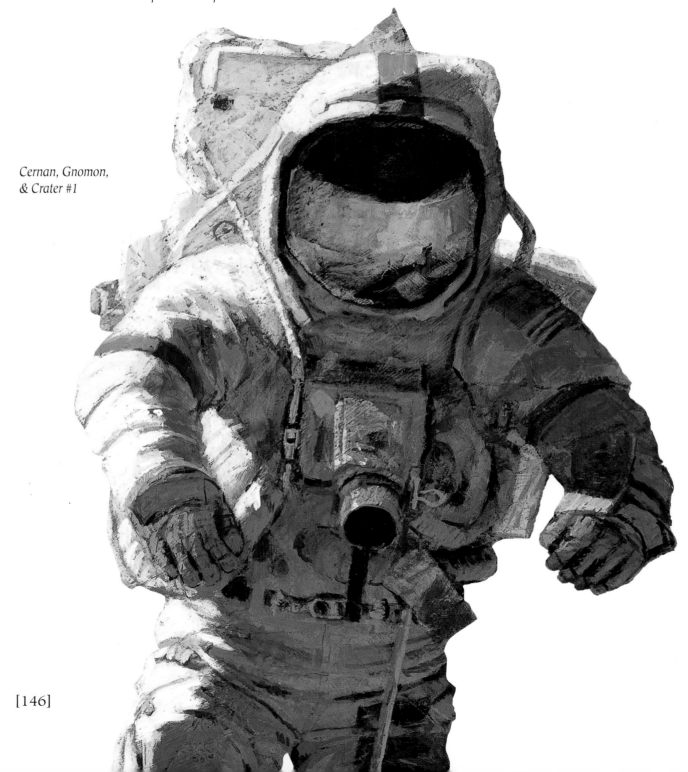

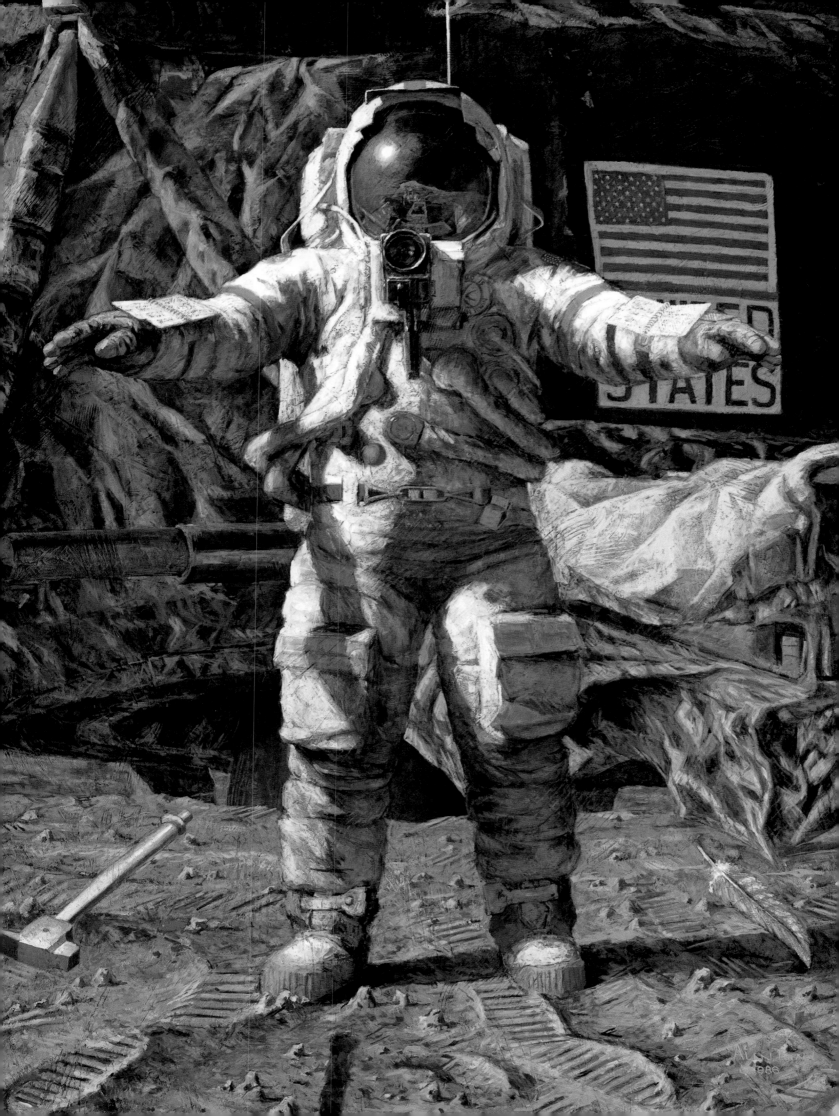

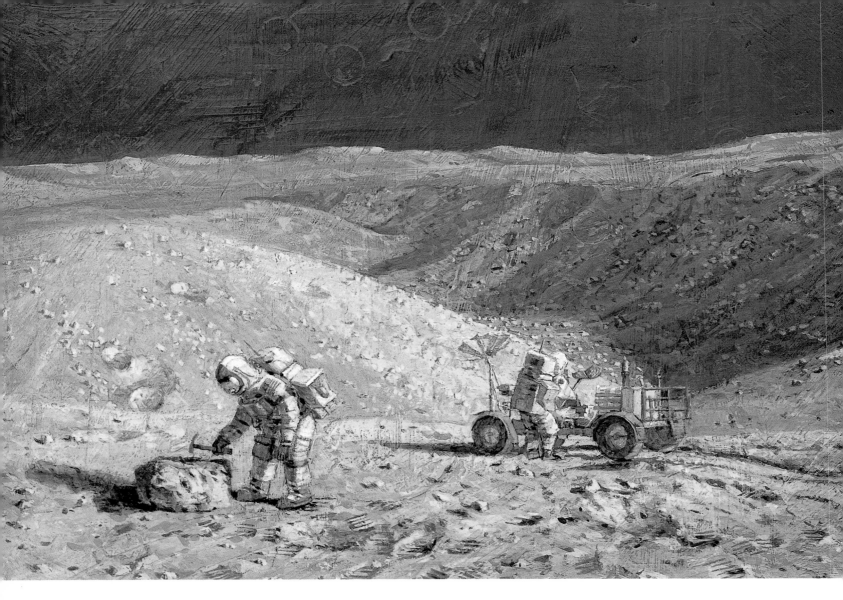

HADLEY RILLE

Hadley Rille was perhaps the most visually exciting feature we visited on any of our six lunar landing missions. Canyon-like, it meanders almost 70 miles across the lunar surface. From our point of view looking north in this painting, the Rille is about 1,100 feet deep and three quarters of a mile wide. We can see the sunlit far wall of the Rille moving left to right just beyond Apollo 15 astronauts Dave Scott and Jim Irwin. It then turns northwest and disappears in the distance, its east wall in shadow.

When they drove up in the Rover a few minutes earlier Dave reported, "Man, you ought to have a great view on your TV . . . this is unreal . . . the most beautiful thing I've ever seen."

Dave is using his hammer to knock small pieces off a lonely boulder. Dave felt the boulder might be significant because its isolation suggested it had been blasted from deep within the moon when a meteoroid hit the lunar surface nearby. Jim Irwin, back at the Rover, is getting the rake ready so that he can collect a variety of small rocks near the boulder.

As a result of Jim and Dave's exploration, we now believe that Hadley Rille was formed by flowing molten lava some 3.3 billion years ago. The lonely boulder was probably blasted out of the large crater we see beyond and to the right of the Rover some 17 million years ago.

LUNAR GRAND PRIX

Apollo 16 Commander John Young is putting the Lunar Rover through a full test. This was the second mission with the Rover aboard and this "Lunar Grand Prix" would allow John to evaluate the performance of the Rover in the light-gravity, and the dusty, cratered, and rocky surface of the moon.

His companion, Astronaut Charlie Duke, is photographing it all with the 16mm data acquisition camera normally mounted on the Rover, but hand-held temporarily to document the Rover motion.

John later said, "The tendency was to drive wide open or very close to that and take what you got. The best reference to speed control was the speedometer as I really didn't have a feel for the difference between 7 and 10 kilometers per hour."

Later he demonstrated a sharp turn at max speed, about 10 kilometers an hour. "I made the Rover end break out to show the engineers how it looked. It is no problem as all I had to do was cut back like I do when driving in snow . . . I didn't get up to any great speed, maybe 10 clicks at the most, but the terrain around there was too rough and rocky for that kind of foolishness . . ."

Charlie, who was filming it all, told Houston, ". . . man, Indy has never seen a driver like this."

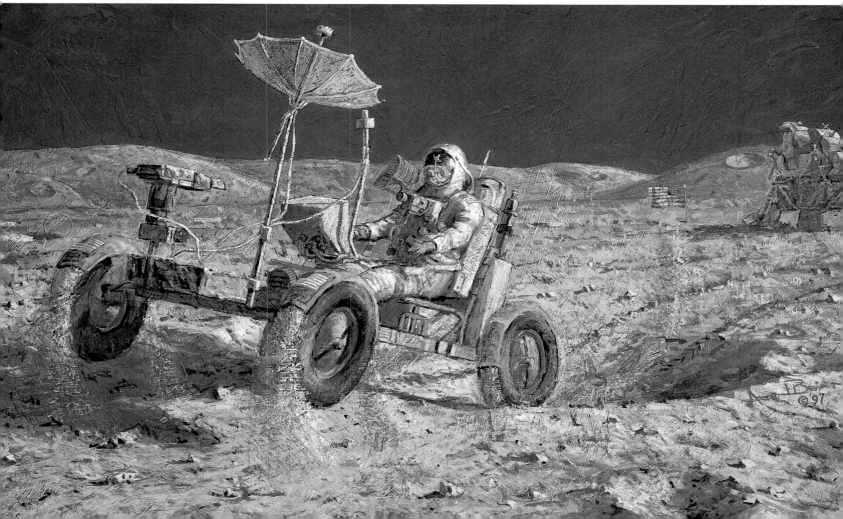

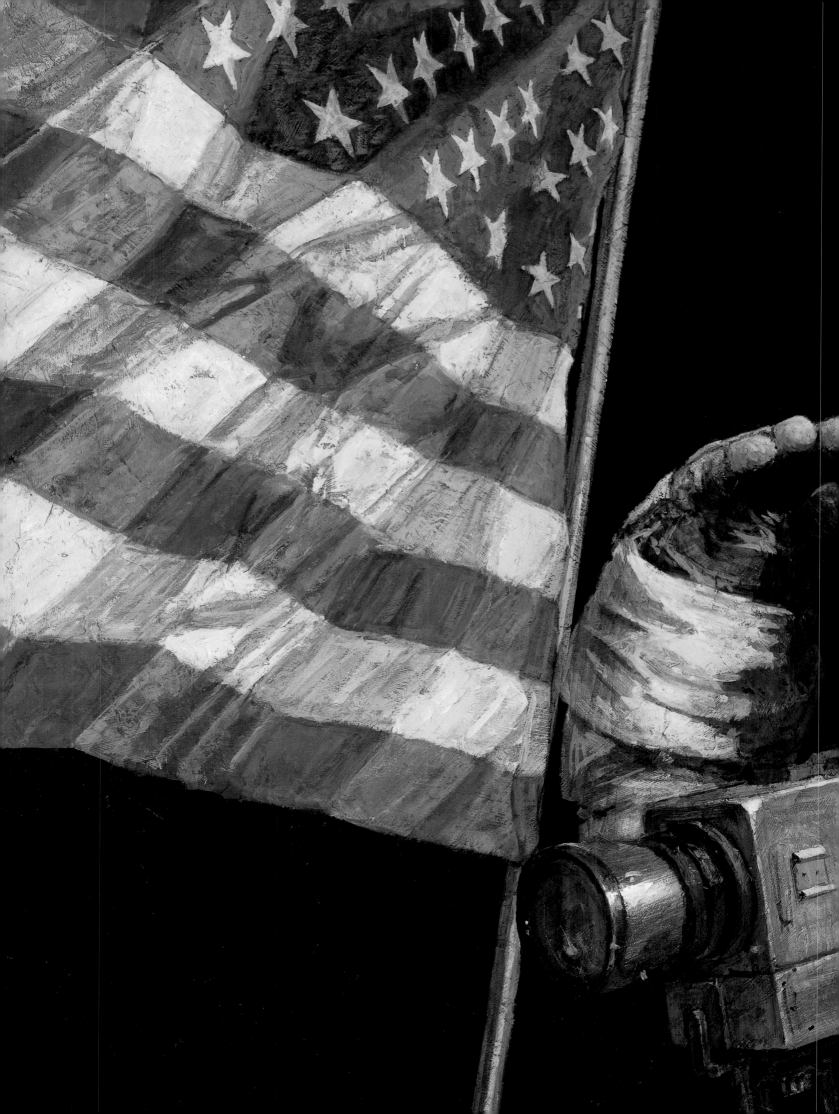

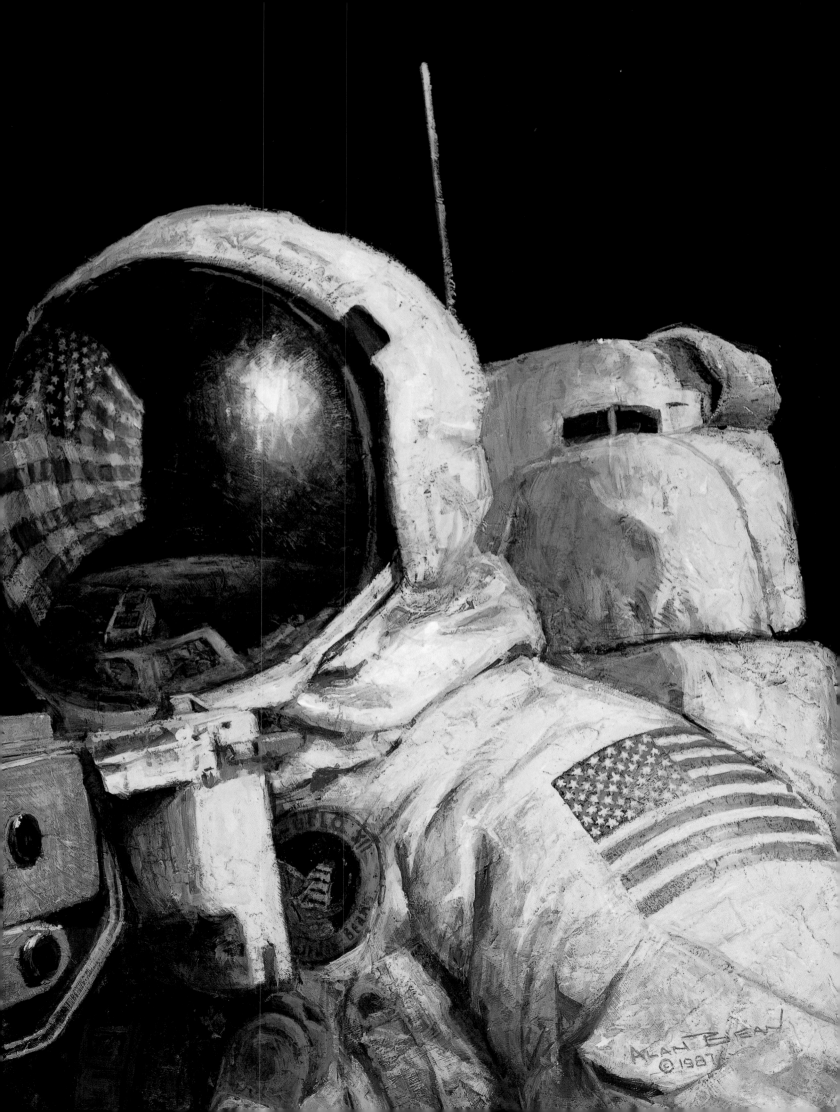

A REFLECTION OF THE BEST

[P R E V I O U S P A G E]

The American flag still proudly flies at six dusty, now-abandoned exploration sites on the moon. Apollo 11 placed the first at Tranquillity Base as we all watched transfixed on our television sets. Pete Conrad, Dick Gordon, and I were next to place the flag, this time on the Ocean of Storms. Fra Mauro, Hadley-Apennine, Descartes, and Taurus-Littrow followed. These missions are distant memories now, but each was a step toward answering the questions, "Who are we? Where do we come from?"

As an astronaut on the moon, I was one of the most visible members of the Apollo program, but I understood perfectly that the success of each lunar mission was dependent on the dedicated performance of the entire Apollo team. One of my most vivid impressions as I walked and ran and bunny hopped on the cratered surface was a feeling of the immense distance, some 239,000 miles, between Pete, Dick, and me and everyone else I had ever seen or heard about. Also on my mind at this moment was the knowledge that a lot of sophisticated hardware would have to perform as advertised to get us back home again.

I knew, we all knew, that this hardware on which our lives depended was designed and built, not by the lowest bidder, but by the best people on the planet earth. And our country's best was not just 'good enough,' it was perfection . . . it was unbeatable. The American flag was the first, and still the only, flag on the moon.

MY BROTHER, JIM IRWIN

[R I G H T]

Jim Irwin was assigned as my backup on Apollo 12. He knew his job extremely well. I knew that if anything happened to me at the last minute, Jim Irwin would do an excellent job on our mission and fit right in with Pete Conrad and Dick Gordon.

It was easy to like Jim. He had a personality that suggested you could have a lot of confidence in him. He wasn't an individual who tried to convince you that what he was doing was right or what you were doing was wrong, it was more like he wanted to work with you, and find the best way to do something together.

He flew a wonderful flight on Apollo 15 in July, 1971. He and Dave Scott were there 3 days and had what I felt was the greatest mission of Apollo up to that point. Not only because theirs was the first extended lunar scientific expedition, but because of their skill. While they were on the moon, Dave Scott and Jim Irwin both worked extremely hard and displayed some heart irregularities. It was only after they got back that they discovered the extent of NASA's concern for them and worry that this situation may have caused permanent damage.

After all the post-flight activities were complete, Jim left NASA and founded High Flight, an interdenominational evangelical organization devoted to spreading his word, his witnessing, his experience to other people. Jim described being on the moon as a deeply spiritual experience. Less than two years later, Jim experienced the first of several serious heart attacks. He felt that his physical efforts on the moon, combined with the way the human body eliminates excessive potassium and other minerals in zero gravity, had damaged his heart. He died of a heart attack in 1991 at the age of sixty-one.

We used to see each other at astronaut reunions or accidentally in airports from time to time, and when we parted company, he would put his arm around me and say, "Well, I hope I see you again soon, brother." It was a surprise the first time as that isn't the way one astronaut talks to another and I didn't know what to say. After this happened a few times, I wanted to reply because I felt very close to him but I just couldn't make myself say those words. Since I left the space program and became an artist, I think differently about myself and my life. I miss Jim a lot and I understand how I miss him and respect him as the brother I never had.

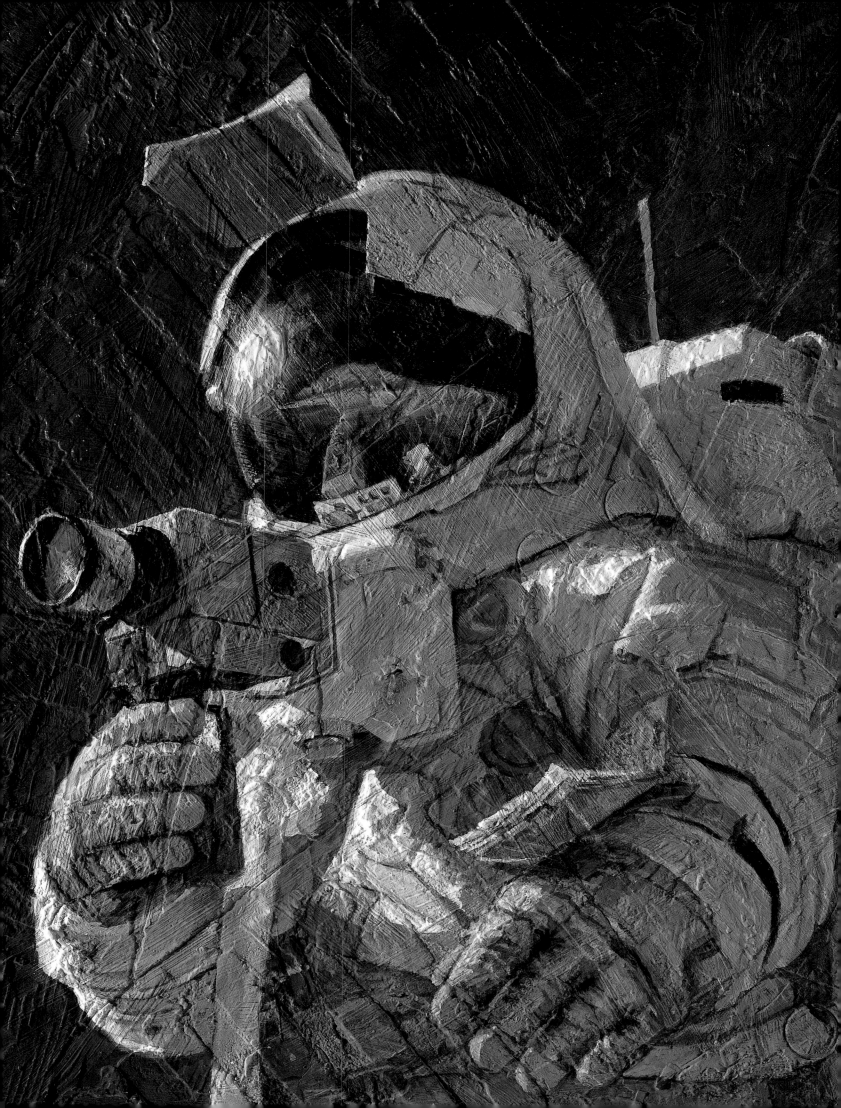

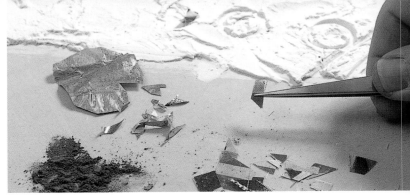

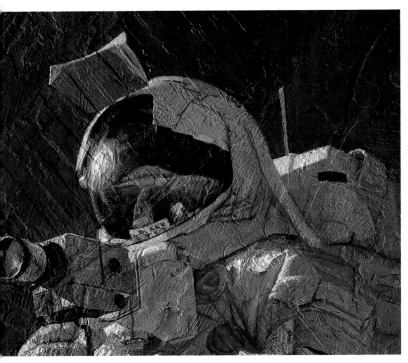

MOONDUST AND FOOTPRINTS

One of the things I most want to achieve with my paintings is to give people a connection with the otherworldly feelings that I and my fellow astronauts had on the moon. I try to do this not only in the motifs I choose to paint, but in the way I prepare the painting's surface. The moon was a strikingly beautiful world, yet rough and unpolished. I want my paintings to have those very same qualities, and to have a special, tangible connection with Apollo, and with the moon.

I begin the process by cutting to size a sheet of aircraft plywood, the plywood that is used in the construction of many light airplanes. I cover the entire aircraft board with a thick acrylic modeling medium to provide texture. I watch very carefully as the modeling medium begins to set, and at just the right time I begin to work on the surface, using some of the tools I had with me on the moon.

First, I use my heavy, metal geology hammer—the same one I used on the moon to drive the staff that held up our American flag, and to pound in the core tubes to obtain soil samples. With the hammer, I dig into the surface, and pound at it, and scrape it. Next comes a sharp-edged bit that was on the cutting edge of one of the core tubes. Now I use it to make round indentations on the surface of the painting. These tools, which once helped me explore the moon, are now putting the moon's stamp on my paintings.

I also use a replica of the soles of my lunar boots to create a special "lunar" texture. With them, I make "footprints" like the ones that I and the other Apollo astronauts left in the moon dust. Together with the marks I've made with the tools, the footprints create a texture that is, like the moon, rough and unpolished. Each painting has its own unique set of imprints that reproduce the first marks made by human beings on a world

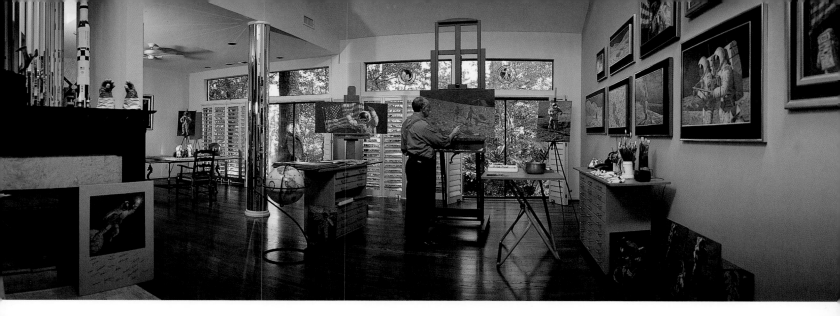

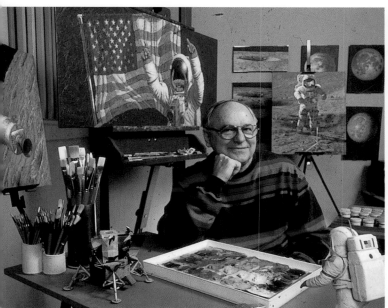

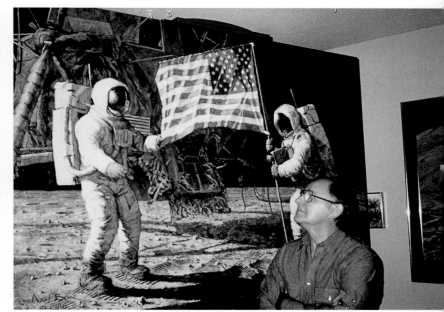

other than the earth. These marks can be seen in the finished painting above left.

There are two more things I put into my paintings. Several years ago my friend Max Ary, who is director of a museum with an extensive collection of space hardware, received our Apollo 12 spacecraft for display. When he opened the shipping container, he found that tiny portions of the charred heat shield, which protected us during the fiery reentry at 25,000 miles per hour, had shaken loose in transit. Also scattered about were bits of the gold foil used to cover the spacecraft's sides and hatch. He collected these things and gave them to me to use in some way. I mix some of these materials into the modeling medium before I apply it to the board.

I really wanted to have a small chip of lunar rock to grind up, so that I could put a little bit into each painting. Contrary to what some people have thought, NASA did not give any astronauts a moon rock as a souvenir. What NASA did give us, though, were the American flags, NASA insignias, and Apollo mission patches we wore on our space suits. For years, mine were neatly framed and hanging on the wall of my study. One day I looked at them and realized they were dirty with moon dust. I cut off a portion of each of the emblems, chopped them into small bits, and put a few of the bits into the modeling medium. I have found a way of putting a little bit of the Ocean of Storms into each of my paintings.

And so, within my paintings now are actual particles of the spaceship I flew to the moon, some charred black by reentry heat, and minute amounts of moon dust that coated my space suit as I walked and worked on the Ocean of Storms.

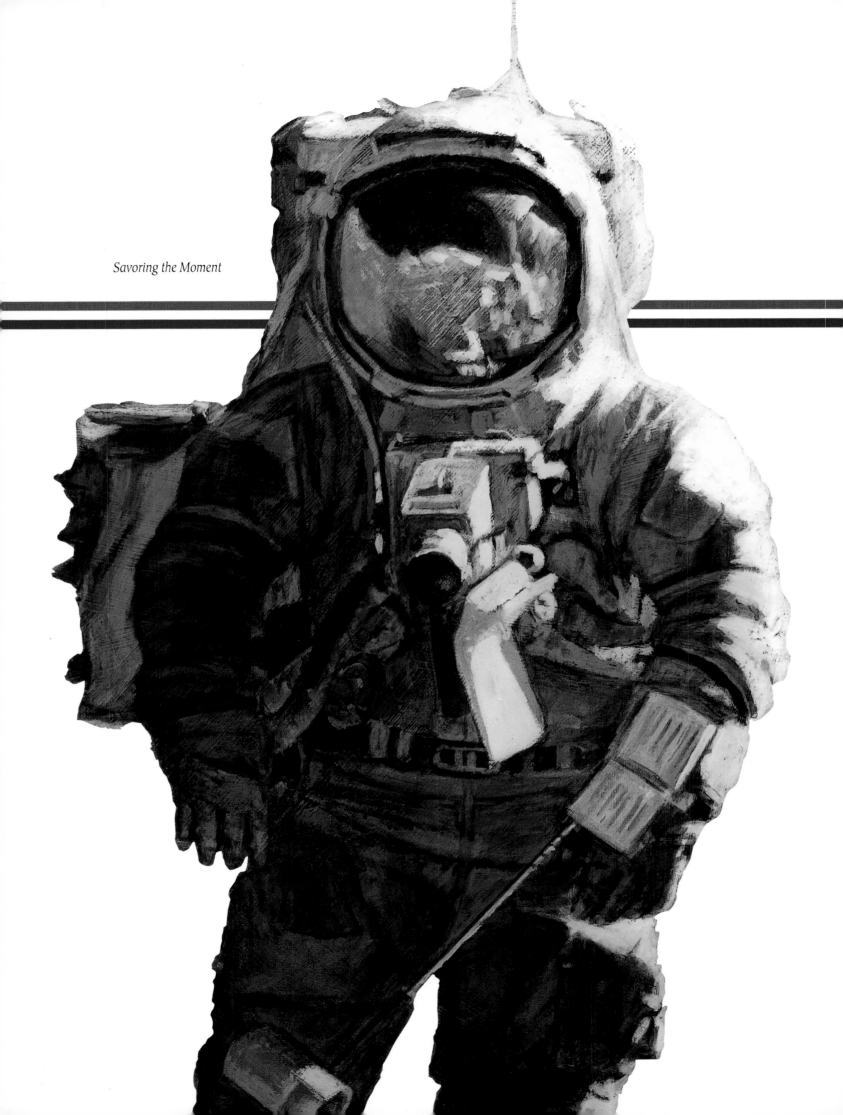

Savoring the Moment

·V·
ONE PRICELESS MOMENT

On the trip back to earth Bean told his crewmates,
"No computer program could tell you where human beings
will be ten years, or twenty years, or one hundred years from now."
Today, he says, "We're living in a golden age right now. Our
chances for living the life of our dreams have never been greater
in all of human history, and the future looks even brighter.
We are unlike anything else we know of in the universe.
The only limits we have," he says, "are the ones
we place on ourselves."

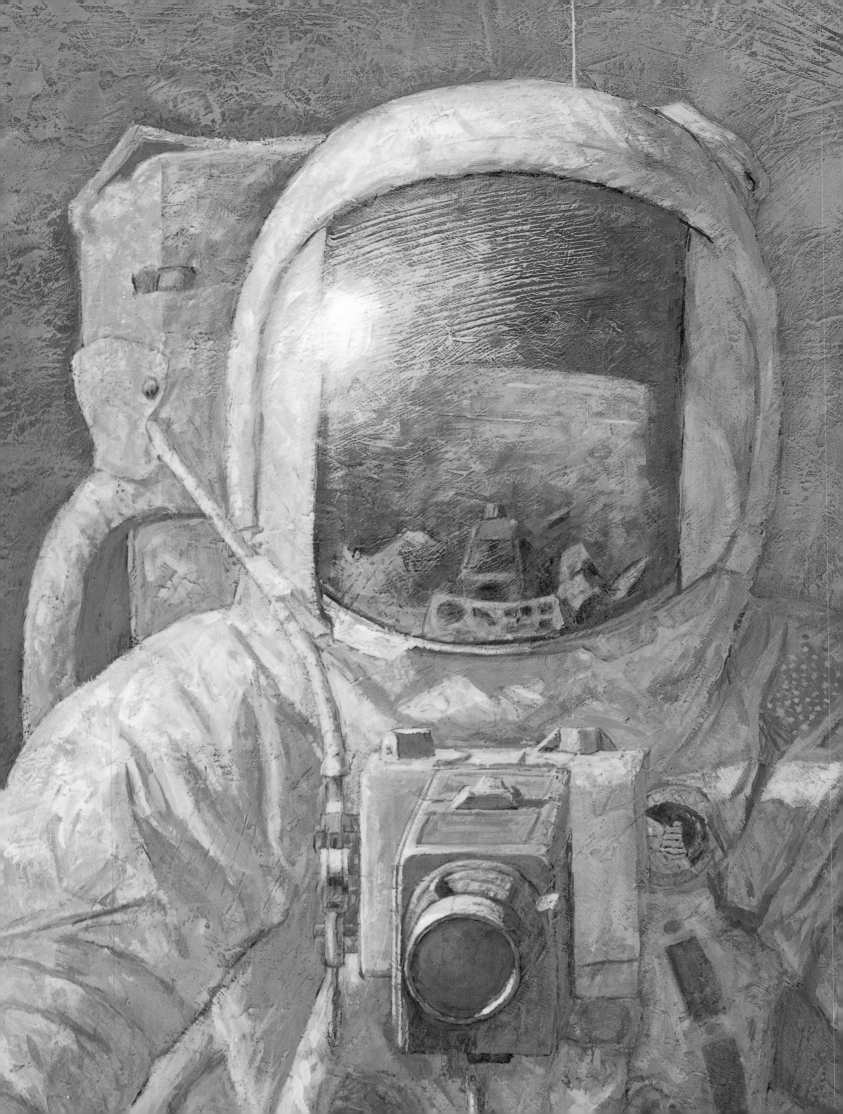

·V·
ONE PRICELESS MOMENT

In April 1969, when I was twelve years old, my parents took me to Cape Kennedy as a birthday present. What I wanted, most of all, was to meet an astronaut. By luck, we stayed in the motel where the astronauts stayed. The next morning, in the parking lot, Alan Bean met a boy he did not know, and was kind enough to spend a few minutes talking to him about his upcoming Apollo flight. And then he and his backup, Jim Irwin, were off to the space center.

Hours later, so were my father and I. We saw the Saturn V moon rocket, and its giant Vehicle Assembly Building, and one of the massive tractors built to transport it to the pad, each of whose treads weighed a ton. We came away with the sense that we had become witnesses to the great adventure that was underway. For me, it was a precious first glimpse into a special time and place which has remained central to my life even as an adult.

Later that year, like countless millions of people, I watched as Alan Bean and Pete Conrad walked on the moon. I have no doubt that I was seeing the opening act in a story that never ends, one that will eventually see people visit other planets, and even other stars. But those voyages belong to our descendants. What belongs to us—and what we must cherish as we would any priceless possession—is the time when it all began. We cannot relive Apollo, but we can preserve its legacy; we can continue to tell the story. And that is Alan Bean's job now.

In many ways, Bean follows in a tradition of explorer artists like Albert Bierstadt and Thomas Moran, who accompanied expeditions into the American West in the second half of the nineteenth century. In works like Bierstadt's *Storm in the Rocky Mountains* and Moran's *The Grand Canyon of the Yellowstone*, easterners were presented with the magnificence that lay beyond the Mississippi. Bierstadt and Moran helped to create in the public imagination the idea of an American Eden.

But their vision of the West proved more romantic than real. In 1869, a century before the first moon landings, the transcontinental railroad was completed. The wilderness that was celebrated and even embellished by Bierstadt and Moran was invaded by an unrelenting wave of settlers. By the early twentieth century cowboys were already a vanishing breed, and the mythic West was taking shape in the romantic yarns of writers and storytellers. Even as the frontier vanished, its hold on our national psyche was cemented.

The moon is different. There are no wagon trains to ride a quarter million miles through the void, and no lure of an Eden waiting at the other end, at least not yet. The paradox is striking: We can see Apollo's moon with our own eyes—unlike the Old West—but we cannot go there. The first era of humans on other worlds remains a brief, singular event in our history. There isn't any need to romanticize Apollo as we have the American West; the reality is enough.

Alan Bean has no doubt of that. When he first began his life as an artist, he wondered whether Apollo would offer him enough stories to build a career. Now he laughs at the question. In his studio he keeps a book with ideas for new paintings, many gleaned from conversations with his fellow moon voyagers. "That book," Bean says, "has more stories now than it had when I started. Certainly many more than I can accomplish in my lifetime." He hopes to complete some two hundred paintings, but he knows that even if he succeeds the Apollo saga will be incomplete. "I just hope I can live long enough, and be healthy enough, to create a record that is representative. It won't be everything. But it will be a start."

In rendering the Apollo voyages, Bean is doing what no other artist can; he is working from his own experience. In the 1960s and 70s, images from the moon program appeared in works by artists Robert Rauschenberg and Andy Warhol among others. But these paintings were abstract commentaries, not eyewitness accounts. Like letters sent home by the explorers of the Old West, Bean's works tell us of a strange new land, and the risks and exhilaration of getting there.

In a sense, painting is the closing of a circle in Bean's life that began on the Ocean of Storms. In those precious hours on the

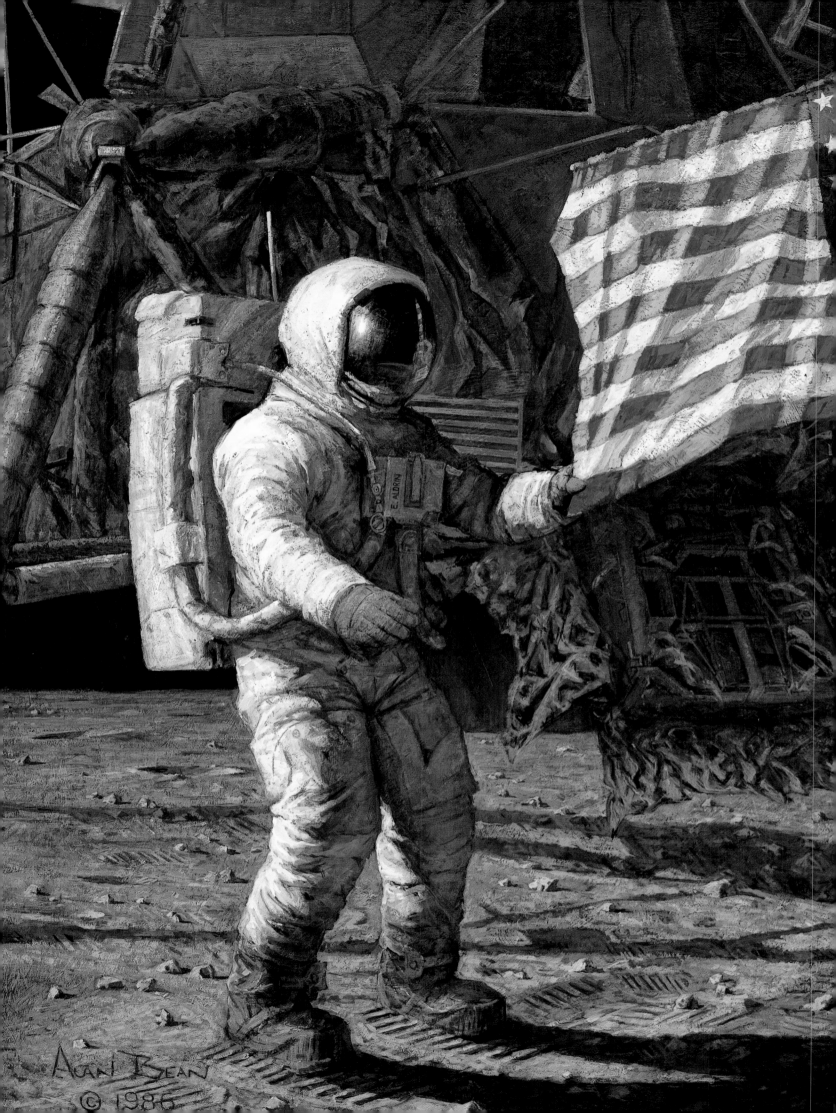

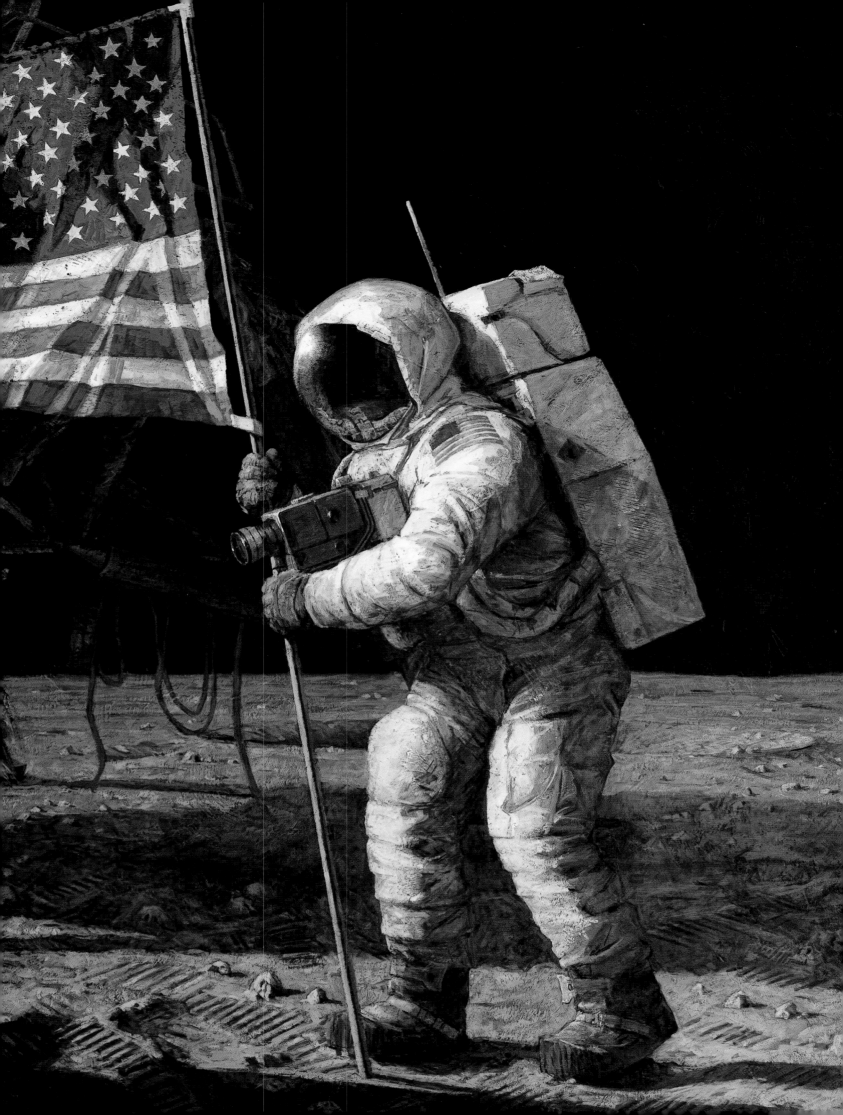

FOR ONE PRICELESS MOMENT

[P R E V I O U S P A G E]

I painted Apollo 11 Astronauts Neil Armstrong and Buzz Aldrin completing, in my opinion, the most significant thing they did during their historic journey. The flagstaff was stowed in two sections. The upper section included the flag mounted on a fold-up telescoping metal rod. Neil remembered, "It went as planned except the telescoping top rod could not be extended. Both Buzz and I operating together were unable to apply enough force to extend it." Buzz added, "We thought maybe we could extend the rod by both pulling but we didn't dare exert too much force because if it ever gave way, we'd find ourselves off balance."

It was only a few minutes later that President Richard Nixon, calling by telephone from the oval office in the White House, said, "For one priceless moment in the whole history of Man, all the people on the earth are truly one; one in their pride in what you have done, and one in our prayers that you will return safely to earth."

The television picture we all watched was from their black-and-white camera, some 40 feet in the distance. I composed this painting so that if you stand back exactly eight feet, you will see Neil and Buzz and our flag, with the Eagle in the background, just as if you stood nineteen feet away on the Sea of Tranquillity, Sunday, July 20, 1969.

moon, when Bean felt the amazement wash over him, he would remind himself to get back to work, that the time to reflect on the experience was after it was over. That time has come, and we are richer for it. Bean says he is, too. Visiting another world, he says, has given him a new appreciation for his life on this one. "I am happy every day just being on the earth," he says. His memories of the moon—lifeless and unchanging, a place where only shadows move—have made him grateful to look up from his easel and see a squirrel foraging just beyond his window, or the wind moving through the trees. A rainy day is a blessing. The noise of traffic on a busy Houston street tells him the earth is alive. "In the whole universe, this is the best planet we know of. We're living in the Garden of Eden, and the vast majority of people don't even realize it."

There is another lesson Bean learned from his trip to the moon, and it is about our future, on this world and off it. One day during the trip back to earth, Bean and his crewmates looked out the window and contemplated the universe they were flying through. They talked about the fact that Apollo 12 was only a tiny speck in the blackness, so small that no telescope on earth could have spotted them. And yet, Bean realized, no other creatures could have made the voyage he and Pete Conrad and Dick Gordon were now completing. "If we had the right programs in our computer," he told his crewmates, "we could figure out where the earth and the moon were a million years ago, or where they will be a million years from now. But no computer program could tell you where human beings will be ten years, or twenty years, or one hundred years from now." Today, says Bean, "We're living in a golden age. Our chances for living the life of our dreams have never been greater in all of human history, and the future looks even brighter. We are unlike anything else we know of in the universe. The only limits we have," he says, "are the ones we place on ourselves."

It may be some time before anyone follows in Bean's lunar footsteps. For now, he is content to see a new generation of

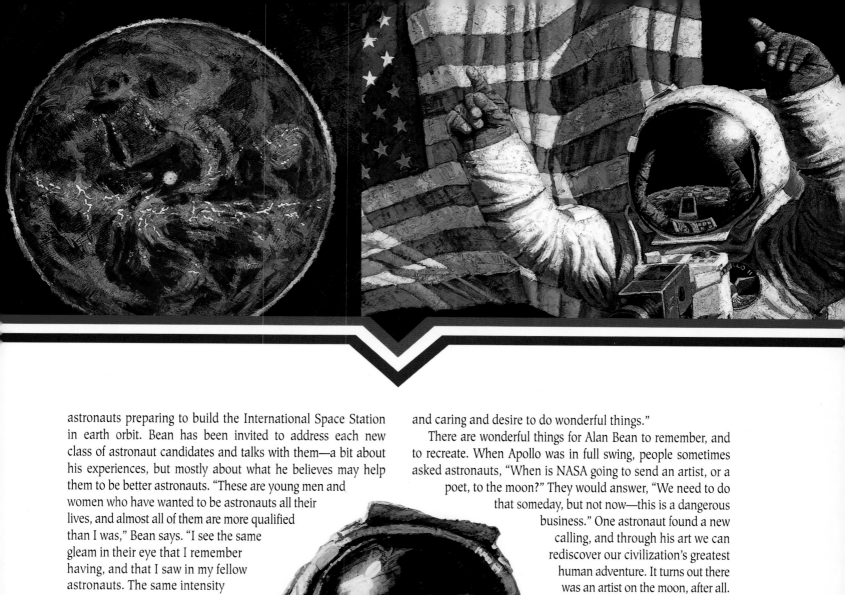

astronauts preparing to build the International Space Station in earth orbit. Bean has been invited to address each new class of astronaut candidates and talks with them—a bit about his experiences, but mostly about what he believes may help them to be better astronauts. "These are young men and women who have wanted to be astronauts all their lives, and almost all of them are more qualified than I was," Bean says. "I see the same gleam in their eye that I remember having, and that I saw in my fellow astronauts. The same intensity and caring and desire to do wonderful things."

There are wonderful things for Alan Bean to remember, and to recreate. When Apollo was in full swing, people sometimes asked astronauts, "When is NASA going to send an artist, or a poet, to the moon?" They would answer, "We need to do that someday, but not now—this is a dangerous business." One astronaut found a new calling, and through his art we can rediscover our civilization's greatest human adventure. It turns out there was an artist on the moon, after all.

The Spirit of Exploration

SAVORING
THE MOMENT

*Harrison "Jack" Schmitt is taking a brief break
to look in wonder, and to just appreciate how
incredibly fortunate he is. As the only profes-
sional geologist ever to study firsthand another
world, he needs a little time to let the signifi-
cance of the event sink in. He is near the end of
his third lunar surface exploration, and
exploration is hard, hard work.*

*Both Gene Cernan and Jack have been going
full speed. The human body gets tired in a dif-
ferent way on the moon. This is largely caused
by the 3.7 pounds-per-square-inch pressure
inside the suit that is required to keep us earth-
lings alive in the moon's vacuum. With this in-
ternal pressure the fingers want to stay open
and a lot of conscious effort is required to hold
tools, rocks, or just anything.*

*Jack probably won't be back this way again,
and he's trying to capture in his memory the
magnificent desolation of the lunar world. This
spot hadn't changed much over the last three
billion years. Now there are signs of visitors
from another place; part of a spaceship,
an abandoned car, a flag. They will remain
just as they are for at least the
next three billion years.*

*Jack is living a dream that is almost as
old as man himself, to voyage off this earth and
out toward the stars. As Jack said earlier,
"Oh, what a nice day . . . there's not
a cloud in the sky."*

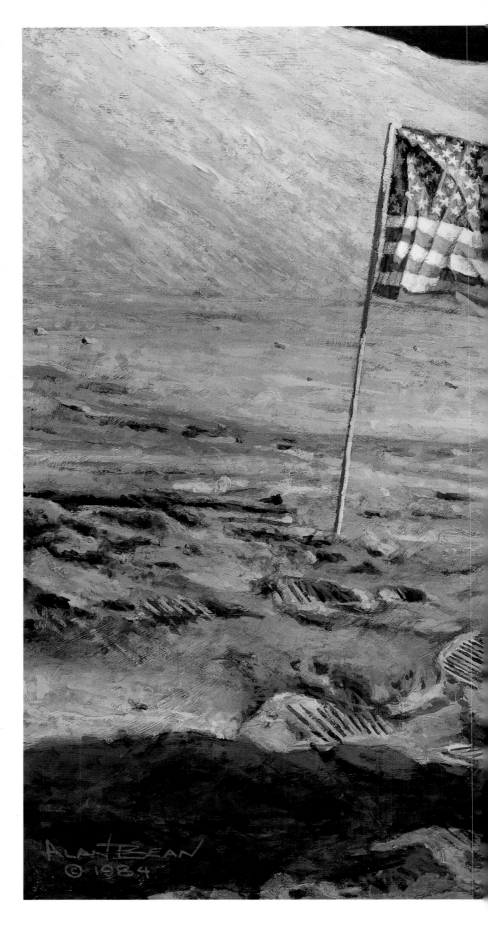

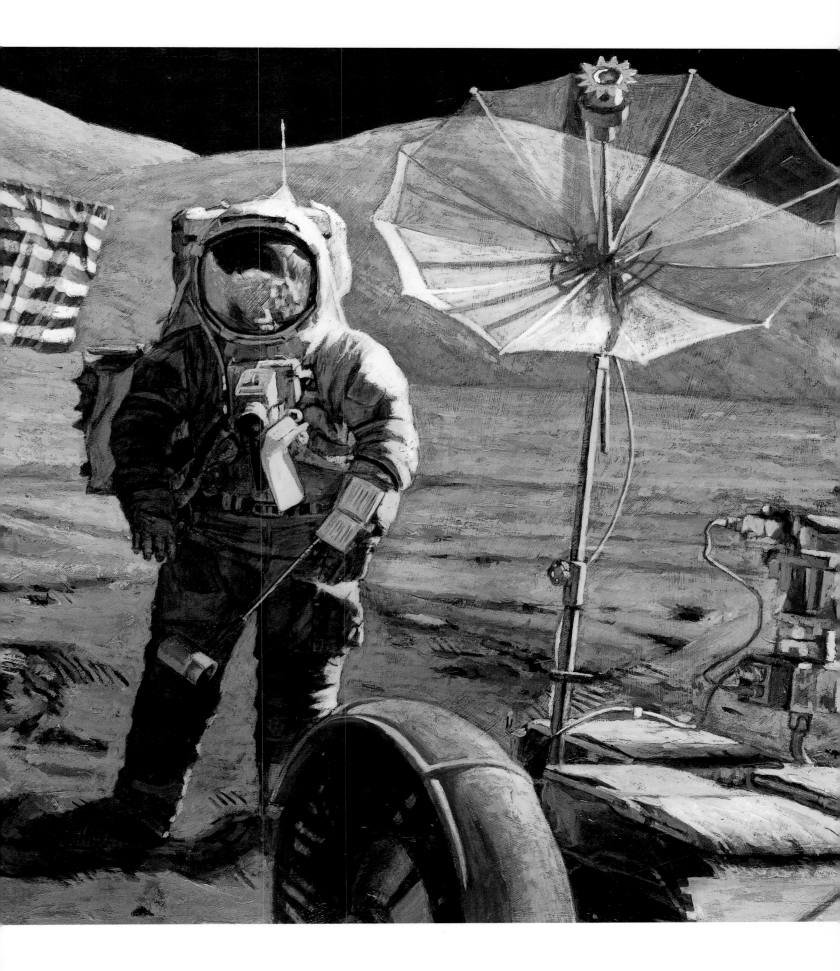

MOTHER EARTH

The planet earth seems a long way off because it is—about a quarter of a million miles off. From the moon, the earth would appear as a beautiful blue-and-white marble. Occasionally, there would also be a small orange area visible. I knew the orange areas were deserts, but just which ones was extremely difficult to tell. When I wanted to know which desert I was looking at, I would ask mission control which ground station was tracking us. If they could see us, we could see them.

The moon itself was a foreboding place when viewed from orbit. Mostly gray with stark, angular mountains and deep, rough canyons and craters. It was as if nature had pounded the moon again and again with a big, big hammer.

In contrast, our earth was beautiful—all shiny and bright. or seen on TV, and the places they lived and played were all on that little blue-and-white marble. It's still hard to believe.

It was hard to believe that everybody I had ever known,

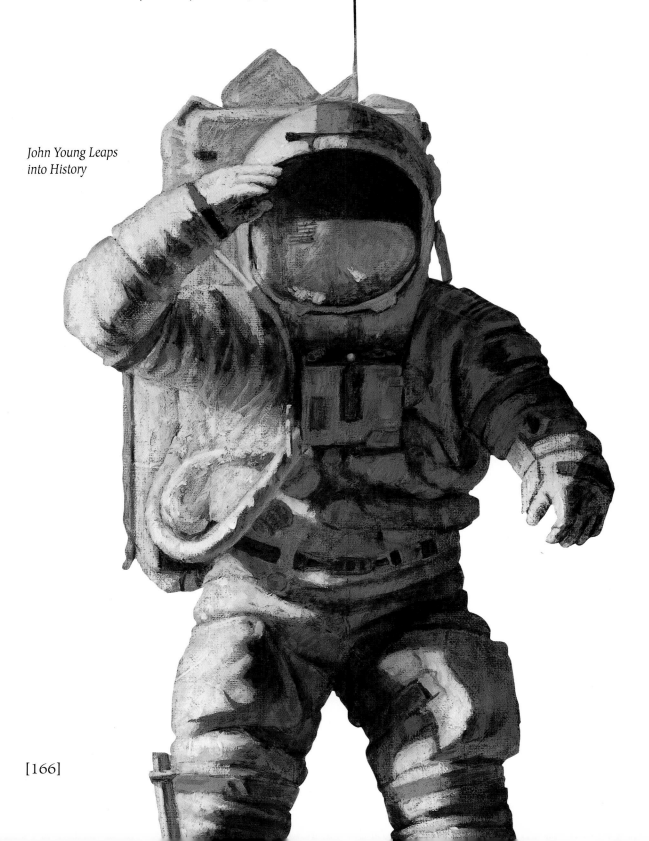

*John Young Leaps
into History*

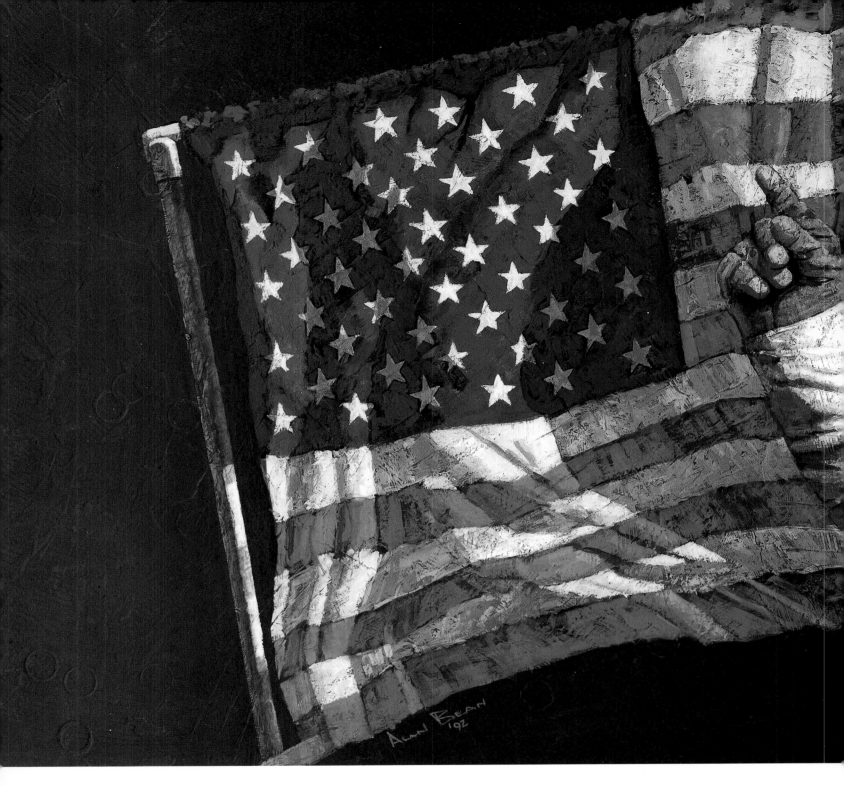

AMERICA'S TEAM . . . JUST THE BEGINNING

One day in mid-1992 the phone rang in my studio. On the line was a representative from Space Center Houston, a futuristic visitors center under construction near the Johnson Space Center in Houston, Texas, where I had spent my eighteen years as an astronaut. They wanted me to create a mural for them based on the theme of my painting America's Team . . . We're Number 1.

That painting was one of my favorites since it showed how Neil Armstrong must have felt and how all of us here on earth felt, when he first set foot on the moon.

I went to Space Center Houston and looked at the proposed wall, which was thirty-nine feet wide and seventeen feet high—a long wide shape, not the shape of the painting they selected. No problem, I would create a different painting with a similar theme, move the flag, and change the proportions.

Well, here it is! Neil's first step was a wonderful moment in history, an impossible dream that Americans made into reality, but it was just the beginning of human movement off this planet earth and into the infinite ocean of space.

REACHING FOR THE STARS

In one sense this is a painting of a universal astronaut, symbolizing everyone who flew in Mercury, Gemini, Apollo, Skylab, and Apollo-Soyuz. It also represents those who fly on space shuttles and will fly on a space station and on future missions only dreamed about at this time.

The astronaut is an emissary of us all, soaring away from our planet earth and traveling as far as it is humanly possible to go with the technology available in our age. Although we haven't yet explored distant stars, we are moving inexorably in that direction. As the centuries unfold, humans will visit all the planets around all the stars that it will be possible to reach at that time, for this desire to explore our limits appears to be a unique and magnificent characteristic of human beings.

But in a broader view, this lone human figure not only symbolizes those of us in the astronaut profession, but all of us who possess a dedicated and adventurous spirit no matter what our interests or age. For we earthlings, we human beings, are the only life form that we know of that can dream, then plan and work together to achieve that dream. We are extraordinary in the universe in that our only limits are those we place on ourselves.

I painted this astronaut, this "star sailor," to represent the best in each of us, what we can accomplish, who we can be, if we will create the courage and determination to move in the direction of our dreams. It is up to each of us to keep reaching for our own stars and to understand that they are not light years distant but as close as our workplace, our home, and our family.

"THE FIRST ECLIPSE OF THE SUN"—WORK IN PROGRESS

I haven't finished this painting but it has an interesting story which begins with its curious title. Most of us have seen the moon eclipse the sun at some point in our lives, so what is the meaning of this title? On our way home from the moon, Pete Conrad, Dick Gordon, and I became the first humans since the dawn of time to see the earth eclipse the sun. We were about 27,000 miles out at the time, on a trajectory for our entry point. I have painted the sun fully eclipsed, and at that moment we could see the atmosphere of the earth. It was quite thin and acted as a prism that caused the light rays from the sun to break up into spectral bands which I've attempted to paint.

We could look down into a moonlit earth. We were just off the east coast of Africa and we could see Saudi Arabia and India to the right as we moved very rapidly to the east. As we looked down, we could see a bright light appearing to move quickly across the earth. We didn't know what to make of it. We also noticed scattered small flashes of light. Dick Gordon mentioned that it looked a lot like lightning in clouds when flying above a thunderstorm. We looked very closely and saw that they were, in fact, little streaks of lightning. We wondered for a moment why they seemed to be arranged in a band across the earth, maybe 20 degrees wide. We looked again and realized that the lightning flashes were along the equator. We were seeing the electric discharges from thunderstorms that had built up over the equatorial zone during the day.

I told this story to Jacques Cousteau and he said it sounded as if the earth were wearing a necklace of diamonds. I thought his response to my technical description was poetic and as beautiful as the sight itself.

We didn't figure out the bright light we saw moving across earth until we got home. Fellow astronaut Rusty Schweickart told us that at the point the earth eclipsed the sun, the full moon had been behind us, and what we had seen was the reflection of the moon off the water.

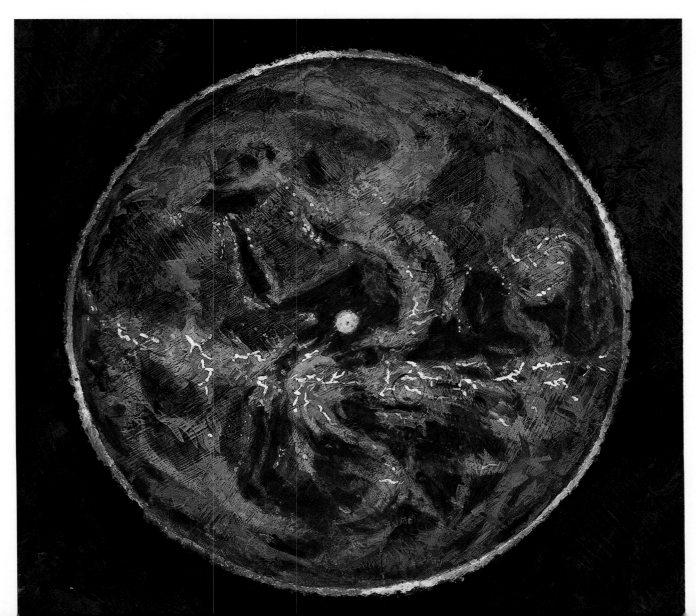

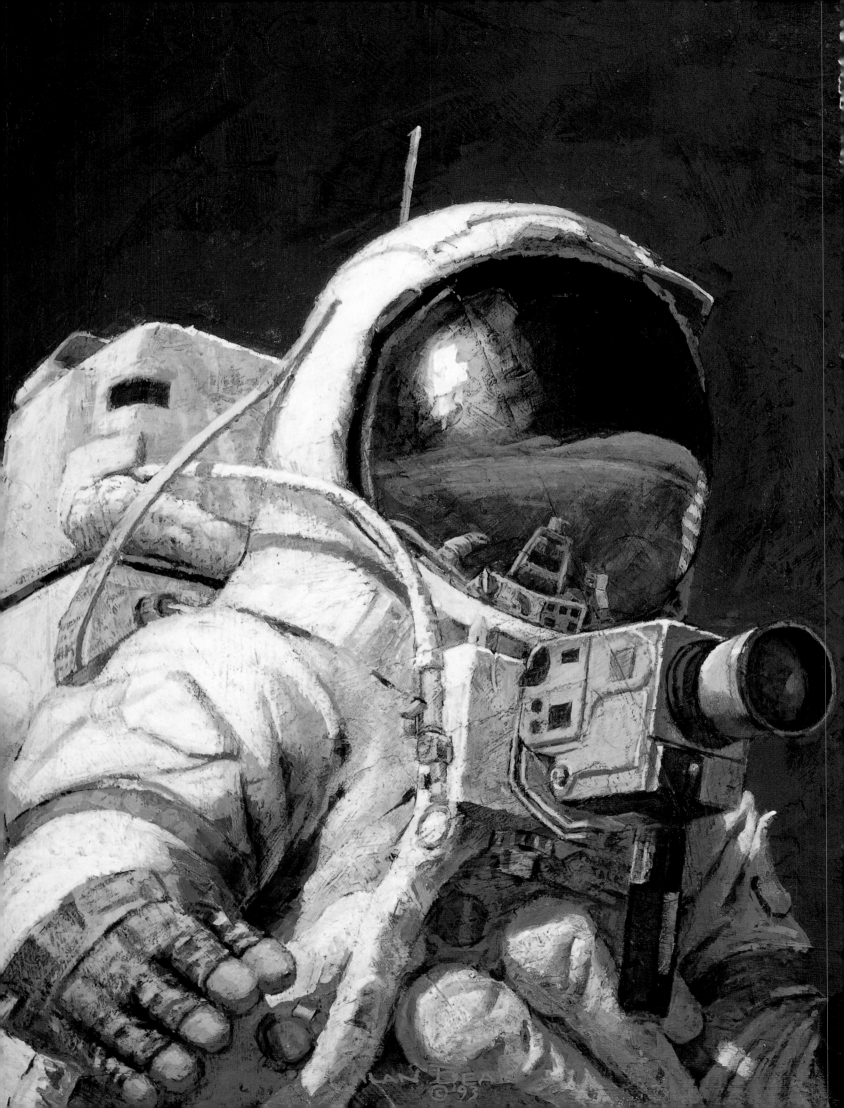

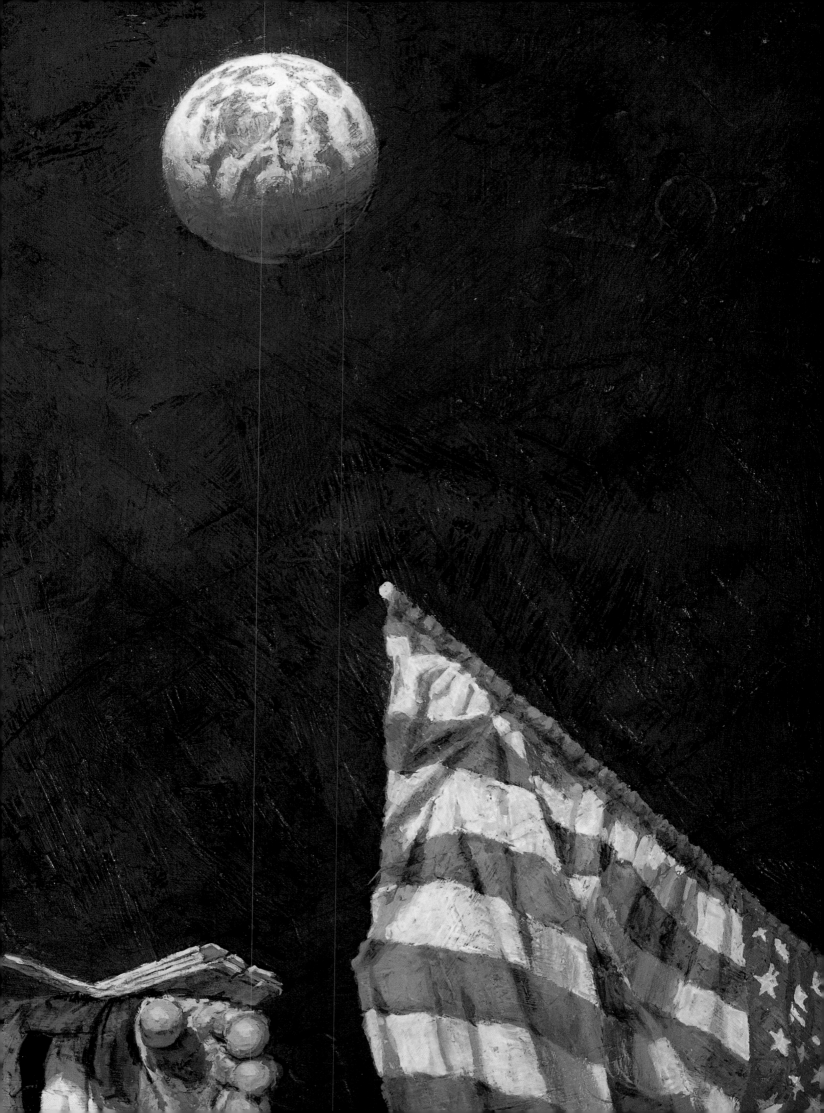

THE LAST MAN
ON THE MOON

===

[P R E V I O U S P A G E]
In the early morning hours of December 14, 1972, Astronaut Commander Eugene Cernan jumped to the lower rung of the ladder, cautiously climbed up the nine rungs, crawled across the small platform and moved carefully through the tight fitting hatch at the front of the lunar module. Gene was the last human being to stand on the surface of the moon.

There were a total of twelve of us who got to explore another world as representatives of the people of the United States of America. As Gene Cernan had said a few minutes earlier, "We'd like to uncover a plaque that has been on the front leg of our spacecraft . . . I'll read what it says . . . 'Here man completed his first exploration of the moon, December 1972 A.D. May the spirit of peace in which we came be reflected in the lives of all mankind'."

Astronaut Jack Schmitt, his partner on the moon, would say, "Humankind has started to do something that they have never done before. They have gone somewhere they have never been before, and shown they could live there. That is an exciting thing."

There are only six flags on the moon and all of them are the stars and stripes. The United States of America did it by working together. Landing men on the moon and returning safely to earth was a brilliant triumph of the human spirit.

THAT'S HOW IT FELT TO
WALK ON THE MOON

===

[R I G H T]
"How did it feel to walk on the moon?" That is the single question I've been asked most often since November 19, 1969. I've said, "It's that feeling of excitement a person experiences only when their life's vision becomes a reality." Or "It's the feeling one has when years of intense dedication and training finally make their most cherished dream come true." Often I'll remember, "I felt a long, long way, 239,000 miles at least, from most of the people and places I love." I might also add, "It seemed unreal . . . impossible . . . but my space gear, and the familiar voices from earth told me otherwise." From time to time I would look down and say to myself "This is the moon," and then I would look up at a small, beautiful, bright, blue-and-white sphere hanging in the mysterious, luminous black sky and say to myself "That is the earth." I've tried a lot of words over the years but I don't think I've ever completely expressed my feelings about that incredible experience.

The original idea for this painting came to me in 1986. I began painting what had taken shape in my mind but when it was nearly completed the painting just didn't feel right.

I set it aside for several months but studied it every day or so. A new vision emerged that elicited happier and more exhilarating thoughts and emotions, ones closely related to how it actually felt. Then I was able to finish the painting.

[174]

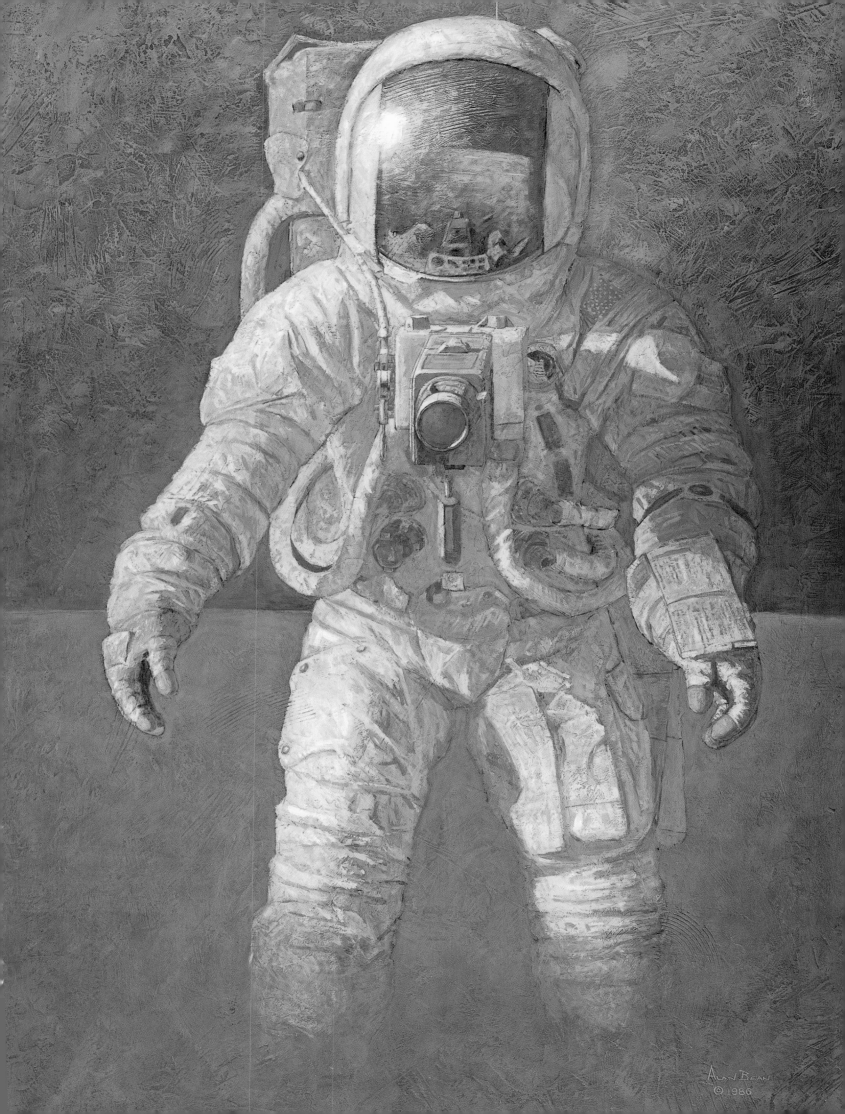

Alan Bean
© 1986

LIST OF PAINTINGS

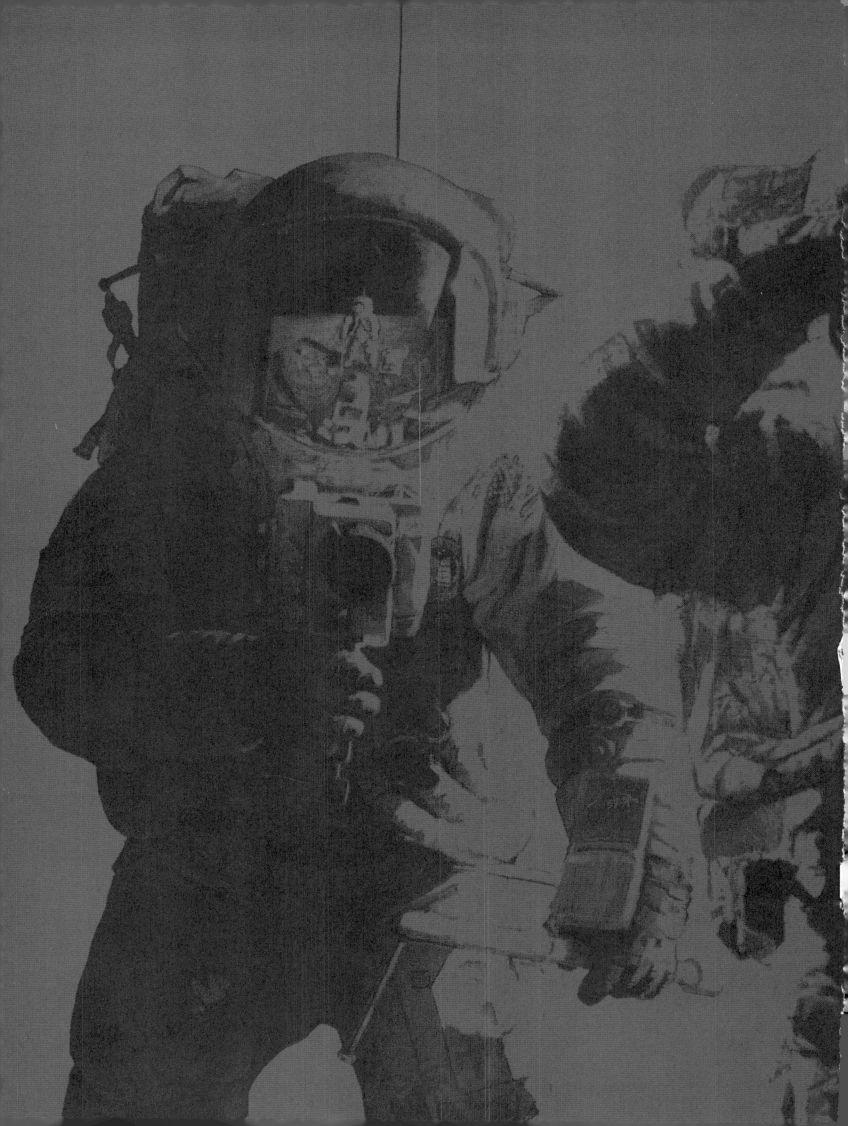